HIGH-FOCUS DRAWING

For all my students.

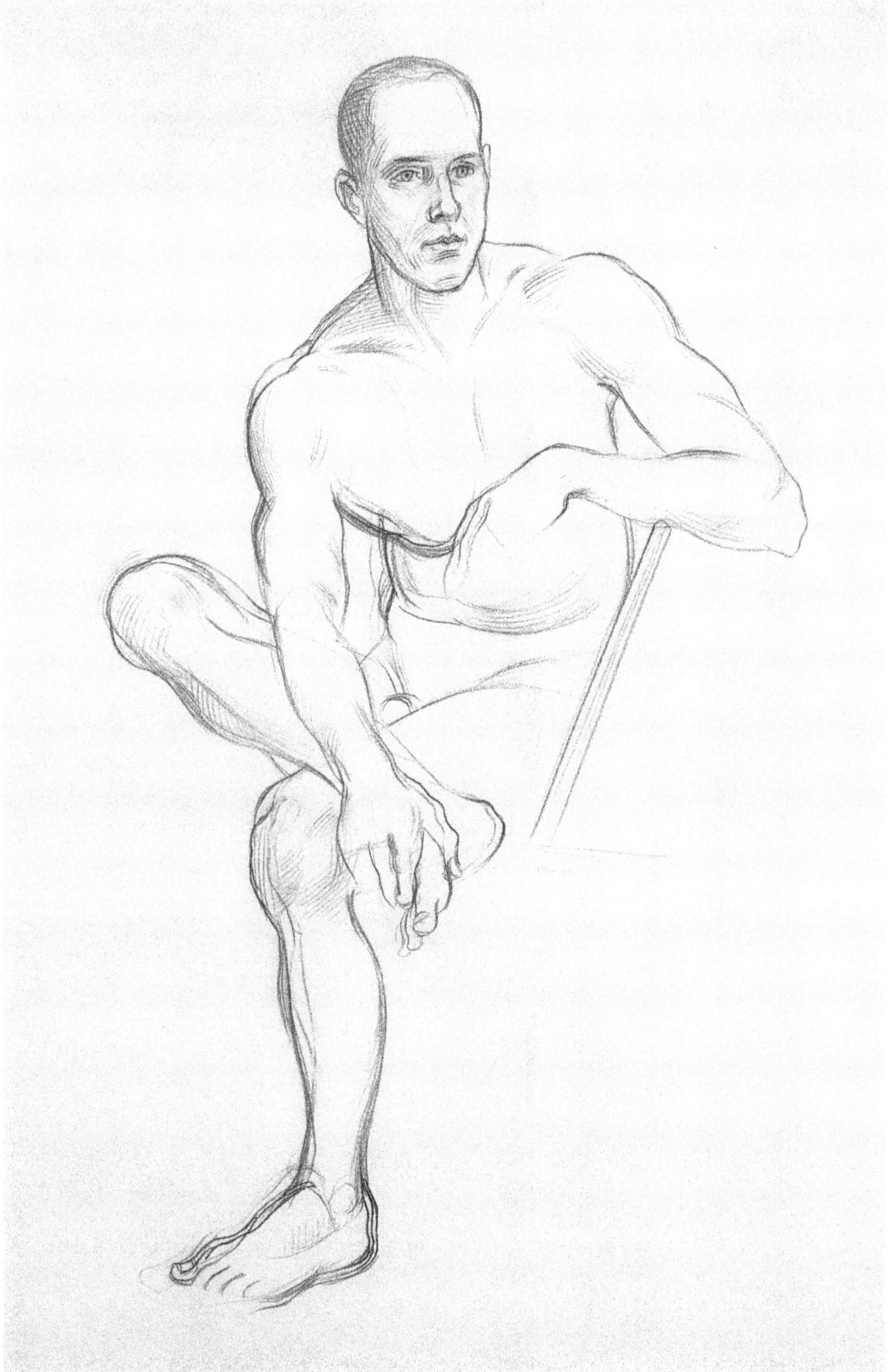

High-Focus Drawing

A REVOLUTIONARY APPROACH TO DRAWING THE FIGURE

James McMullan

Published by Echo Point Books & Media
Brattleboro, Vermont
www.EchoPointBooks.com

All rights reserved.
Neither this work nor any portions thereof may be reproduced, stored in a retrieval system, or transmitted in any capacity without written permission from the publisher.

Copyright © 1994, 2016 James McMullan
Casebound Publisehd in 2018

High-Focus Drawing
ISBN: 978-1-62654-076-7 (paperback)
 978-1-63561-682-8 (casebound)

Interior design by Barbara Balch

Cover design by Justine McFarland
Editorial and proofreading assistance by Ian Straus,
Echo Point Books & Media

CONTENTS

HOW TO USE THIS BOOK 8

INTRODUCTION 9

CHAPTER 1 *What Is Real in Realistic?* 19

CHAPTER 2 *What Lines Can Do* 35

CHAPTER 3 *Drawing the Model* 59

CHAPTER 4 *Student Progress* 110

CHAPTER 5 *Enjoy Yourself* 147

How to Use This Book

High-Focus Drawing is both an explanation of how to see the figure and a practical guide in how to proceed in a drawing. The High-Focus method helps the student to see the rhythm of the whole figure so that each pose is like a story that can be read from beginning to end, rather than a group of unrelated sentences telling about the torso, the arms, the legs. With this approach, artists can capture the liveliness of their models and make drawings that are increasingly specific and interesting.

This book will be most helpful if you read the introduction and the first three chapters before starting to draw. Chapters 1 and 2 prepare the reader to use the specific lessons of Chapter 3. After you have made some headway, read Chapter 4, "Student Progress," to see how the experience of these students can help you in your own drawings.

INTRODUCTION

A particular incident from more than thirty years ago sticks in my mind. I was in my second year at Pratt Institute when a teacher—I'll call him Professor X—stopped by my easel and praised me for having drawn the model fairly accurately. But as he walked away, he turned to me and said, "Now you're ready to do something with the figure. Why don't you blow it apart?" He said it in an offhand way, but I knew that his suggestion was serious. I remember feeling uneasy about disassembling the figure, since I had barely reached the point of being able to assemble it, but nevertheless I was even more uneasy about being regarded as a reactionary or unimaginative student, so I set about to undo what I had just put together. Fortunately, because I had seen the instructor's paintings, I knew what was required. I proceeded to explode the model's body parts into stylish fragments that ended up occupying the corners of my drawing paper in a fashionably graphic way, and I was rewarded on Professor X's next circuit of the class with a chummy pat on my back.

This small event reflected the let's-be-done-with-the-figure mood of Pratt in the 1950s, as well as the wrongheaded view, which persists to this day, that the figure exists primarily as a stereotype from the history of art and mass media, and that the living model need be studied only to solve the technical problems of proportion. Professor X chose, in his own work, to use portions of the figure reassembled to express some notion of modern life. Given that he was using the figure at all in a period when abstract expressionism was at its zenith shows that he was not exactly at the cutting edge of the avant-garde. Nevertheless, he exhibited the basic assumption of many artists: that the figure in and of itself had been exhausted as a subject, and that to make it pertinent to the psychology of the present day, it had to be manipulated in some way.

Although he may have been shortsighted about the figure's possibilities, one can certainly see how he jumped to that conclusion. Much of the angst, skepticism, and irony of the past fifty years would be difficult (although not impossible) to express without some formal dislocations of figurative subject matter. But it is the second assumption hiding within the first that gives us trouble—that because one is going to change the figure radically, one doesn't have to pay that much attention to it in the first place. No wonder this teacher encouraged me to blow the figure apart as soon as I had made some headway in evoking it realistically. He was really telling me that there was nothing of much value or pleasure in the figure itself and that I should quickly begin

to exploit it as a motif for my own ideas. What his attitude reveals is that in his own observational drawing, he never appreciated how rich a subject the figure is or how profound an experience of response it offers to the artist. To believe that any human subject can be quickly understood is essentially to bypass figure drawing.

Professor X was an artist who, like the majority of artists in our time, wanted to move from straightforward realism into the more radical use of shape, abstracted motion, collage elements, and "primitivism." Yet, like many others, he misunderstood the whole process of assimilating the physical world for the purposes of his art. Because he denied himself any real contemplation of the figure, his figurative stylizations would have to come from other art or the conventions of popular media rather than from the deep recesses of his own psyche. He obviously saw the figure as a mechanical problem of proportion that could be expeditiously solved.

What one ends up with, unfortunately, when one sees the figure in these terms is a mechanical figure. Many of the approaches to drawing that are taught in schools or in books pander to this appetite to see drawing as a mechanical system or as a way of circumventing its perceived difficulty. To reduce drawing to a problem to be overcome or to the unpleasantly rigorous preamble to the "fun" work of art is to confuse the objective of drawing. In this mechanistic view, realistic "correctness" is all we can hope to get from drawing—simply the skill to lay out the figure with correct proportions. We could say that this approach lies almost totally within the province of the eyes. Once you begin to understand the possibilities of drawing, however, you realize that the eyes are only the first threshold and that everything really important and satisfying in evoking the model calls upon the intuition, the empathy, the susceptibility of the artist. In fact, all the intellectual and emotional skills we use in any art. When we begin to use our heart as well as our eyes to see the model we realize that correct proportion, the quality we might have thought was the goal, is really more like a by-product of our search. The more important things we get through drawing are to be able to think coherently about what we are looking at and to connect more strongly to our own physical reflexes so that we can express unhesitatingly the physical qualities in our subject.

If Professor X embodies the naively optimistic belief that we can shortcut drawing without cutting ourselves off from the experience of drawing, then a story involving another of my teachers reveals a more useful truth about drawing. This teacher was the painter Richard Lindner, whom all of us students very much wanted to impress. My memory is of a particular Lindner drawing class in which I had brought in a new and untried set of colored pencils, which I began to use to draw the model. My inexperience with the pencils led to a certain amount of frantic trial and error in my lines, which was nerve-racking but completely absorbing. When Lindner saw what I had done, he stopped his impatient striding of the room long enough to utter the one word: "Good!" This was the most encouragement I had ever elicited from the man and I was euphoric.

The next week I bounced into class with my magic set of colored pencils, determined to wring from him two or three more words of praise. After working dili-

Introduction

A drawing from my art school days which exhibits the unfortunate tendency to change the model into a design.

gently on a handsome drawing which employed nearly every color in my pencil set, I did indeed extract several words of response from this austere man. He stopped, bent low, and in a harsh whisper said, "Now that you've learned that little trick, why don't you move on to something else?" It took me months to recover from the blow of that acid comment and years to decode its meaning.

What I finally came to realize is that when Richard Lindner praised me for my first colored pencil drawing, he was recognizing that in my struggle to use the unfamiliar medium of colored pencils to draw the model, I was paying more attention than I might have in a less desperate mood. The novelty and the difficulty of the situation had shifted me from the feeling of being calmly in control of my drawing to being forced to respond to the model with more spontaneity and attention. What *I* understood at the time was that I had made something that appealed to a teacher I very much wanted to impress, so in the following class I turned the teetering high-wire act of my previous drawing into the "improved," self-conscious performance of the second drawing. The focus had shifted from struggling to capture the model in a new medium to struggling to make a drawing that had all the graphic qualities I thought the teacher liked. In one week I had turned a new experience into a style.

When he leaned over me and called my drawing a trick, he may have been unnecessarily mean about it, but Lindner was telling me something very important about observational drawing: it is essentially about the struggle to take in something new (and every figure, no matter how familiar, is new), not to create a graphic product. I use the word "struggle" in this context to suggest an engagement of one's wits and one's hand reflexes toward a subject that is acknowledged both to be not known and yet to be valuable. It is an effort as filled with delight as it is with willfulness. Unlike the dogged effort of memorizing irregular French verbs, for instance, this concentration of focus, in order to succeed, must engage one's sense of celebrating the subject by drawing.

Much of this book will deal with the issue of pleasure as a necessary part of perception in drawing, but for the moment, let us just say that what I hadn't really tuned in to when I was making my first drawing with colored pencils was that mixed in with the adrenaline rush of my effort was a kind of pleasure very different from the pleasure of

impressing my teacher. The pleasure was contained within the moment itself and not projected out into the future in hopes of praise. I had stumbled, however momentarily, into the state of "here-and-nowness" that is both the prerequisite and the reward of drawing.

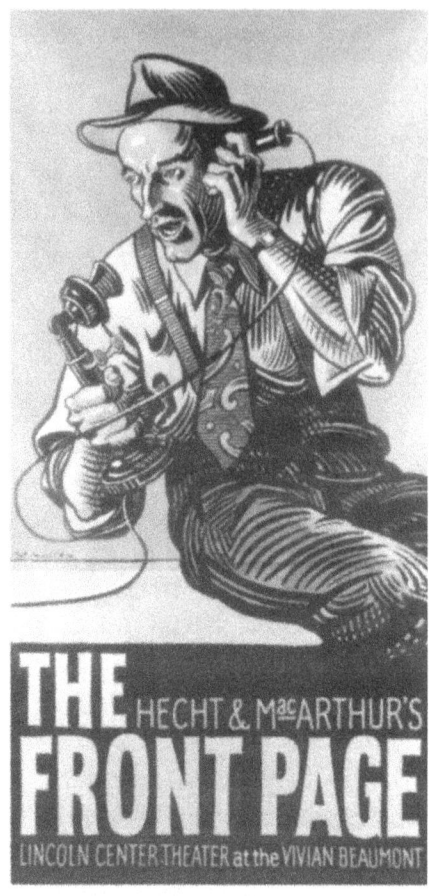

The effect of this Lincoln Center Theater poster depends on the energy of the man's gesture.

Since I would have these flashes of insight from time to time in art school and then later, more frequently as I struggled to make my illustrations better, why did it take me so long to understand clearly that observational drawing is an exploration and not a performance? First of all, because in the art culture of our time, drawing is seen so much as something done for an audience, and secondly, because I was good at performance it was difficult to let go of wowing whatever audience I had with the fluid assurance of my drawings. The fact that I did it so easily (and so repeatedly) was, in fact, part of the performance. I could count on it. I had a good eye and, because I had drawn frequently as a child, had good control of my hand. I liked drawing the figure, but what I saw in each figure was the opportunity to omit huge sections of the figure to achieve a spurious mystery or to use a favorite kind of leg or to be able to describe everything between the armpit and the ankle with one languorous, graceful stroke. I loved Matisse's drawings, but like most young artists, I had no idea what layers of experience lay behind *his* languorous, graceful strokes.

Beyond my attachment to this theatrical conception of drawing, I was also suffering, in those days, from a common bias in regard to art: I felt that drawings should be an opportunity to express myself, and that drawing's expressive possibility lay not in my encountering the model's reality but in using the model as a kind of mannequin for my manipulations of medium and form. I had not yet realized that to see and understand the model called upon incredibly high levels of creative synthesis. I was like many other students of my time in seeing my expressiveness as a paramount issue, as though it existed in and of itself as some kind of holy grail.

To a great extent, all our exercises in art school were just strategies to take our expressiveness by surprise, since that seemed to be the only way to get in touch with this ethereal muse within ourselves. It was not surprising that we saw life drawing in the same way—a chance to attack our drawings mindlessly or modishly in order tease the shy rabbit out of the hat. By doing this, we made an unfortunate error of judgment. By shifting the emphasis away from the model and toward ourselves and our drawing, we learned nothing: nothing about the model and even less from the mess of expressiveness on our pads.

Introduction

The students who come to my drawing classes these days are slightly different in this respect. They are still concerned about personal expression, but they see it less as a butterfly to be netted than as a territory to be conquered. Yet, as far as drawing is concerned, both approaches lead to the same consequence. The student who now comes into class with a kind of pencil stroke so determinedly unique as to be patentable is declaring that it is his *way* of drawing that is important and not the unfortunate model who suffers anonymity at his hands.

What I was so reluctant to accept in art school—that one cannot see or react to a subject when one is busy using that subject to assert creative domination—has another paradoxical side to it: we express ourselves most powerfully in our work when we have put aside the issue of self-expression and have turned simply to the problems and opportunities that the work, second by second, presents to us. We are revealed in our work, to some degree, by the aesthetic choices we make, but infinitely more by how we perceive our subjects. How paltry is the degree of "personalness" we achieve by making our drawing in a certain style next to what is revealed when we forget about the style of the drawing and simply try to evoke the model in front of us. In the first instance, we show what we have learned from art history and from our physical materials, but in the second we show how we see and respond to the world.

There are times, of course, in any artist's work when the issues of style, consistency, and conceptual manipulation are appropriate and necessary. Yet the assimilation of the real world must have preceded these stylizations simply because we need raw material in order to invent. Robert Hughes, writing in the *New York Review of Books*, states:

> *There is perhaps no great work of art, abstract or figurative (and especially none figurative), without an empirical core, a sense that the mind is working on raw material that exists, out there, in the world at large, in some degree beyond mere "invention."* [1]

To understand the potential of observational drawing, we have to recognize that it is first and foremost an act of assimilation. In drawing something from life, we are using the pencil (or pen or crayon or brush) and paper to intensify our responses so that the nature of what we are looking at becomes internalized. Certainly, as we see when Matisse does a series of drawings from the model, the act of assimilation can flow seamlessly into the act of stylization. What is useful to recognize, in the example of Matisse, is the intensity of his absorption in the actual figure he sees. His graceful simplifications retain the power of specific human gestures because he pays so much attention to the flesh-and-blood model in the first place.

I have raised this issue of style—or if you prefer, the elements of art that move beyond naturalism—because I think it is important to see observational drawing as an essential preamble to all the manipulations of subject matter that an artist might later choose to make. Seeing something and reacting to it through drawing is part of an artist's opening up to the world in order to nourish and enlarge the impulse to make

[1] Robert Hughes "On Lucien Freud", *The New York Review of Books*, Vol. XXXIV, No. 13, p. 54, August 13, 1987.

art. To honor the real demand of drawing is to recognize that it is no small feat truly to internalize the meaning of any subject to which we might turn our attention, and that by accomplishing this we have created a powerful springboard for our imaginations. Matisse's own words about the connection between observation and invention are as true now as they ever were:

> *The first step towards creation is to see everything as it really is, and that demands a constant effort. To create is to express what we have within ourselves. Every creative effort comes from within. We have also to nourish our feeling, and we can do so only with materials derived from the world about us. This is the process whereby the artist incorporates and gradually assimilates the external world within himself, until the object of his drawing has become like a part of his being, until he has it within him and can project it onto the canvas as his own creation.*[2]

I made the point before that to internalize something is no small feat. Matisse uses the word "gradually" in his phrase "incorporates and *gradually* assimilates the external world." In drawing, it is important not to try to turn our observations too quickly into ideas.

The most useful decision you can make to achieve progress is to devote yourself in your drawing entirely to taking in the model. Once you begin to understand how much there is to react to in the human figure, you will see that there is a great deal to be accomplished before any of us is ready to take the next step. Instead of rushing to "blow the figure apart," we should immerse ourselves in our devotion to the model's reality, which, after all, has been sufficient to artists as diverse as Rembrandt and Lucien Freud.

As you can see, I have placed observational drawing within the context of imaginative possibility while at the same time encouraging you to give the study of the figure a great deal of time to mature as its own, circumscribed, "non-imaginative" activity. This seeming contradiction will sort itself out for you as you make progress in drawing. Inevitably, you will see that it is an experience that is larger than you expected, that it contains the seed of imaginative organization, and that the question of how you use observational drawing in your work will be answered by the particular rewards you find in studying the model.

In my own life I have returned repeatedly to drawing the model to remind myself of the life force that surrounds me all the time and which I am always in danger of overlooking. It is humbling and exhilarating to celebrate this great mystery in the physical life of a particular model and to do so as a dialogue with myself. This is a bracing change from the need, as an illustrator, to communicate with and charm an audience, and at the same time life drawing brings to my public work some renewed ability to speak plainly.

Studying a real human figure in real space also puts work done from photographs into perspective. It makes me wish that the complications of illustrative assignments didn't so often preclude drawing from life, since stories that involve multiple figures or a sense

[2] Henri Matisse, "Looking at Life with the Eyes of a Child," *Art News and Review*, London, p.3, February 6, 1954.

Introduction

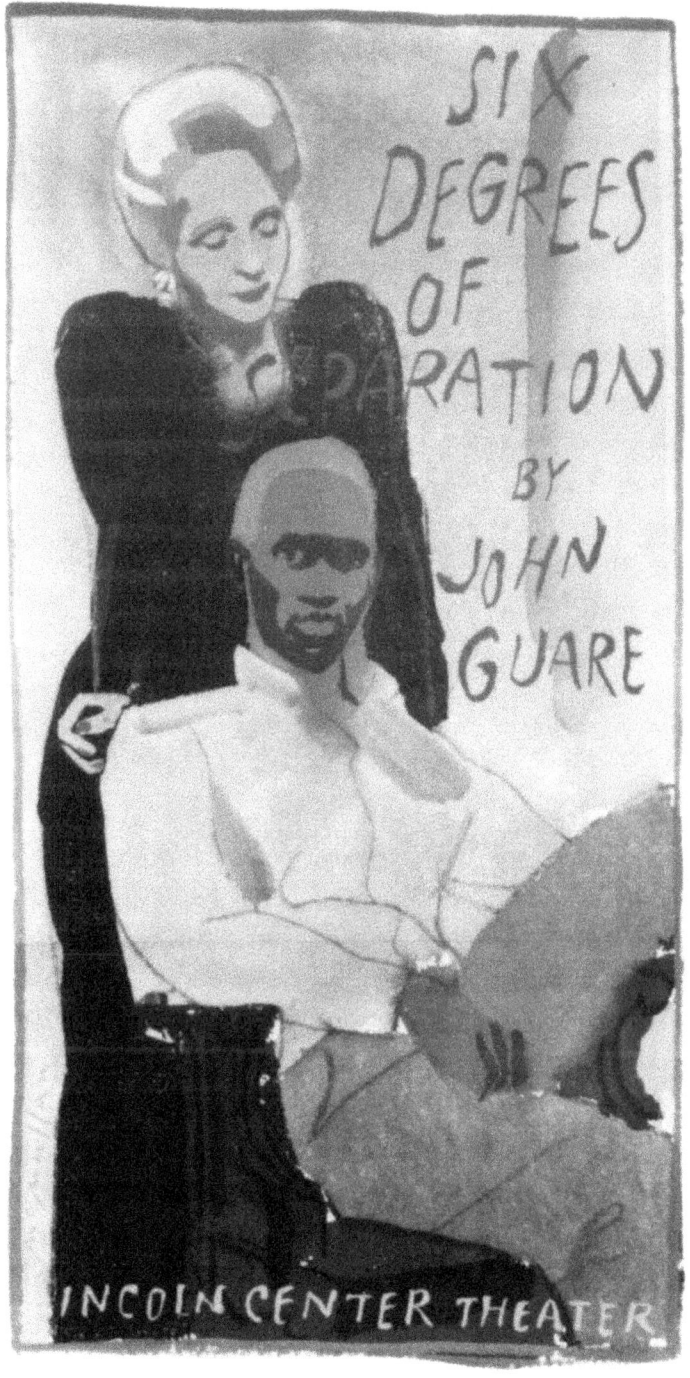

The simplifications I made in this poster were preceeded by much more realistic studies of the two figures.

of interrupted quick action seem to demand using photography at some stage. I will say, however, that my life drawing has helped me see the potential for vitality in photographic reference and to feel much freer in the way that I translate this kind of information. I have in the last few years directed my photography sessions like little films, albeit poorly budgeted, and I think my pleasure in life drawing has somehow contributed to the pleasure I get from working with models and actors. I notice, too, that because I draw frequently from the model, I am able to make fairly evocative pre-photography sketches from my imagination that focus my ideas and the mood I want to achieve in the photos. The shots I make in this way feel as if they simply amplify my vision rather than lead it, and I am more willing than ever to change the information of the photos to achieve the original vision. I would think that any artist who makes progress in high-focus drawing would find increased roundedness and energy within reference photographs. I cannot promise, however, that the experience of studying a live model will make the artist more enthusiastic about working from photographs, only that it is possible to exploit photographic information more vigorously.

One way or another, I have been trying to heed the admonishment of my teacher Richard Lindner to move beyond the little tricks of art and to aspire to that condition of susceptibility where we see things as if for the first time. Drawing from life and having to clarify the experience for my students has certainly helped me to resist the crassest of my working impulses. Without the snap-to attention that drawing from life represents, it would be a great deal easier for me to sink back into the comfort of familiar generalizations or to repeat past successes.

The two stories from art school reflect only a small part of the larger framework of ideas needed to understand what we are doing when we draw from life, but they seem a good place to start. If we can make the model the true center of our drawing activity and see the drawing itself as an exploration of the model's meaning, we will have made a solid beginning. By acknowledging the miracle and the mystery of the model's physical life, we have a chance to connect to our own empathy and curiosity and to use the full range of analysis and intuition of which we are capable.

This book offers the fruits of my experience as an artist and what I have learned in teaching my drawing classes for the past eight years. As you will see for yourself in Chapter 4, students in my classes have made extraordinary progress in drawing. I have taken the approach I use in class and have described it here in a way that I hope will give you guidance through the several stages of accomplishment you are likely to experience. I have also anticipated sticking points you may encounter and provided methods of working through these momentary glitches. I hope that this book is a practical guide and that it will lead you to the absolutely unique kind of sensual thinking and dexterity that we call life drawing.

As it is, there are many parts, yet one body. The eyes cannot say to the hand, "I have no need of you," nor again the head to the feet, "I have no need of you."

— I Corinthians 12:20-21

The important thing to bear in mind while drawing the figure is that the model is a human being, that it is alive, that it exists there on the stand. Look on the model with respect, appreciate his or her humanity. Be very humble before that human being. Be filled with wonder at its reality and life. There is a human creature that lives and breathes and feels, a thing with a mind and character of its own—not a patchwork of light and shadow, color shapes.

— John Sloan

HIGH-FOCUS DRAWING

CHAPTER 1

What Is Real in Realistic?

When you start drawing with the general idea of making a realistic likeness of the figure, you may find that you are not quite sure what part of the reality of the model you are after. If you choose "everything," you may spend a lot of time meticulously rendering every change of tone along the surface of the skin and end up with a disappointingly waxen effigy. If you choose to ignore the skin tones and concentrate on the edges of the forms, the drawing may look more like a map or a wire armature than a figure. If you concentrate on the dramatic darks of the figure, the hair, eyebrows, armpits, and crotch will emerge triumphant, but your drawing will have the incoherence of an actor who either whispers or shrieks. If you decide to explain how light is falling on the figure by blocking it out in terms of its shadows, you may achieve some solidity, but it is likely to be the concreteness of an armchair rather than that of a living creature.

In order to understand what is worth drawing in the human figure, we must ask ourselves what it is about the human figure that is unique. The answer is quite simple: what we respond to in looking at the human body is that it is physically and psychologically alive. This fact gives us an objective in drawing that focuses us and lets us see all the characteristics of solidity, light, and color as aspects of one central drama. Once we begin to see and appreciate energy in the body as the expression of will, habit, physical grace, exuberance (or depression), and so on, we have a key with which we can begin to decode each body's coherence.

You may be tempted at this point to say, "I know what you're talking about! I've done gesture drawing!" But I would caution you to bear with me a little longer before jumping to any conclusions. Gesture drawing is part of an approach to drawing in which different qualities of the figure are considered separately. In gesture drawing, typically, the student is encouraged to draw quickly in big, dynamic strokes that generalize the action of the body. This explanation, I realize, leaves out many permutations of gesture drawing but it describes the fundamental characteristic that it is important for us to distinguish here: gesture drawing isolates the idea of movement or dynamism as a discrete issue and in doing so it generalizes energy and separates it from the body's specificity.

HIGH-FOCUS DRAWING

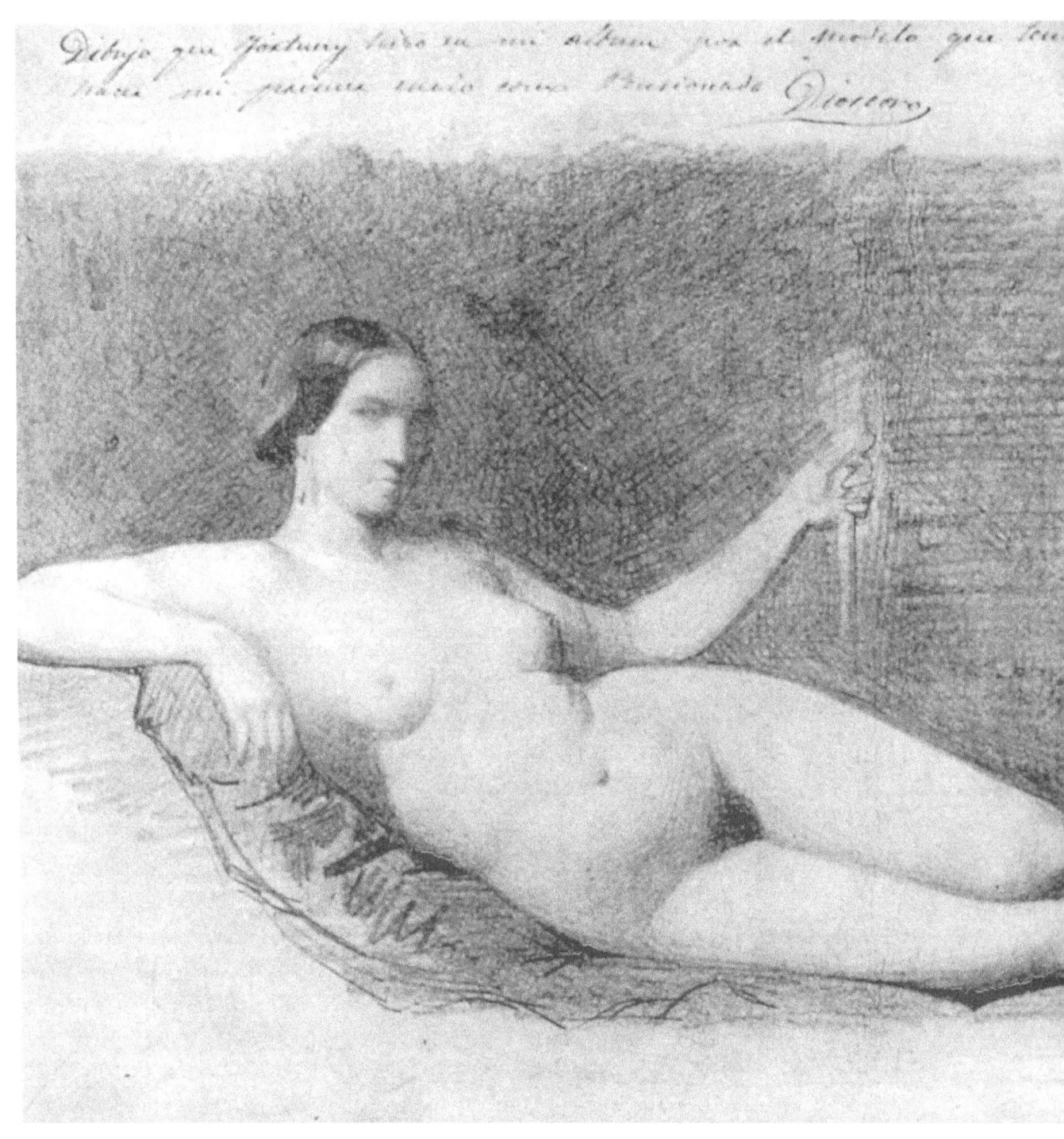

Mariano Fortuny. *Reclining Nude.*
An example of a drawing with very little sense of energy.

1859. Pencil on colored paper, 7-3/16 x 10-11/16 inches,
Madrid Real Academia de Bellas Artes de San Fernando.

If gesture drawing treats energy as a kind of inner spring that can be isolated and generalized, high-focus drawing accepts energy as a life force that suffuses every part of the body and can't be separated from a particular torso's heft or the languor of a particular arm or the way a particular head is held. Simply by sustaining its contours against the pressure of gravity, the roundness of the body already expresses its energy, even before it walks or leaps up or twists. When we become aware of this, the three-dimensionality of the body will always be inseparable from its expression of energy. Energy is not just the motor force of the body—it is also the nature of how different parts of the body respond and cooperate with one another.

It is helpful to see energy in symphonic terms, as the orchestrated ebb and flow of major and minor forces, more than to see it purely as a dynamo pushing out power. With the symphonic model, we are much more likely to be attuned to how much each body finds a different character of cooperation between its parts in order to accomplish physical tasks. We have only to think about recognizing a friend from far away simply by the way he or she walks to understand how powerfully identifying is the way we use our body.

Because the idea of energy coming ahead of light and volume in observational drawing may, at first, be hard to accept, I am going to show you two drawings in which the artists have treated these issues differently.

The first is a reclining female nude done by Mariano Fortuny in 1859. The drawing evokes the luxuriant form of the model's body seen through a slightly hazy atmosphere. The drawing at first seems accomplished and even attractive. Certainly the artist has worked very hard to give us the round meatiness of the woman's body, and he has achieved a convincing sense of the body bathed by light. Nevertheless, despite the romantic atmosphere and the three dimensionality of the body, the drawing is curiously dead and not evocative of a real human being. The action of the lifted arm is as inert as a mechanical doll's, the static head and neck sit on top of the shoulders without any sense of the real push and pull that would have to occur in that pose. The abdomen sustains its almost perfect roundness in a way that is totally unresponsive to gravity's inexorable pull. Each piece of this body has been considered lovingly in terms of its voluptuous softness but also very separately. Whatever little action this figure has comes from a conventionalized tilting of the hip, yet because there is no sense of transition between the waist and the breasts, this movement is not carried through convincingly to the upper torso. Fortuny has concentrated so wholeheartedly on getting the fleshy realness of the legs, arms, and torso that he has missed the actual energy that brought the living forms into harmony.

HIGH-FOCUS DRAWING

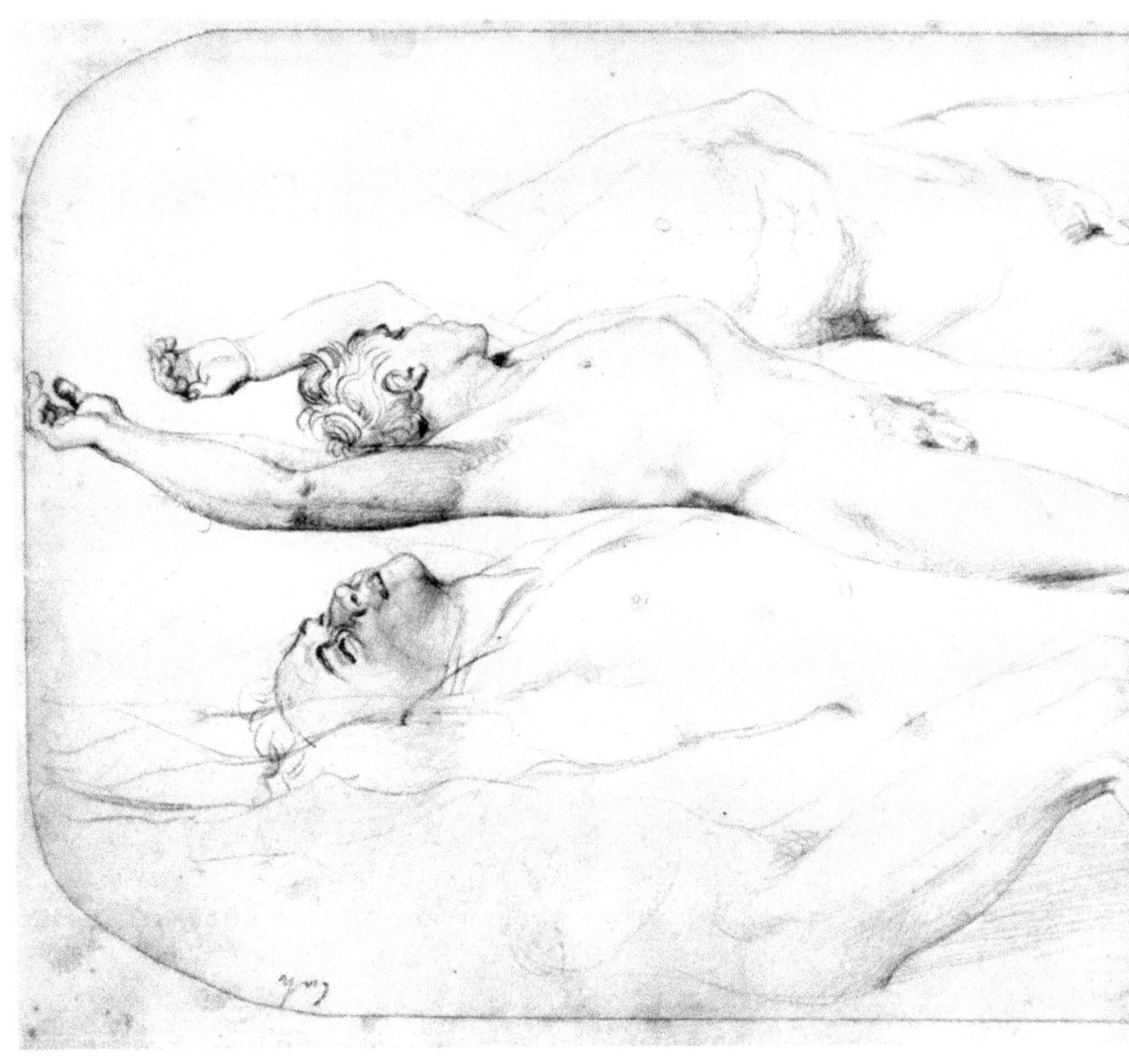

Jean August Dominique Ingres. *Study for "Acron Conquered by Romulus"*.
A drawing full of the energy of a real body.

1808. Pencil, 19.7 x 36.4 cm. New York, Metropolitan Museum of Art.

Another aspect of energy lacking in Fortuny's drawing is the way an artist's own physical drawing movements reflect what he is seeing and feeling. When an artist is tuned in to the energy of his model, the strokes made by the artist's hand become a sympathetic mimicking of the subject's vitality. He actually internalizes what he is seeing so that he feels in his own muscles the particular quality of the muscles he is looking at and drawing. It is as though, as he makes the mark on the paper, he is saying to himself, "It feels like *this!*"

Fortuny's drawing line has none of this empathy for the energy of a living figure. The lines are fussy and made with an evenness of pressure that suggests a monotonous, dogmatic kind of thinking. They could just as easily be the lines describing a pillow or a slightly overripe piece of fruit. Because he is seeing his model as an object on which he can demonstrate certain atmospheric effects, he draws her essentially as a receiver of light. Solid, yes; soft, yes; but finally no different from a solid, soft sofa. Along with missing the real animation of the body, Fortuny also falsified the figure by sentimentalizing her and using a classical mood to justify (for his particular age's moral point of view) the implicit voyeurism of showing this naked figure.

In several ways, this drawing moves away from good observational drawing. Instead of coming nearer to the truth of the model's reality, Fortuny imposed on the model a false ideal— a genteel body that exhibits no muscle strain or sag—and, because he pretends to be showing us a goddess or mythological figure, he obscures his real motivation for drawing. Fortuny's figure is a good example of what drawing becomes when the essential "thingness" and energy of the subject are ignored and the emphasis is put on volume and light. Drawing then becomes rendering—the inch-by-inch explanation of surfaces and volumes through regularized lines and tones. This distinction is important because so much of what passes for drawing in our time is really rendering: the careful visual scanning of subjects without the sense of hierarchy and relationship of parts with which artists reach for meaning in what they draw.

Now, for a completely different attitude toward drawing, we move, with relief, from Fortuny's imitation goddess to the study of a man lying face up by Ingres for his painting "Acron Conquered by Romulus." Ingres has used another kind of history as a subject for his drawing, but instead of insipid voyeurism masquerading as classicism, his figure resonates with straightforward physicality that gives it a feeling of real classicism and nobility. As much as Fortuny's drawing seems to whisper, "False," the Ingres drawing seems to say, in a clear voice: "True." Where Fortuny chose a pose with actual

physical action but evoked no real animation at all, Ingres chose to show a man completely supine, but nevertheless he invested the figure with so much life that we can imagine what his toes feel like at the end of those long, stretched legs.

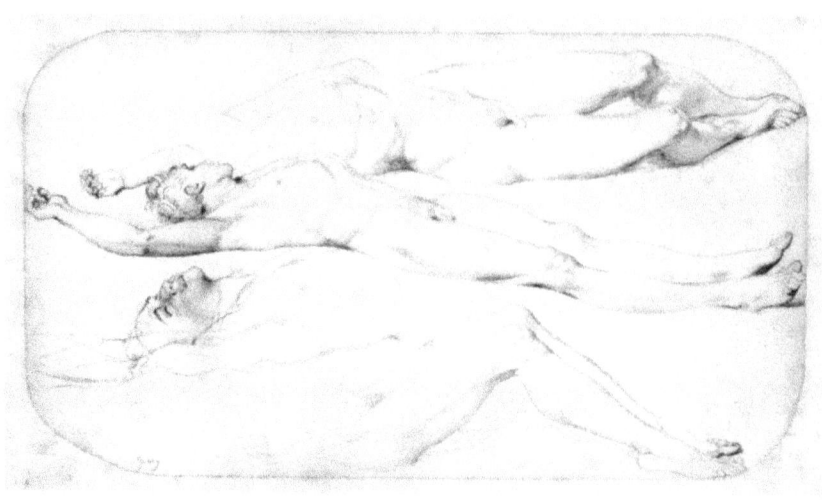

And speaking of legs, consider for a moment the exquisite play of the long curving forms of the legs against the tighter curves of the uptilted rib cage. This is the exact opposite of looking at parts of the body separately. Take a moment to enjoy how much this is a drawing of the whole body, yet each part is responding in relationship to the position of each other part. We feel the stretch in the belly as it accommodates the high promontory of the ribs, the opened-up armpits as they accommodate the high-thrown arms. Everything here is like a dialogue among the parts, nothing seems isolated or considered alone. The more one enjoys the symphonic wholeness of this figure the more one is struck by the almost abstract pattern of curves that echo the sympathetic tensions of the body. (This drawing is too complex and too beautiful to diagram in any significant way, but later in the book I will point out some of the rhythms that underlie the energy of particular poses.)

The Ingres drawing is a wonderful example of an artist seeing his model as a specific human being animated by specific energy. The subtly modulated drawing lines themselves seem invested with the artist's own empathic energy. He is living out, in his drawing, what he sees and senses about the body of his model. One might say that there is a typical Ingres line in all his drawings, and that is true. Yet what a range of responsiveness Ingres has to different models within the elegant personality of his line, and what a range of pressures and darknesses he employs in each drawing in order to evoke what he sees!

I have, of course, loaded the dice by showing you a decidedly minor draftsman, Fortuny, next to Ingres, a great master, and none of you, I am sure, would ever have picked the first drawing as superior to the second. I used these two examples, however, not so that you might choose which drawing is better, but rather to demonstrate that correct proportion, effects of three-dimensionality, and convincing light atmosphere are not sufficient objectives for drawing without the more fundamental goal of seeing how energy animates and connects the forms. Fortuny's drawing, finally, is the rendered likeness of a human object; Ingres's drawing is the evocation of the particular life he saw and experienced in the forms of his model.

What is Real in Realistic?

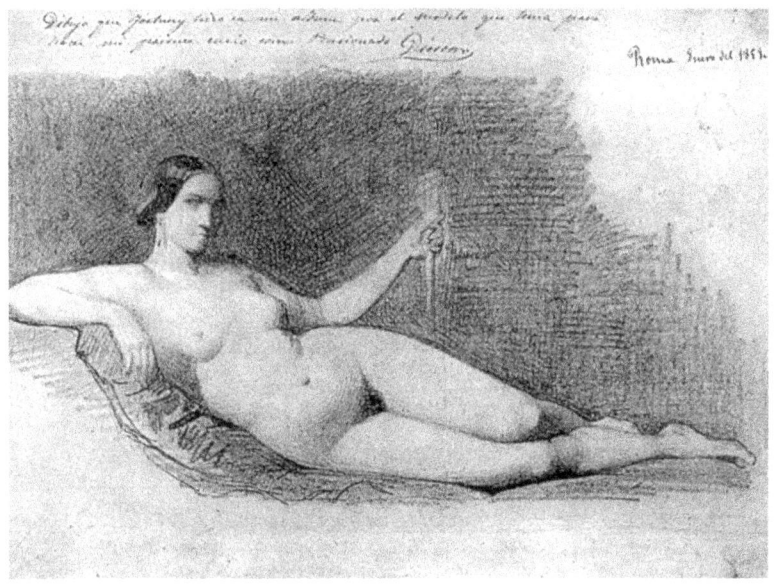

Ingres epitomizes for us a goal that we can achieve: seeing the body always in terms of its energy. He also represents a far more difficult goal, and that is to be able to see that energy with all its psychological and spiritual emanations. No matter how distant the second objective may seem, in recognizing energy for what it is, we will have put ourselves on the right pathway.

In pursuing the question "What is real in realistic?," Ingres has demonstrated that the quality of animus—the blending of motor power and the spirit of life—underlies the solidity of the body and provides us with a first-priority objective. This may seem to suggest that instead of paying attention to each part as we come to it, we now have the nearly impossible task of paying attention to all parts of the body simultaneously. And as if this were not difficult enough, we must also attend to some fancy energy that flickers here and there throughout the body.

I never said this would be easy—yet, on the other hand, paying attention to the whole figure simultaneously actually uses a kind of thinking you already know how to do. Consider this: If a woman, a stranger, walks into a room, do you ever react to her eyes without, instantaneously, also reacting to her voice and her posture and her hips and a thousand other tiny details about her presence? No, you never compile a reaction to someone in an item-by-item way; you are always taking in a person's singularity with a ping-pong series of reactions, one thing against another. Your brain's natural mode of perception is always to move quickly among the various aspects of any phenomena it considers. Asking you to channel and focus this natural thought process for drawing is actually making a much more reasonable demand on your sensibilities than asking you, as many approaches to drawing do, to forget how you usually perceive people and to draw them in layers or as piecemeal assemblages. This is not to say that because high-focus drawing exploits your natural mode of thinking that it is easy. You may never have sustained focus on any subject for as long as drawing requires you to do, nor will many of you have opened yourselves up to the reality of a subject in the way that drawing invites you to do. Nevertheless, good drawing is possible for many people because of this heightening of impulses that are already present and waiting to be encouraged and refined.

In high-focus drawing, our responses to the model are not separated into, for instance, proportion, gesture, and volume. Rather, we allow analytical thinking to merge with intuitive thinking so that the eyes' ability to judge the length of an uplifted

arm is infused with intuitive reactions to the sense of reaching in the arm. An artist's knowledge of how the pelvis operates can fuse almost unconsciously with the way the artist reads the particular qualities of fleshiness along a hip. In truth, this open, multi-stranded receptivity to the model is the only possible means we can use to begin making sense of the complex interplay between the body's parts. Pure anatomical knowledge, no matter how deep, is of value to us only if we are willing to employ it simply as a background to our intuitive reading of the body. The mechanics of the skeleton and the muscles, not to mention the nervous system and the flow of blood, are far too complicated to see in action if we try to do it with logic alone. But we can understand a great deal more if we allow all our human responses to contribute to our reactions. At the heart of high-focus drawing is a melding of common sense, memory, consciousness of our own bodies, and an eager curiosity to see and to accept what is unique in our subjects.

There are a number of ways in which we can encourage ourselves to increase our responses to the model. The most important is to recognize that in the state of high focus, we accept risk; we are always operating at the forward edge of what we can understand and do. This is the opposite of deciding what we are going to do at the beginning of a drawing and proceeding, through stages, to do it.

Compare the Fortuny and the Ingres drawings and see if my distinction becomes clearer. Ingres appears to have understood a great deal about the model in the first moments of his observation, yet the lines themselves feel as if they contain an experience of the form they delineate that did not exist in quite the same way the moment before Ingres moved his pencil. In other words, the act of drawing is a kind of thinking or feeling that always goes slightly beyond the nondrawing thinking that preceded it. Drawing leads the artist out to the edge of what he sees and understands. In the Fortuny nude, the line seems always to drag behind the thinking, simply carrying out, in careful stages, what the artist had already decided to do.

In the Ingres drawing, real risk is apparent because we can sense in his pencil lines that the physical act of drawing always pushes him out into new territory. He is, with each line, experiencing more and more of what he had not known before. Those moments in the drawing where he reconsiders a line are not like calm second thoughts; they have the impatient feeling of Ingres saying to himself, "No, no, no! Not like that—like *this!*" Even with the delicate touch and voluptuous shading, a persistent feeling of urgency pervades this drawing. Ingres exemplifies for us the artist in that heightened state of consciousness in which the past and the future fall away and everything is directed to the moment. In this state, drawing proceeds in a constantly surprising chain of reactions in which somehow the parts are constantly being connected to the whole, not so much by a preordained or remembered ordering as by an almost trancelike susceptibility to the underlying harmony of what is observed.

In thinking about this quality of immediacy in the Ingres drawing, I am reminded of what a student once said to me when I asked him how he had accom-

plished a dramatic improvement in drawing. He answered, "I got rid of the space between my hand and my head." This is what we see in Ingres's drawing—this direct linkage between what he sees and feels and the hand expressing it on the paper.

In the Ingres figure, as in all truly great drawings, there is no evidence of an understructure or construction lines with which the artist eases himself into the proportions or the gesture of the model. We have no faint center lines or rough outlines that box out the major body masses. You might argue that there are no construction lines here simply because Ingres' great skill made them unnecessary, but that is not the real reason. Ingres understood that high levels of intuitive perception are only achieved when drawing is experiential—that is, when it feels as if you are actually creating the specific forms of the model through the movement of your hand and pencil. As soon as you try to approach the experience in stages, you lose the direct link between seeing the model and feeling out the model's reality through your drawing. If you draw the model as a series of generalized forms, that is all your drawing can feel like. When you polish and add details to your generalized forms, that is all *that* can feel like. You will have reduced the experience of a complex animate creature that must be accepted as one indivisible phenomenon to the experience of making an object through rough and fine stages.

To reach high focus in drawing, you need the sense that you are always seeing and feeling and drawing as much as you can; that the effort and the opportunity are here, right now. The appeal of construction-line drawing is that you can think about the model a little bit at a time—make a few stabs at drawing the model in a generalized way and then fix it up later. Apart from the fact that a generalized construction drawing is always a lie and simply leads to more and more lies about the model, it robs you of the chance to reach a high level of focus. It is the difference between your degree of attention walking along a beam that lies flat on the ground and your degree of attention when the beam is twelve feet in the air. When you cover your risk in drawing by giving yourself the false safety net of construction lines, you begin to think of pieces of things and it is difficult to think of pieces in a very intense way. In this piecemeal state of mind, everything important is shifted to the future: "I'll get to the big stuff later." This is exactly the opposite state of mind you need to be feeling in order to draw well.

All of this might be making you a little nervous, because among other things you may be thinking, "If I don't start my drawing with construction lines, how do I start it?" You will start your drawing where it is important for you, in each particular pose, to start it, and in Chapter 3 I will tell you more about how to make that decision. For now, it is enough if what I have been saying about energy and the absence of construction lines is becoming apparent to you in the Ingres drawing we have been discussing.

Another great drawing, a nude by Edgar Degas, can help to broaden our understanding of the way artists respond to the reality of their models and how they use an exploratory frame of mind in order to draw. I love the way this Degas drawing of a seated woman expresses two different aspects of time: the forms of the model responding more and more to gravity as she settles into the pose, as well as her boredom with

HIGH-FOCUS DRAWING

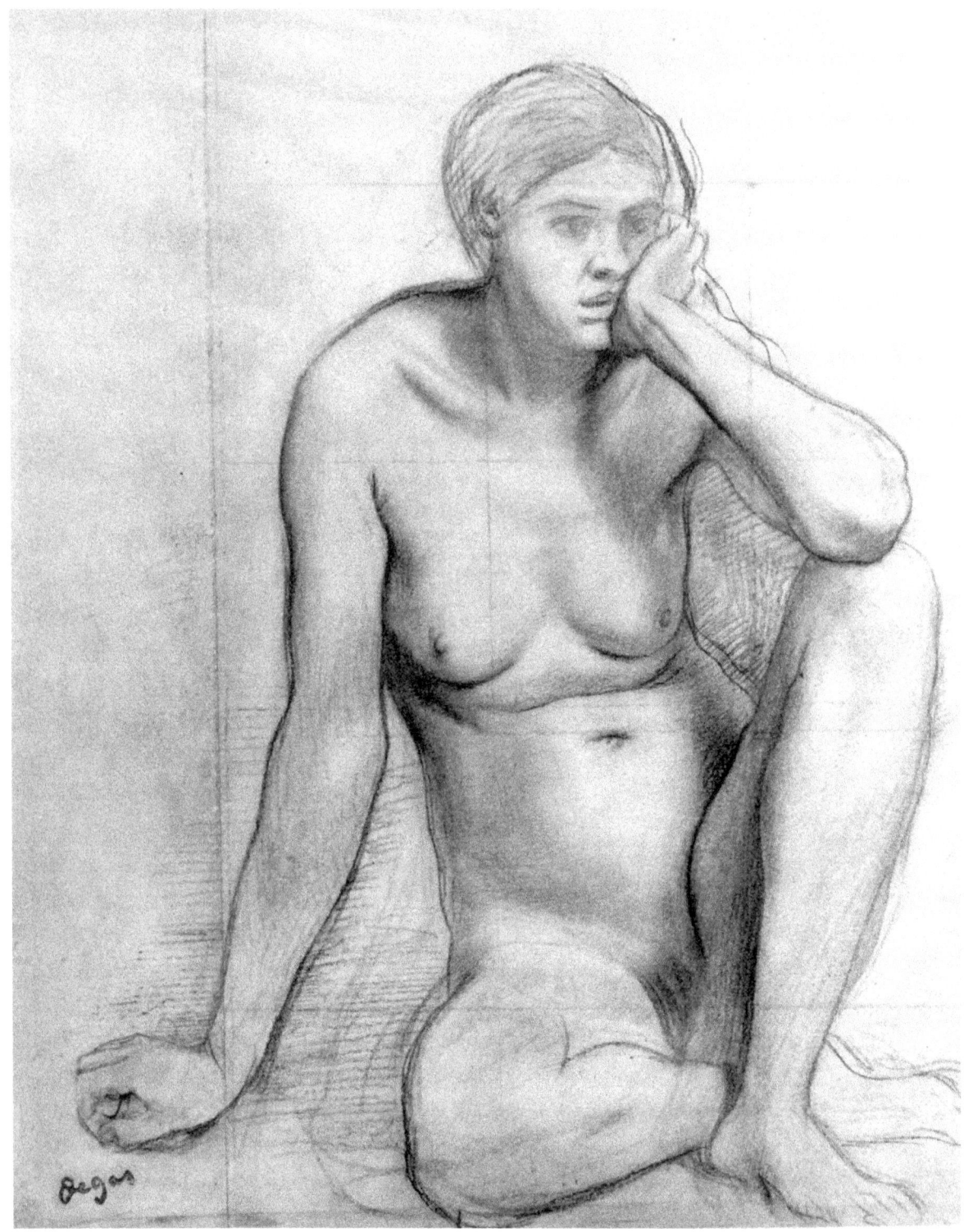

Edgar Degas. *Seated Nude Woman.*
The artist wonderfully evokes the energy of "sittingness" in the drawing.

1864. Black chalk on beige paper, 12-3/8 x 11 inches. Paris, Musée du Louvre.

sitting there for as long as it takes for Degas to make this drawing. I used to think of the woman as depressed, but the more time I spent with the drawing, the more I saw a vitality in her body that led me to the conclusion that this was a young, interesting woman who wished she had more amusing things to do than to sit for this crotchety artist.

The drawing so amazingly nails down the specific body and mood of this model that it is like time travel—we are transported back to an hour in the lives and minds of both model and artist. If the Ingres drawing of Acron was centered on an idea of stretching that almost negated the force of gravity, the Degas drawing is about a body resting and giving itself up to gravity. Much pushing together is going on here; the buttocks and leg against the floor, the hand against the floor, the elbow against the knee, the left thigh against the stomach, and the magnificent hand mashing the mouth and cheek. Despite the drawing's solidity and tonal completeness, it is, nonetheless, very exploratory. We can see and sense Degas's search for the right edge and his insistent emphasizing of certain forms, such as the top of the shoulder and the area under the right breast, as though he were dissatisfied by the lines he had made before. This drawing feels so much like real time, it is easy to imagine it emerging from the paper in one urgent line after another. How very different this is from the Fortuny, in which it is difficult to imagine anything but the completed drawing.

The Degas drawing also demonstrates an important aspect of the way lines are made in high-focus drawing. Notice that the only chalk lines that could be called "sketchy" are the ones that suggest the darkness of the background, and even those are clearly under control. All the other lines in this drawing have a very intentional and specific quality. The edges of the forms are described with decisive yet sensuous curvy lines, and the inner forms are described with subtle yet definite strokes that tend, in their direction, to explain the movement of the muscle. This approach to line making always adjusts itself to the character of each specific part of the body as it comes to it.

How different from the way many people have been encouraged to draw, using some kind of comfortable handwriting line all over the drawing of the body to describe changes in gray value! In such a drawing, the quality of line changes very little, since it is to shadow and light that the artist is responding and not to the coherent interplay of the parts of the body. This "scanning" view of the model assumes that the reality of the figure comes from its photographic presence—that is, simply from the way the parts of the body are arranged and what patterns of dark and light are created by that arrangement. In this approach, the drawing implement is used to hack away, in evenhanded strokes, at the appearance of the figure, as though the body were being created out of a large chunk of wood with a not-too-sharp and not-too-subtle broadax. Although hacking may actually accomplish an elegant surface texture, this kind of attack in drawing often uses many poorly directed lines in the belief that some of them will find their mark and that the artist can gradually describe the figure by emphasizing those lines that seem most accurate. The state of mind that accompanies this choppy style of drawing is only half attentive to the model. The artist hopes that this

"search" made by the many pencil lines will entrap the model's actual gesture within their hairy web, and he will be able to pluck it out with some judicious eraser editing or with an even darker pencil. This fast, many-lined approach to drawing may feel sensuous, because it seems as though we are impelled to this frenzy of intermingling lines by a vague yet emotional response to some generalized quality of the model, like her chunkiness or hair style. Unfortunately, this voluptuous sensation has more to do with moving our drawing hand in a pleasantly abandoned way than in reacting truthfully to the sensuousness of the model.

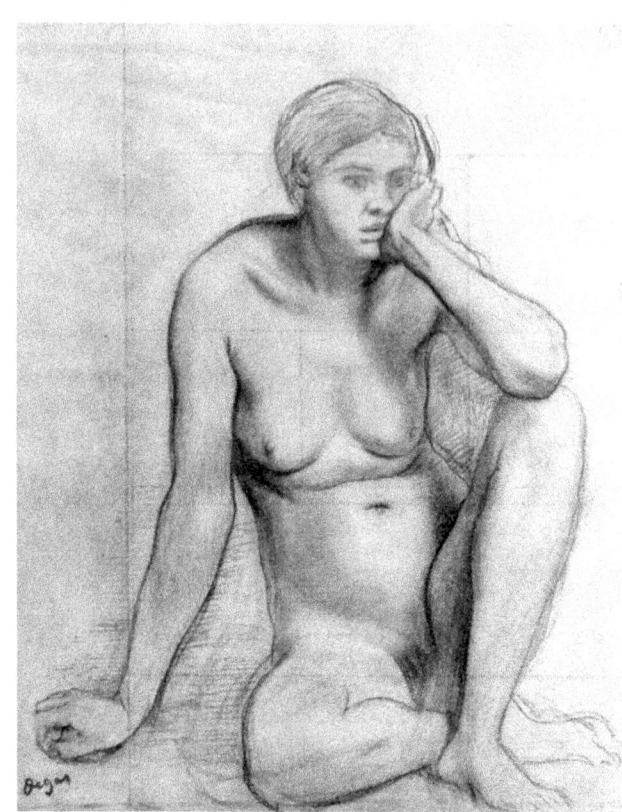

Most of us have, at one point or another, wanted to believe that we could draw trusting in the intelligence of our hand alone. We hoped that our fingers, loosened from the reins of our conscious control, could guide us to a higher level of comprehension, the way a marker moves mysteriously across the surface of a Ouija board.

This belief in the leadership qualities of our unconscious has led to a great deal of scribbling in the name of "automatic writing" or "mark making"—some of it decorative but all of it impenetrable. If we want to reach the satisfaction and the sense of accomplishment that drawing can provide, we have to recognize that our unconscious will always play its part, the Greek chorus that never goes home, but that it can't be asked to stand in for our intelligence and our sense of purpose. If we want to draw a subject, we have to embrace the activity of drawing by calling upon our highest functions of perception. Anything less becomes a parlor game or some kind of feel-good finger exercise.

Neither lines that chop away at the general position of the model nor lines that weave a multistranded perimeter around the model can give the artist the sensation of actually recreating the model in a drawing. The states of mind that guide these approaches are too vague and the lines are too all-purpose to feel, as you draw them, like different parts of the body. Two things need to happen in order to achieve high-focus drawing: the mind and the hand must work in close harmony, without a hope-for-the-best fuzzy space between them, and the lines themselves must become purposeful and specific, echoing the sense of force and direction in the forms of the body.

Changing from a low-focus, multistroke attack on the drawing to a more thoughtful use of fewer lines can usually be initiated simply by deciding that it is worthwhile. When my students struggle with this transition, it is usually because they are heavily invested in a particular way of drawing that they see as a form of personal

expression and they are reluctant to let it go. Once they understand and experience the fact that it is the way they see and think that really makes their drawings personal, it becomes a little easier for them to draw in a simpler and less texturally embellished way. In the final analysis, our most "objective" drawing of the model can't help but reveal the nature of our inclinations and of our nervous system. Perhaps it is even true to say that our most "objective" drawing *most* reveals our biases.

In the Degas nude, the cool, deliberate lines of the drawing might seem to reach the ultimate pinnacle of objective observation of this young woman. Could any draftsman be less intrusive while seeing and recording the model? Aren't we entirely convinced that this is exactly the person we would have encountered had we been in the room with Degas? Despite the fact that I think Degas set out to do exactly that—to record the woman in front of him—he unconsciously loads the dice with every choice he makes, with every edge he chooses to emphasize. The real woman emerges but somehow edited and touched, not just by the artist's pencil, but also by his opinion. Her body is sensuous but not entirely sexualized.

In fact, I feel a strange chemistry of hot and cold operating in the artist's view of his model. All the emphatic, definite edges and precision of his observation tend to make the woman very real, very much in the world, but the almost idealized, slightly simplified quality of the shading, undercuts the "here-and-nowness" of the figure and subtly distances her, as though she were at the same time a mythic figure. Even the heavy, pushed-together aspect of the forms, which I mentioned earlier, is something that Degas chose to emphasize and which, although I am sure it existed in the model's body, was probably not the only physical mood that the artist might have seen as paramount. Imagine, for instance, what Ingres or Michelangelo would have seen in the same model.

Degas chose the model, chose the pose, chose the day and the light under which he drew, and in those choices, he was expressing a great deal. I don't believe, however, that he chose to change the model or to load her with his particular opinions about the battle of the sexes or his emotional state. He didn't have to, for no matter how hard he concentrated on capturing the specific body and energy of his model, all his opinions have insinuated themselves unconsciously into his thinking. This addition to his perception isn't, as you can see, a string of little narrative clues that jump out to reveal Monsieur Degas. Rather, we can feel a permeating sense of the artist that we pick up from the way we imagine his hand moved as he worked, the particular kinds of texture the drawing has, the emotional space we feel existing between him and his subject.

Degas drew the model in a convincing way, but had a photographer been present, we would have seen a very different reality. The photo would show a woman of approximately the same proportions, taking the same pose. Inevitably, we would see more details, more wrinkles, more cast shadows, more connection to the background and to the room in which she sits. Degas gives us fewer facts, but he has organized those facts in a powerful way. The artist spent at least an hour, probably more, sinking into the presence of the model, absorbed with her reality, struggling with his drawing—

omitting this shadow, increasing that bulge of muscle, becoming more and more sensitive to the model's mood, urgently trying to resolve the major issues of the pose before the model's supporting arm gives out. Time is a big part of what Degas experienced here. The very obdurateness of the drawing process gave him the period of intense concentration he needed to know what he saw. He knew something at the end of that time and of that drawing that he didn't know before. He knew more than the "realism" of the model's body, although it contained much (but not all) of the fact of that realism. He knew something about the spirit of that body because he had to react to that spirit in order to register it within himself. He also knew more than he once did about how he felt about that spirit. Finally, he understood the limits of what he chose to respond to in observing his model.

This chapter began with the question "What is real in realistic?" I have described how the pursuit of the model's animus gives us a central objective in drawing. Now, with the discussion of the Degas drawing, we come full circle to the paradox that even though we can reach a clarified view of an individual body through reacting to its animus, the realism we achieve has as much to do with our own reality as it does our model's. The clarity of a drawing is, in fact, satisfying to the degree that we see the artist seeing the model. We artists focus on our subjects intently not to become neutral in our reactions but so that the encounter between our minds and our subjects can be as unimpeded as possible. The "realism" that results from this focus achieves a high degree of truthfulness in evoking the forms and the spirit of the model, but it will be the truth as experienced by one individual artist through one particular sensibility of the world.

It is that singular view, of course, that gives good drawing its intensity and which separates it from photographic reality. A camera records images in a flat plane of different tones and colors. Each millimeter of the image is, in a value sense, equal to every other millimeter. Although a photographer may make judgments, and although the personality of the photographer may be apparent in the image, a less intensive assimilation of the subject takes place. When an artist draws, his reality is not only the light and shade in front of him but also what the subject means to him. As the famous photographer Cartier-Bresson said, "Photography is a sketchbook, drawing is meditation."[3]

When I speak of searching for the energy or the animus of a model, it is shorthand for saying that we must react to the living model, to what sense the model makes to us. Our search for the model's energy and, by extension, her life, can be a true search to the degree that we are open to the model's unique quality. Our drawings can capture much of what the model looks like, but they can never be, nor should they be, realistic in a photographic sense. Good drawings can be more interesting than that. They can show how we understand and recreate the model for ourselves. It is important to discipline and refine our focus and our drawing hands, not so that we can become like cameras, but so that, in the process of paying attention to our subjects, we can assimilate their meaning and reach aspects of our own perception of the world that are otherwise hidden from us.

[3] Alan Riding, "The Charming Rebel Behind the Camera," *The New York Times*, p. C13, May 11, 1994

What is Real in Realistic?

Taddeo Zuccaro. *Standing Nude Man.*
In this drawing the interdependence of solidity and energy exemplifies the goal of good drawing.

1542. Red chalk, 42.0 x 28.7 cm. New York, Metropolitan Museum of Art.

HIGH-FOCUS DRAWING

Henri Matisse. *Nude*.
A sophisticated use of simplified lines to show how this figure sits in space.

1947. Pencil, 37.2 x 25.7 cm. Private Collection.

CHAPTER 2

What Lines Can Do

Before you start to draw the model, you need to understand what lines are capable of doing in a drawing. In this chapter, I will describe these capabilities, and also give you two exercises in which you will explore the characteristics of line in subjects that are not as complex as the human figure. In this way, you can practice using line in an evocative way while, at the same time, organizing your observations so as to see the details contributing to the whole sense of the subject. I am not expecting you to solve *all* your drawing problems as you work on these exercises, but I hope that you will identify what you need to do to see and draw the figure, and will make some progress in both producing confident lines and in seeing your subjects in a coherent and three-dimensional way.

Seeing the roundness of figures and the space they occupy is a very important part of observational drawing. The roundness of your models is so much a part of their life and their sense of "presence" as they stand in front of you that it is difficult to reach pleasure in drawing if you can't open yourself up to this quality. Some people can *see* the roundness but have difficulty sending that message into their hands or in figuring out what intersection of edges and what differences in line pressure will give them spatiality.

We are aiming, from the first lines we make, to suggest that the forms before us turn in space and that the forms are either in front of or behind each other. Making your lines search out this three-dimensionality is the opposite of treating your lines as unbroken perimeters of an encompassing silhouette and leaving all your roundness to be evoked by shading. We want our shading to grow naturally out of what our first lines begin to describe. This occurs sometimes sooner, sometimes later, depending on when we reach forms that require more of a sense of roundness or more subtlety than simple lines can accomplish. If you can think of shading lines as extensions of the perimeter lines rather than as an entirely different kind of line, it may help you to understand how an edge line can flow into the shading of interior forms so that there is not the sense of one thing ending and another thing starting. Think about the perimeter you see in looking at the model as an accident of where you happen to be sitting in relation to the model and not as an immutable fact. If you're in a class with others, your perimeters are somebody else's inside tones, and vice versa. This should help you to treat the two issues in a more equal way.

HIGH-FOCUS DRAWING

Michelangelo. *Study of a reclining figure.*
A drawing which shows how Michelangelo used intersections to position the forms in relation to one another.

1508. Pen and ink. Florence, Casa Buonarroti.

I have chosen two drawings that exemplify different aspects of simple lines describing roundness. The first is a Matisse nude, done with very reductive single pencil lines, which manages to tell us a surprising amount about the foreshortening of the woman's torso as we look down on her, and even suggests the space she occupies. His drawing of the left shoulder, for instance, the shape suggesting the pressure it is under, makes us believe in the unseen supporting arm stretching out behind her, so we end up feeling an implicit stretch of surface occupied at one end by the left hand and at the other by the right foot, two points in space not even in the drawing. Matisse accomplishes this volumetric sleight-of-hand with simplified compound curves that suggest a great deal more complexity of form than they actually describe, and by using forceful intersections that tell us clearly what is in front of what. The two lines around the abdomen, which disappear behind the left breast, are perhaps the most dramatic of the volume-producing choices he has made. But consider also the subtle confluence of lines around the right breast, torso, and arm, which manage this potential linear traffic jam with complete aplomb; we end up knowing exactly where everything is.

I hesitated before using this Matisse in the book, because although it is a wonderful example of how intersections create space and volume, I knew that its graceful charm might represent a seductive style model for the reader, a path I do not encourage. Yet since the question "When is an artist ready to make simplified, flattened drawings?" will come up sooner or later in the book, showing the Matisse now gives me a chance to start on the answer.

This drawing's stylized simplicity is the reward of studying thousands of poses. Matisse's superficially easy line, like the one going from the armpit down to the thigh, suggests, at different points in its swooping journey the pressure of the lower rib cage, the strength of the hip, and the meatiness of the thigh. This line represents a mastery that has level upon level of experience with and susceptibility to the body. Yet while we enjoy the drawing, and take in its lessons about line intersection, we must realize that for now, at least, we need to describe with many lines what Matisse, in his evolved shorthand, could encompass with very few.

My second example of how relatively simple lines using intersection and some shading can explain complex muscle forms is a study of part of a torso and legs by Michelangelo. This is far from the most beautiful Michelangelo drawing, but for my purposes, it shows better than a more developed and tonal example the first stages of thinking about forms in drawing. With very few lines in the abdomen and lower leg, Michelangelo establishes for himself the basic position and movement of the parts, and in the raised leg, Michelangelo begins to develop the roundness and energy of the thigh, knee, and calf. Notice particularly how the shading lines seem to grow out of the perimeter lines and how they have equal weight. What this reveals is that Michelangelo thought of the interior forms as dynamically as he thought of the contours, a point that might not be as obvious in other drawings, where the interior forms are described in more subtle undulations of tone.

In the Michelangelo, as in the Matisse, the lines are conceived as if they travel in three dimensions, and in fact they represent the way the artist's mind travels as it takes in the figure before him. Out of the mass of information that the real body presented him with, myriad tiny tone transitions and wrinkles, Michelangelo has selected these few as representing to him the central issues with which to begin his drawing. Two things are happening here that are important to understand: that the artist thinks of his subject as forms moving coherently in relationship to one another and that the lines he uses in his drawing are like records of his mind tracing these forms in space. His use of intersections is a natural consequence of this spatial thinking. You can't take in the three-dimensionality of the body without constantly asking yourself what is in front of what.

I emphasize the issue of seeing forms dimensionally because most of us, in our maturation as artists, have to overcome the tendency in our drawings from childhood to see our subjects as flat silhouettes. We begin drawing people usually as large ovals with dots and squiggles for features, and if any limbs are present at all, they are rudimentary little slashes sticking out from the all-important head. Gradually, the concept of the whole body begins to bring the head into a more realistic proportion, but the impulse to keep the figure flat lingers on for a surprisingly long time.

Seeing this persistent flatness in the work of some of my students has led me to the theory that what many people want out of drawing the figure is to contain it. Perhaps not consciously, but on some level, drawing is a kind of fence around whatever threatens to burst out from the subject. This containment is not an entirely unworthy goal in drawing, since we see heavy or at least emphasized perimeter lines in beautiful drawings by Picasso, Klimt, Derain, Rodin, and Leger, among others. I must add that in the case of all these artists, the perimeter line contains in its simplicity the sense of all the complex merging of forms and the roundness of the body that is really there. They all achieve the satisfaction of containing the body within strong edges, (perhaps the same satisfaction we sought as child artists), while at the same time investing those edges with all the implication of complexity that their experience of drawing the body has given them. Even in the Degas drawing I showed you before, there is a sinuous thickness to much of the outside edge. But far from flattening or undermining the round dimensionality of the body, Degas's line manages to set us up nicely to see the forms as though they were swelling out to meet us.

The persistent enveloping edge that I mentioned in student work doesn't have this power to evoke or to suggest dimensionality, because almost no young artist has had the experience of studying the body sufficiently in order to give these simple lines richer meanings. A young artist is not generally thinking complex thoughts as he makes simple lines; he is thinking simple thoughts. In order to produce one gliding line that explains four things at once, in the way that Matisse or Rodin can, or to make one emphatic edge that is entirely plausible as the beginning of many subtle forms, as Degas does, we have to begin by working against the impulse to flatten the figure and, by using intersecting lines in our drawing, acknowledging all the forms we can see making

up an edge. This may be a rather long-winded way to encourage you to use intersections forcefully in your drawings and to try to see as spatially as you can, but since my experience shows me that the flat, fencelike contour line has a powerful siren call, I feel it is important to stress the dimensional nature of our endeavor.

If this short discussion about the appeal of containing the figure makes you realize that some of the time, at least, you are attracted to making drawings that feel finished and complete because they surround the figure with an unbroken hard edge, there are two things in particular about high-focus drawing that should help to open up both your thinking and your drawings. First, there is no emphasis here on completeness, neatness, or any other "presentation" virtue; you are free to begin drawing as a dialogue with yourself, with all the experimentation, false starts, reconsiderations, and happy surprises that entails. Second, since energy is our leitmotif and since energy is always implicitly operating against containment, you have every encouragement to start seeing the body in an entirely new way. Pancake Man is touched by the pencil of our enlightenment and becomes 3-D Man.

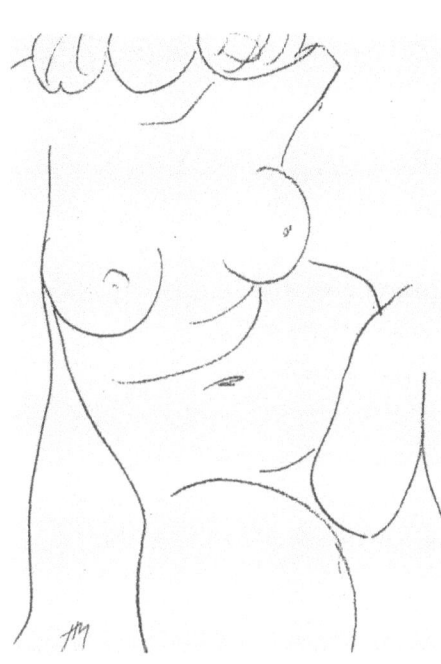

Let us consider lines in a more specific way. I have already mentioned that the undulating curvy lines in Matisse's drawing are simple-looking but, in fact, conceal much information and experience. Look again at the torso line I described before and at the diagram of the four distinct anatomical sections that he managed to evoke with one line.

My diagram inadequately conveys the sophistication of Matisse's drawing, but nevertheless it makes the basic point that for the student of drawing, it is important to understand how many coherent muscle curves make up any one edge and to register that knowledge by drawing them. Notice that Michelangelo, in his drawing, does exactly that except for one encompassing compound curve right at the bottom of the drawing. There are times, particularly in short poses, when there is a reason to draw with a line that moves around in a complex shape, but for the most part, try to see and to draw each form as a distinct muscle bulge. What you are learning by doing this is perception of the body which will finally inform whatever simplifications you choose to make. The more you draw and learn, the more you will see Matisse's (or any other great draftsman's) accomplishment for what it is and the more you will be motivated to give your own drawing a foundation of real understanding.

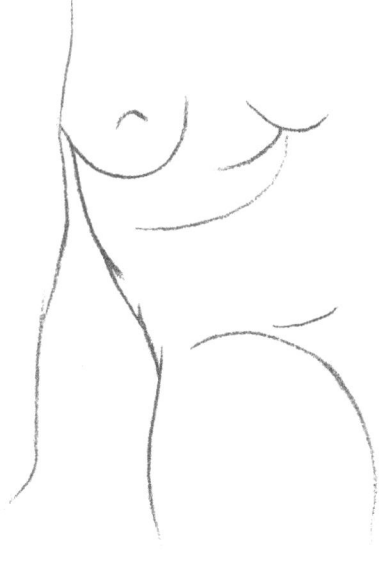

In the last paragraph, I described a compound curve—an unbroken line that changes the direction of its curving progress at least once and, in figure drawing, describes more than one muscle along an edge. As I have explained, it is not a kind of line through which a student in the first stages of study is likely to learn very much about the figure. What, then, are the kinds of line appropriate to begin drawing the figure? Let's start by identifying the nature of what we are looking at when we study the body. Most of what we see is the surface layer of skin animated by the interlacing of muscles of various sizes and thicknesses, which could be characterized as elastic tissue connected at each end to cartilage or bone.

A muscle works by contracting, but even when it is in its most relaxed state, it has a certain amount of tension. What we need then is a line that can suggest edges made of elastic muscles and, better yet, a line through which we can feel out this swoopy tension in our own hand.

Here it is! A line that I call the *trajectory curve*—you can find it in a hundred

variations in figure drawing throughout history. It is essentially the "ball-throwing" curve. By that, I mean it uses the same chain of events that you do in throwing a ball: the brain deciding, the eye calculating, and the muscle reflexes carrying out the physical act. In both actions, your eye and your brain decide on a goal, make all the necessary computations, and then tell your hand, wrist, arm, and shoulder to carry it out. In both of these physical activities, there is a moment when you must turn over your second-by-second mental control to the intelligence of your muscle reflexes. This is not the same, I hasten to add, as turning over aesthetic choice to your muscles, as in automatic writing, since here you are telling your muscles what to do. The "throw" of the ball or of the line must be accomplished at whatever speed is necessary to reach the objective, and that speed precludes "thinking" about it. If we tried to think through, for instance, what our arm needed to do in order to throw a ball accurately, we would slow down the action of our arm so much that the ball would simply dribble out of our fingers. We can't literally teach our muscles to throw a ball, but we can throw a ball repeatedly until our reflexes train themselves. When we have done this, we will have gained a certain confidence that lets us "risk" that moment in a physical activity when we need to turn over our mental control to the control of our reflexes.

What Lines Can Do

Reflexes in drawing also need the training of repeated drawing experience so that we can risk making lines that, at least for a nanosecond, depend on the intelligence of our hands and arms to carry out the commands of our eyes and our mental judgment. If our reflexes lack this experience, we tend to resort to many short choppy strokes to produce a curve, or to one slow line that ploddingly proceeds under the careful control of our minds, or even to spasmodic whipping strokes, which can't describe very much since they tend to repeat exactly the same fast arc. All of these "safe" ways of producing a line are exceedingly dull experientially. Their choppiness, slowness, or whippiness makes them feel like work or chaos, and because their actual physical texture is so broken, wandering, or repetitive, they cut us off from reliving in our own muscles the sinuous tension of the bodies we are drawing.

To illustrate the character and some of the myriad possibilities of trajectory curves, here are some more examples:

You will notice that some of the curves feel faster than others, and in fact, they *are* faster. Describing the form of a buttock as the leg is raised takes a faster line than describing the curve of a relaxed thigh. The line is echoing the degree to which the form is stretched out or twisted. It is interesting that the speed of the line may actually mimic the speed of the molecules in a limb under stress.

Trajectory curves give us several qualities that we need in drawing the figure, including the chance to feel out in a sensual way the subtle muscularity of the body. Making this kind of curve feels like a building to a crescendo, reaching it, and then leaving it in a smooth diminuendo. It feels as much as a line can like physically stroking the arc of muscle we are looking at. The natural tendency of a trajectory curve to start fairly softly, to build to a greater degree of pressure and darkness, and then to end softly as the pencil finishes the curve and leaves the paper gives this kind of line making the ability to suggest the way muscles actually swell up out of other forms, reach their maximum point of tension, and then merge subtly back into the connecting surface. Because the reflexes we use in making these curves are under the direction of our brain, there is a huge variety of lengths, shapes, pressures, and points of emphasis that we can achieve. This is in contrast to the spasmodically "whipped" curve which, as I have said, seems to repeat the same trajectory over and over. The trajectory curve has the quality of urgency and emphasis we need when we are drawing subjects that are full of the energy and the physical assertiveness of human bodies.

Not everything we draw will have the same quality of energy as the nude human body, of course. The clothed body, for instance, involves all the wrinkles and softness of fabric, which are quite different from the smooth tautness of skin. Mechanical objects are also smooth and taut, but in a much harder and more unyielding way than flesh, and they call for a drawing line that is more geometric in spirit. Plants have the energy of growing things, but their edges are only occasionally similar to the edges of the human body. Even subjects that are different in energy from the nude body but seem superficially like each other are seen on closer study to need their own kind of line. Amorphous objects, such as a lump of coal, seem linked by their chaotic surface to every other rocklike object, but somehow coal's character is different from the surface of a piece of granite, for instance, that has been formed by the effects of rain and grinding. Even man-made objects as similar as a wooden easel and an aluminum easel exhibit some subtle difference in their straight edges simply because of the difference in their material and the way they were manufactured. Recognizing that every kind of subject represents a different energy and calls for a different kind of response in the way that we draw it means that every conceivable kind of line will be required at one point or another.

I have described the trajectory curve as an essential line for drawing the figure (but not the only one—think of what hair requires, for instance), and in the drawing exercises that I am about to describe, I want you to think of the lines you make with your pencil not as some all-purpose marks defining the edges of what you are looking at, but to try to adapt and to change your line to suit the energy of each particular subject.

What Lines Can Do

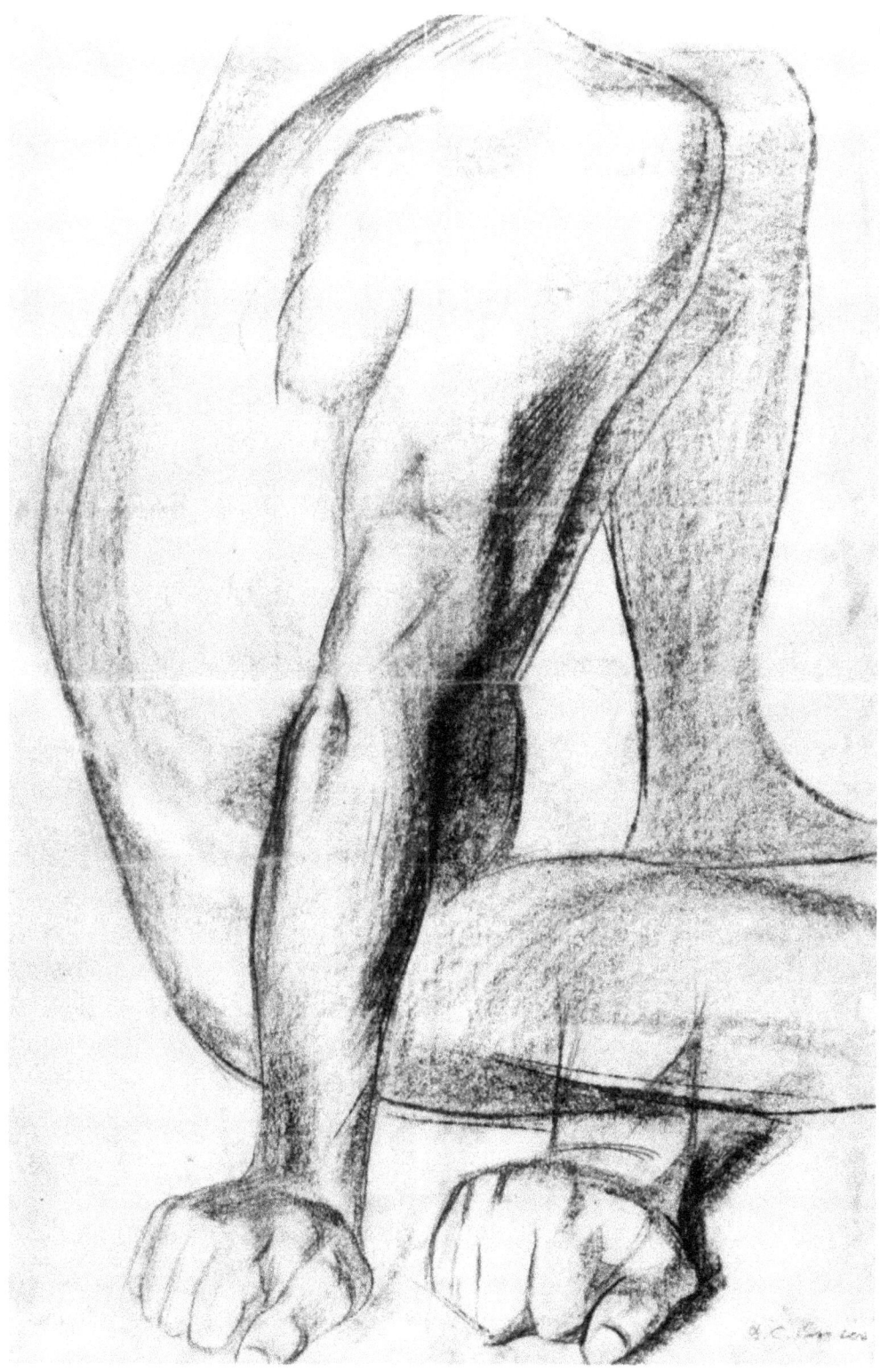

Jose Clemente Orozco. *Study of sitting nude man leaning on right arm.*
This is an example of the vigorous use of trajectory curves and intersections.

1926. Charcoal on brown paper, 27-1/4 x 15-5/8 inches.
New York. Collection of Mrs. Alexander Dobkin.

HIGH-FOCUS DRAWING

The materials you will need for the drawings you are about to do are the same materials you will need for all the drawings you will do in the high-focus approach:

- *18" x 24" 32-lb. ledger bond pad*
- *several 2B pencils*
- *a few 4B pencils*
- *kneaded rubber eraser*
- *pencil sharpener*

Some of you may be used to drawing classes that encourage variety in the materials and, in fact, teach drawing principally as explorations in media, so let me briefly explain why I have chosen these specific materials. Because simplicity and clarity are so much a part of the philosophy of this book, it is important to use drawing materials that do not interfere with the clearness of your thinking or with the way in which you make the drawing. For this reason, it is not productive during this period of study to use textured papers, charcoal, conte, pens, or any other materials that call attention to themselves as a particular kind of texture or line.

The ordinary pencil is one of the most versatile mark-making tools we have: it is easy to hold and to direct, and it is capable of a great range of pressures and line qualities. Essentially, it is a "sharp" mark maker (as opposed to charcoal, for instance), and as such, it is ideal for drawing when you wish to be clear and to commit yourself to a particular view of something. Of course, even a pencil can be used confusingly when you are not ready to be clear, but in the way that I will encourage you to use it in this book, a pencil will help you to clarify your observations.

Smooth bond paper is the ideal partner for the pencil here, since it provides a surface over which the graphite can effortlessly slide and it clearly records the softest or most dramatic line. It is also tough enough as a surface to take a great deal of working of the drawing and to withstand erasure. Both of these materials, the pencil and the bond paper, could be said to be essentially neutral in their character and to allow for the greatest differences where they actually mean something— that is, the differences that you see and understand about the model and are able to evoke in your drawing.

The two studies I am asking you to do, one of a shoe and one of a plant, call for different responses from the observer. One is man-made and one is a natural, growing organism. You may feel more interested in one of the subjects over the other, and that preference is understandable and even desirable, since part of what you are learning to do here is to register your feelings as you draw. This feeling of preference will also come to the fore as you draw from life, leading you to find that on one day your drawings seem to go better than on another day, because the model is particularly interesting to you (or, of course, the opposite). Ideally, the more you draw, the more your sense of curiosity will be awakened, so that eventually a subject that you might have thought of as boring will actually turn out to have more surprises than you at first thought. You should certainly try to become interested in every subject, but at the same time it is important to recognize your feelings, whatever they may be, in relation to a particular

subject. When you are confronted with a subject you find less than thrilling, you might try—and I think this is a very productive game to play—to draw into your image just what it is you find so dull in your subject.

Make your drawings of the shoe and the plant either on separate pages of your pad or side by side on the same sheet. In the examples I show from my classes, I present the drawings side by side when the student drew both subjects, since it is illuminating to see the correspondences and the differences in the way a particular student handled the two. These examples of student drawings are not meant to represent a standard for you in drawing, since, as you will read in my comments, not all the students were equally successful in understanding their subjects or in describing what they saw. What I hope these examples will give you is a more specific idea of how the quality of observation can be reflected in a drawing. Also, I hope these examples will dramatize the fact that in order for observational drawing to succeed, the artist must not only pay attention to the changes that occur within a subject, such as going from a harder stem to a softer leaf, but also to the underlying order, such as the radial growing pattern, that connects those changes.

What my students are learning in these exercises and in their life classes is that the discipline of seeing and drawing clearly involves letting go of several kinds of impediments: stylistic or decorative devices, such as repeating one kind of curve throughout the drawing or ending every line with a dot, automatic lines that are made without thinking or feeling very much, and passages of tonal charm that are either irrelevant or premature. This "stripping-down" period in their drawing represents a lens through which their sensibilities can focus, emerging on the other side with a much stronger connection between their perception, analytical and intuitive, and the reflexes of their drawing hand. This also gives them a strong basis from which they can eventually make decisions about subject matter, media, and embellishment or simplification.

Typically, the students bring to the beginning of the process some kind of attack in the way they draw that they view as being personal or sexy, and they see the lines themselves as having abstract qualities of strength or sensuousness. The first improvement happens when they realize that any "attack" in the way they draw, that, by its speed, puts the physical movements of their hands far ahead of what the mind can comprehend essentially disconnects the brain from the hand. Along with this insight, the students must also recognize that lines are sensuous or strong only to the degree that they evoke the sensuousness or strength of their subjects. To make fewer lines that evoke more about the subject and to slow down the drawing process enough to let the brain catch up seems, at first, to kill all the fun of drawing. Fortunately, some inner voice—or my voice—usually keeps the students going through this transition, and they are most often rewarded with their first drawing of the model that ever made any sense. The paradox, of course, is that in toughening the approach to drawing and letting go of the sexy style of attack, the student discovers a new and more powerful kind of sensuousness; his mind and his hand are now linked and can recreate the sensuousness of the model together.

Drawing a shoe and a plant presents a chance to practice looking with increasing curiosity and to proceed in your drawing so that you have more and more insight into what you are looking at. This means, at the very least, not letting the drawing get too far ahead of what you understand and not trusting the notion that you can "block it out" and then decide on what's important later. As one of my students once said to me with a quality of shock in his voice, "Oh! You want me to *think* while I draw?" the answer is *yes!*

Exercise 1: The Shoe

Choose one of your shoes that seems interesting to you. Place the shoe on a drawing table (or plain table) in front of you at whatever angle seems to clarify the construction of the shoe, probably at some 3/4 view. If you feel you are looking down at the shoe too much, find a box to put it on that will lift it to a better viewpoint. Make sure you have enough light to draw by and to illuminate the shoe. You can play around with the lighting of the shoe to make the construction clearer, but remember that form, not light drama, is what you are after in your drawing.

In looking at the shoe, begin to think about how it was made to fit around the foot, what parts of it are constructed of stiff materials for strength, and what parts are flexible and softer. At the same time, try to react to the personality of the entire shoe so that those feelings have a chance to enter into the drawing.

As you start to draw with your 2B pencil on the ledger paper, let the scale of the drawing be whatever is natural and comfortable. Don't worry about filling the page or about any other page design consideration. The size of the pad is likely to give you more room than you need, but that's better than not having enough room. Don't forget to sharpen your pencil every once in a while or to switch to a new pencil. You want enough point in the pencil to be able to make finer, lighter lines when you feel they're appropriate. Darker, thicker lines you can create with more pressure on the pencil or by stroking in more than one line at points of emphasis.

In choosing a place to start the drawing, look for a part of the shoe that expresses for you the structural integrity. That might be the curve of the sole near the toe, or the heel, or part of the instep, or in fact almost any part. It probably wouldn't be a lace or the bent ridges between the toe and the instep, because they are not structurally significant. Try to make a choice that isn't just a reaction to the darkest thing you see or to whatever decorative design is on the surface. Remember, you're trying to make sense of the shoe as something that is really worn and used and which, at some point, had to be logically thought out by the manufacturer.

Drawing the shoe gives you a relatively simple object to think about spatially as well as practice in making the kinds of curves that will convincingly evoke the way the heel and toe turn in space or how different parts of the shoe conform to the same axis. Two things may help you to see the three-dimensionality of the shoe: one, you can pick it up and look at it from many angles, and two, it is a familiar object.

What Lines Can Do

HIGH-FOCUS DRAWING

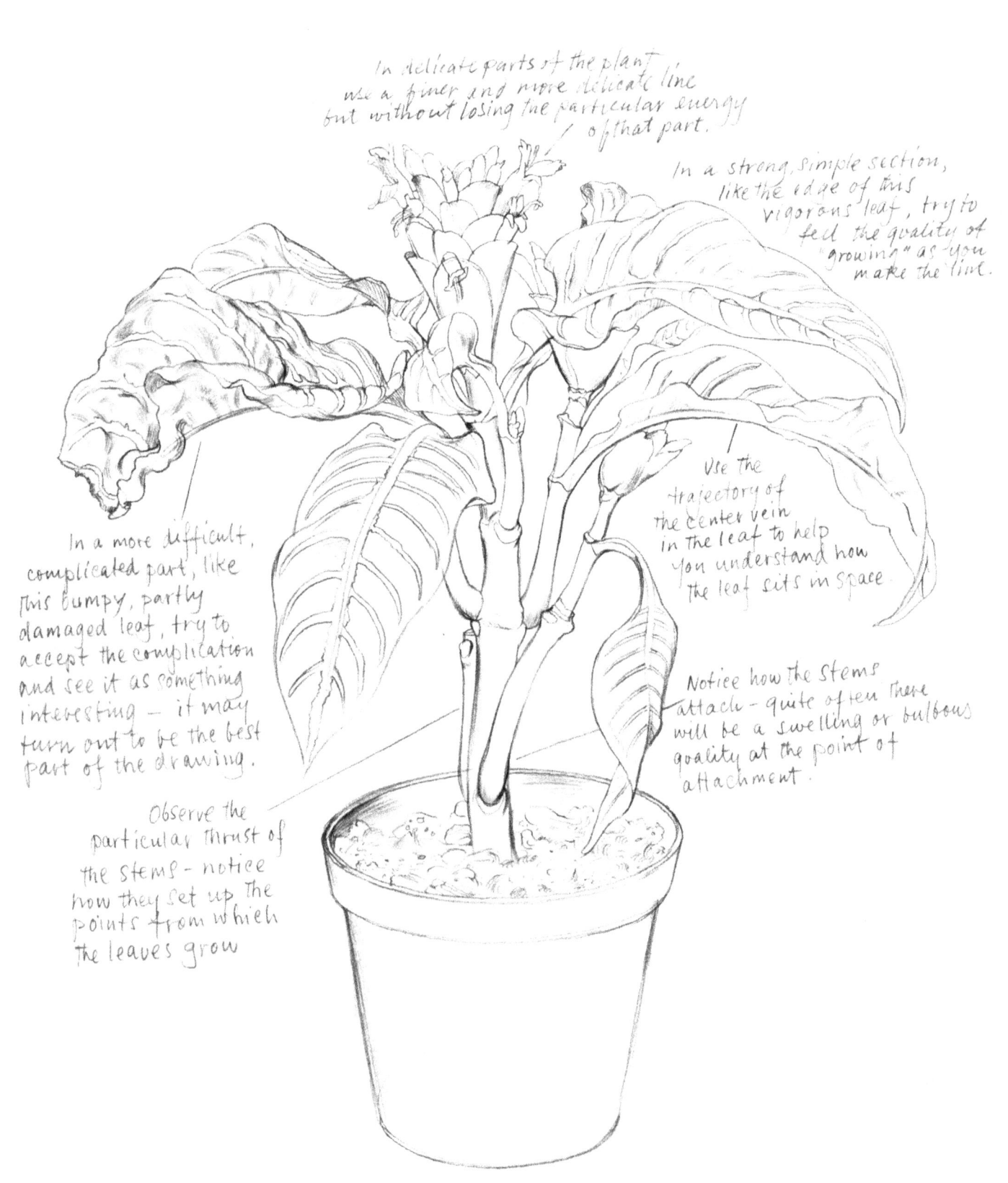

48

Exercise 2: The Plant

Choose a plant, a flowering one if you like, and position it so that it is comfortable to observe and at an angle that makes the leaves or petals clearest in their structure. Again, as with the shoe, adjust the light for clarity but without making light drama the central issue in your drawing.

The plant will make a different kind of sense from that made by the shoe. It is not a manufactured object, and its structure is more subtle. The angles of the stem or stems will not conform to some simple pattern, and although the leaves will all be based on the same silhouette, each leaf will take a different shape as it sits in space. Examine the plant with these kinds of patterns and similarity of parts in mind. Remember that no matter how strange the shape of a leaf as seen in perspective, it still conforms to the basic characteristics of all the other leaves on the plant. Pay attention, too, to the implicit growing pattern that you sense in the curve or the jointed angularity of the stem. What you are seeing in these stems and in the leaves and blossoms themselves is an upthrusting, opening out kind of energy. Try to evoke this as you draw. There may also be parts of the plant that are past blooming and are beginning to die, in which case the energy becomes the opposite, drooping and curling in.

As in drawing the shoe, adjust your line and the impulse of your drawing movement to match, as much as you can, the different parts of the plant. Where the plant is vigorous and strong, think about what role this plays in the whole organism or at least in the surrounding parts of the plant and echo this quality in your drawing line. Where the details are faint, yet seem important, try to reach for the particular energy of those parts while, at the same time, making delicate lines.

I have made two straightforward drawings, one of a shoe and one of a plant, and annotated them to point out aspects of their manufacture, structure, or growth that may be of some help to you in thinking about the logic of your own shoe and plant subjects.

Student Drawings of Shoe, Flower, or Plant

In captions accompanying the drawings, I have noted where the spatiality and energy of each study has either succeeded or failed, and where the student has gone beyond explaining the shoe to begin to express some of its character. Responding to such observational drawings may take a little getting used to in relation to their clearness and centeredness on their subjects, and their lack (at least in this context) of atmospheric backgrounds, rich texture, and exotic line quality. Initially, you may find yourself liking the quirky charm of a drawing for which I have some criticism. Give yourself time for these different values to sink in. Clarity in art may, at first, seem like a thin reward, but once you tune in to it, it becomes paradoxically rich and indispensable. And perhaps more important, it forms the strongest basis for more elaborate images..

HIGH-FOCUS DRAWING

Ronald's Drawings: In both the shoe and the flower drawing, there is a good proportional sense and the lines are made with fluidity and assurance. There is not much variety, however, in the way details have been seen or changes in energy have been recorded. When I look for the areas that seem to have been enjoyed the most, the top stems and leaves of the plant and the soft cushion opening of the boot are what I find. The strength in the sole of the boot and the vigor in the lower leaves is missing. Ronald, like a lot of other drawers, has trouble making elliptical curves, and as a result, the heel of the boot doesn't turn convincingly in perspective. The easygoing quality of these drawings would gain from more urgency in the observation and more reaction to the strong energy in the subjects.

Gary's Drawings: The first thing I notice in these two drawings is how emphatic everything is. *All* the lines are vigorous. In the top of the boot and the area around the laces and the heel, the strong lines seem relatively appropriate. In the area of the toe, the strong curving lines seem to be describing something other than shaped leather; these doughy curves are done with more enthusiasm than observation. It looks to me like an "idea" about the forms of the boot that started in the creases above the heel and then began to take over the drawing.

In the case of the flower drawing, the hard, dark lines overwhelm what had to be a more fragile blossom than the stiff plant we see here.

Part of what has led to the less successful aspects of these drawings is simply impatience. The artist wants drama and decisiveness in his drawings and he wants it *now*. Because he makes dark lines so early in the game, he doesn't have a chance to experience what he might do with lighter lines or how he could save his most dramatic darks for fewer and thus more effective points of emphasis.

Joan's Drawing: Despite the fact that it looks nothing like the previous boot, this drawing has a different version of the problems of Gary's drawing. The information of the boot has also been prematurely turned into an idea. Here the idea is the use of elegant curving lines to simplify and abstract the shoe. Although this conception suggests the volume of the boot, it makes all the forms seem as if they contain exactly the same tension. There is no distinction, for instance, between what would have to have been a tougher curve in the sole and the slightly softer curve of the instep. They are both lyrically semitough. There is no question that this an artist with a potential to create strong distillations of form, but that potential could be better served by her paying close attention to forms as they really are rather than by her rushing to "make something" out of her subjects.

Mark's Drawing: Here we have a balanced and volumetric drawing of a sneaker. The lines really feel as if they turn in space and suggest the continuation of the form on the side we can't see. The limpness of the cloth laces is particularly telling against the relative sturdiness of the other lines. The drawing has a satisfying wholeness about it that comes from the artist making sense of the use of the shoe as he draws.

What Lines Can Do

David's Drawing: Here the use of shading seems to have occurred after much of the form was established. The boot seems well proportioned and spatial. It feels like a careful drawing, and that is both its virtue and its weakness—the close observation of the details gives me a satisfying sense of the used, worn-down materials of the boot, but what I miss is the emphasis in the curve of the sole at the heel and in the back of the heel itself that would suggest the strength that has kept this article of clothing from entirely falling apart. If this artist can react to the hierarchies of what he looks at more strongly, his lines will become more varied.

HIGH-FOCUS DRAWING

Melina's Drawings: This is a student with a vigorous and often descriptive attack in her work. She is enthusiastic about forms moving in space and in these two drawings we get a chance to see that enthusiasm paying off yet also letting her down. I think the boot is a convincing and very appealing drawing. The swirling shapes really do feel like leather that has adapted itself to a particular foot and walk, and the pleasure the artist experienced from drawing the patterns on the laces and the stitching is clear, yet she doesn't make those details jump out from the whole drawing as they might have done.

The vigor used to explore the boot doesn't work as well when translated to the flower. The flower seems to separate into little compartments under the onslaught of the swirling lines. The most obvious diagnosis is that Melina really doesn't like the flower as much as the boot—or maybe she should have chosen a big lily to draw—but beyond that she hasn't adjusted the scale of her drawing to the delicacy and complexity of the flower. Her lines are simply too big in character for what she's trying to describe. Also, she hasn't really responded enough to the underlying structure of the rose; she could have seen the petals more in relation to the unfolding center of the flower than she has.

What Lines Can Do

Michael's Drawings: Let's acknowledge right away that Michael loved his sneaker and was lukewarm about the plant. He accepted the plant's complexity and its organic "softness," but he didn't have much fun explaining that to us. The sneaker, on the other hand, bursts with pillowy energy and the confidence of a loved object. I particularly like the laces straining against the memory of the pushing foot and the sensitively described wrinkles at the base of the instep. The changes in line quality he uses here are particularly effective in making a distinction between what is edge of material and what is bent material.

HIGH-FOCUS DRAWING

Alex's Drawing: This drawing explains the shoe very clearly and also evokes much of the shoe's character: a well-worn, slightly beaten-up Oxford. Even its laceless state suggests a story you might imagine as you encountered this shoe on the shelf of a thrift shop—an artifact from the life of a tango dancer who ended up washing dishes in a Cuban-Chinese restaurant, perhaps. This is provocative drawing because the artist reacted to the nuances of the shoe's physical personality, which he took in on the intuitive level while he was paying close attention to the shoe's structure on an analytical level. Even the scribbled lines inside the shoe seem right here, because they are so obviously motivated by the perception of flatness in that part of the shoe's interior.

Critiquing Your Own Drawings

After you have made your drawings, sit back and, as objectively as possible, compare them with the real objects. What aspects of the whole shoe or the whole plant did you get in your drawing? What aspects did you miss? Are the details correct but is the overall spirit somehow missing? Or did you, in fact, capture some central core of the subject, even though the drawing was slightly out of proportion? Are there changes of edge energy in your drawing in the same way they occur in the objects? What part of the drawing did you really enjoy, and does it show?

Use this kind of self examination and whatever is useful from the student drawings to get as much as you can from doing these exercises. By all means do more drawings either of these same subjects or of different ones. By now you should have some idea of what you are having trouble with and what, in either the mental or the physical process, is going well.

HIGH-FOCUS DRAWING

CHAPTER 3

Drawing the Model

This chapter introduces you to the quality of rhythm in the body—the key to seeing that there is a large central idea in each pose and that the model is not just an accidental arrangement of limbs, head, and torso. Recognizing rhythm will help you respond to the model's energy and to move beyond a merely visual assessment of the pose you are drawing. After the section on rhythm, and as a continuation of that discussion, I will explain how artists begin their drawings so that the first lines they make set up the important issues of the pose and so that the following lines can amplify these basic ideas. The last section of the chapter deals with roundness, gravity, and resolution in drawings and how these qualities of solidity and groundedness, although they appear to be the opposite of energy in the figure, are really necessary aspects of the same thing. The explanation of these three fundamental issues—rhythm, where to start, and the qualities of roundness, gravity and resolution—are preceded by an explanation of how to use an anatomy text, how to employ some basic rational ideas, what materials to use, how to sit or stand as you draw, and how to choose a sketch group (if you should need to make that choice.)

Bones and Muscles

As you prepare to draw the model, the question "How much do I need to know about anatomy?" may arise in your mind. The answer is that anything you know about the bones and muscles will help you draw the figure, but perhaps in not as direct a way as you might imagine. The moment when anatomical knowledge will be most useful is when you have advanced enough in drawing the model for curiosity about the underlying structure to lead you to investigate specific questions. It is not easy, as some of you may already have found out, to go from an anatomy book drawing of the skeleton or of the exposed muscles and apply that information to a live model. Every human body is so different that even matching up a "bump" on the model to the anatomy text is a frustratingly difficult thing to do. Once you become aware of the areas of the body that you consistently have problems with, however, (making the heel of the foot convincing or figuring out how the pelvic bone affects the muscles of the hip, for instance), an anatomy book can help a great deal.

I realize that suggesting you study anatomy *after* a period of simply drawing the figure reverses the more typical art school order of things, but in my experience it takes a relatively sophisticated interpretation of anatomical information to go from skeletal and muscle diagrams to a particular human body.

What I suggest is that you get a good basic anatomy book, such as Fritz Schider's *An Atlas of Anatomy for Artists*, as a reference that you can use in different ways as your observation of the real forms progresses. In the beginning, look through it for the basic skeletal and muscular sections, noticing particularly how flexibility is achieved in the pelvis and in the spine, how the rib cage creates the larger form of the trunk, and how the neck is a continuation of the spinal column. Take in whatever you can about the large muscle groups and how they generally affect the shape of the body. Register in your mind whatever is interesting to you and what you see that connects up with what you already know about the body.

One of the most important aspects of this first-stage general knowledge of anatomy is to get a sense of the range of flexibility the body has. The Schider book has diagrams describing the motions of the spinal column, which are helpful and George Bridgman's *Complete Guide to Drawing from Life* has interesting drawings showing the body twisting and bending. Because Bridgman has so much enthusiasm for the action of the body and the interlocking nature of the forms, his book can be a useful introduction to both those aspects of the figure. I particularly recommend it to students who have difficulty seeing the sculptural qualities of the body.

I must add a cautionary word on Bridgman, however: because he draws idealized, heroic bodies making very rococo movements, the student of his work may be encouraged to reject the nuances of the real model in favor of imposing Bridgmanesque forms and gestures. If you can use the Bridgman book for its very solid knowledge of the human body, while at the same time realizing that these theatrical overstatements must be left behind when you are really looking at a specific human being, then Bridgman will be useful. He was one of those experts who became so enamored of the figures he could make up out of his memory of the human body and the drawing he loved out of history that he apparently stopped looking at real bodies some time before he wrote his books. As much as I admire his skill and enthusiasm, I miss the quality of real life in the bombast of his invented figures. Nevertheless, enjoy Bridgman's jaunty exaggerations, check him out for the general forms of a nose or a leg or whatever part of the body you're having trouble understanding, then close the book and concentrate on the living model in front of you. If you let his illustrations intrude into your mental process, then the Bridgman book becomes an obstruction between you and your model.

In general, I am recommending that as you study anatomy, you bounce back and forth between periods of drawing the model and looking at and reading your anatomy text. Let the information sink in little by little, motivated by your interests and your problems of that moment. If you go through a few weeks where the knees in your drawings have more conviction than ever before, then pick up your anatomy text and study the bones that make up those mysterious bumps. If the complication of the shoulders persistently gives you a problem, then study the clavicle bones and the way they attach at each end to help you decipher what is happening in your model's body. Use your enthusiasms as well as your frustrations to fuel your education in anatomy rather than seeing it as a contained period of studying the bones and muscles that comes before observing the real thing.

Some Rational Guideposts

A useful thing to remember as you observe the model and draw is that the anatomy of the human body is essentially symmetrical. If you view the model straight on, face to face, with the model standing evenly balanced, the arms relaxed and hanging down, everything on one side of the body will match everything on the other side. This is a view you will rarely choose, of course, but it helps to remember that in every other view of the model this basic symmetrical quality is being modified by seeing the symmetry either at an angle or rearranged by the pose.

What this means is that you can orient yourself in any view of the model by finding whatever evidence there is of "pairing," seeing one deltoid bump on the shoulder in relation to the other deltoid bump, or matching the muscle over the hip to its partner as two examples. Not only does finding the position of each of the pairs show you how the initial symmetry has been tilted or twisted by the pose, but the changes in shape that will probably differentiate each member of the pair will tell you a great deal about which side is being most stressed or relaxed. This awareness of pairs is most useful in the torso, of course, since there we are dealing with one form with matching sides, but it also helps in drawing the head by finding, for instance, the symmetry of the eyebrows as they are seen in perspective. The limbs, even though they are not symmetrical as single forms (and it is important to recognize the torsional strength of their asymmetry) nevertheless can be usefully matched or compared with each other, in order to understand the character of a particular pose. Often, I find that locating the knees or the elbows in space gives me a strong feeling of the "reachingness" or the "stridingness" of a pose. This mental game of orienting yourself through establishing the position of anatomical pairs is not a simple mechanical exercise, since these match-ups can be quite subtle, but they are part of a way of seeing in high-focus drawing in which you think about the figure existing in space and not as a thin mechanism projected on a flat screen. Your pencil, in this frame of mind, makes marks on the paper as though it were touching different projections in the form as it moves out into

HIGH-FOCUS DRAWING

air, rather than building a coastline around an island on a map. Drawing one of a pair and then establishing its mate is part of this encapsulation of the three-dimensionality of the figure through drawing. When you draw the bump of the hip on one side and then make a line to describe its partner on the other, you are like a sculptor using his hands to shape the essential roundness of that part of the torso.

Recognizing the basic forms of the body—that the head is ovoid, that the neck and torso are kinds of columns, that the limbs are complex tubes—helps the artist to keep his observations of details and of the relationship of pairs connected to the underlying solidity of the body.

The Right Position for Drawing

Either standing or sitting, with the easel, board, and pad adjusted to the right height, take an alert body position. You should feel that you are ready to direct your attention toward the model, and like the body of an athlete focusing toward a goal, your body should feel as though it is loose, unencumbered, and poised to move outward, at least in spirit. Do not sit back in your chair, cross your legs, listen to your Walkman, or do anything with your body that makes you feel uninvolved or distant or cuts off circulation from parts of your body. You are engaging in an intense and sensuous endeavor, so as much as possible your physical self should be focused and alive.

Left: *A student using an alert, focused body position to draw.* Right: *A student who is compromising his ability to focus by collapsing his body, drawing on his lap, and generally, keeping aloof from the activity.*

Drawing the Model

Materials

Use an 18" x 24" thirty-pound bond paper pad (a smooth, white, opaque paper); good pencils such as Rexel Cumberland, in a range of softness from 2B to 4B; a kneaded rubber eraser; and a pencil sharpener. Start with the size pad I have recommended here. If you find that the scale of your drawings as they naturally develop would allow for a smaller pad, then switch to a smaller one for your second pad. Always choose a pad that allows you to draw the whole figure. I also recommend that you draw on an easel rather than a drawing bench, with your pad firmly supported by a lightweight drawing board. I discussed the reason for these materials on page 44, and you might want to look over that description again.

The Sketch Group

The best circumstances for drawing are those in which a model of your choice poses for you alone in a comfortable, beautiful room with light streaming in from large windows. Yet for most students, the economics and the personalized circumstances of having a model to yourself can create undue pressure. There is much to be said for the more anonymous context under which most people find themselves drawing the model—the sketch group or life class. After all, drawing in the midst of other people makes you feel less self-conscious about what you put on the paper and about your relationship with an unclothed model. There is a time and place in every artist's life for carefully choosing and posing the model for his own creative needs, but learning to draw and finding out what the figure means to your art is just as well done in the typical sketch group, if you can identify a good group and know how to use the time.

Things that you should look for in a sketch group are:

1. That it has access to relatively young, nude models in good shape who know how to take and hold a pose for at least 20 minutes. You need this kind of model in order to see the structure of the body clearly and to enjoy the vigorous sense of movement an athletic model can achieve. This doesn't mean that you shouldn't also draw older and less muscular people, but only that there is a particular clarity in a firm, athletic body that will help you in this first stage to make sense of the movement.

2. That the room used for drawing is large enough for the number of people involved, and that there aren't so many people that you can't stand or sit close enough to the model. You must be able to see the model clearly and without strain. It would also be very helpful to be able to change position in the room from time to time.

3. That the room is well lighted, preferably with a combination of overhead light and daylight from windows. Very dramatic spot lighting, which casts hard and often conflicting shadows on the model's body, should be avoided, since it is the form and action of the body on which you are concentrating, not the accidents of light. The lighting should help you to see the model as an essentially uninterrupted form.

4. That the poses are a mixture of longer poses (15 to 25 minutes) and shorter poses (2 to 5 minutes) and that they include a good percentage of standing poses, which you need in order to study the most dramatic manifestations of the rhythm of the whole figure. Repeated poses (those that are resumed after the model's rest period) are fine if the model is experienced enough to be able to take the pose again in exactly the same position.

Rhythm

High-focus drawing encourages your ability to open up to the inherent beauty, cohesiveness, and uniqueness of each figure in each pose before you. We need to be able to modify our own preoccupations and psychological biases in order to accept the fact that the individual who poses before us has his or her own way of being in the world physically and that this individual's way makes its own idiosyncratic sense. The person is animated by basically the same motor skills as we are, but the personality of those movements and the manner in which the parts of the body cooperate with one another is unique. How do we tune in to this uniqueness so that instead of seeing separate parts we begin to see an underlying spirit in the gesture of our subject? We do this partly by deciding to be in a more generous and curious frame of mind. We can decide that the model is more miraculous than our drawing can ever be, so that instead of seeing him or her as simply a hired body to give us a subject for our explorations of drawing style, we see the model as the important mystery at the center of the activity in which we decode and evoke as much as we can through our drawing. You will be surprised, I think, at how much change this simple decision will make. You will begin to think and feel more on a human level and notice some obvious clues that in an "artier" frame of mind you might have missed.

Beyond this adjustment of attitude there is, however, a quality of the figure that has been illuminating to thousands of great draftsmen and can work as well for us. That quality of the figure is its rhythm. Rhythm in the movement of the body has been recognized for centuries, particularly by the artists of the Renaissance, as a reflection of how beautifully parts of the body cooperate together to accomplish physical tasks. Rhythm is a primary key that in drawing gives us a way of seeing the body's unity, which might otherwise be hidden in its complexity.

In an anatomical sense, rhythm is the result of the body's natural tendency to find equilibrium by balancing the movement in any one part of the body with a compensatory movement in another. Thus, in the classic contrapuntal pose illustrated by Michelangelo's

Drawing the Model

Michelangelo. *The Bound Slave.*
A beautiful example of contrapuntal rhythm.
1513. Marble sculpture. Paris, Musée du Louvre.

statue, the shifting of the body weight more onto one leg than the other tilts the pelvis, which in turn tilts the shoulders in an opposite direction.

You can experience in your own body this compensatory adjusting to any shift in position simply by first standing in a very relaxed straight-up-and-down way, with your weight balanced on both feet, and then changing the position of one foot only slightly by—say, moving the heel of your right foot outward eight inches. If you are paying close attention, you will feel adjustments being made in separate parts of your body. This is a good test to start with, since it dramatizes how sensitively the body operates in harmony with itself and how subtle and yet how widespread are the alterations it makes.

The subtlety of these inner adjustments is important to recognize, because though it is relatively easy to see the dramatic rhythms of certain big poses, we need to see rhythm operating in many more ways and with much more nuance in order for it to be useful to us in drawing.

One way to think of rhythm is that it is the aesthetic manifestation of energy in the body. We find rhythm in the figure more by the pleasure it gives us in its beauty than in any other way. We see rhythm because it sets up arcs of force or stress in the body that seem to respond to one another with a pattern that makes abstract sense. What we recognize when we see these areas in the perimeter or in the interior forms of the body is a kind of dialogue of emphasis. The parts of the body that are working the hardest to achieve a particular pose express an urgency in their form, which gives the form a sense of direction that seems to direct the energy toward the next link in this chain of strength. The character of these emphatic moments in the body are very harmonious with one another even when they abruptly change direction.

To understand better how these sympathetic areas of emphasis operate, remember what you felt in doing the "slight-movement-of-the-foot" test. When you moved your foot, you probably felt the shift in the tensing of your knee muscles, your stomach, and your neck—if not in more places. These muscles were signaling that they had the principal responsibility of shifting the weight in your body. They were the muscles using their strength to change the direction of force as it took a more complex route from your feet to your head.

65

Two things are very important here in relation to rhythm. First, the areas of muscular emphasis, which we see on the surface of the body as rhythm, signal where the body is using particular *strength* to accomplish changes in body position or where the natural position of bones and muscles is being most *stressed* in the new position. And second, these areas of emphasis are not usually contiguous but appear in *separated* parts of the body. As you learn to respond to the rhythm of the models you draw, these two factors can help you. Look for the areas in the body that seem strong or stressed, and be prepared to see a flow of strength "jump" from one edge to an edge that is not directly connected to it and is quite often on the other side of the body.

At first, before the beauty of rhythm in the body has become apparent to you, you can begin this search for strength simply by using a little common sense. If, for instance, the model is standing with her weight more on one leg than the other, then the weight-bearing leg will exhibit more strength than the other one. The muscles will be more tensed, and the curves along the edges of the leg will be more taut and will give more sense of implicit "traveling," or "direction." That is, they will suggest in their tautness that they are going somewhere or that they point in a certain direction. The muscles of the other leg, in contrast, will usually form rounder and more relaxed arcs and will not suggest movement. Once you see the strength in the supporting leg, look a little harder to find the points of most pressure.

It will help you, in the beginning, to draw as many standing poses as possible. A standing pose represents a simple and dramatic expression of rhythm, since it depends on the body balancing itself on the support of the legs alone. Such a pose will almost always have a single vertical core of rhythmic emphasis, which you can follow essentially as one chain of events. The arms can often create a dramatic secondary rhythmic system, but this secondary system can usually be seen as complementing the basic columnar rhythms of the legs and torso. Sitting poses and semireclining or reclining poses, because they add several points of support to the body (rather than just the legs), complicate the rhythms because the element of gravity plays a larger part: More areas of the body will be supported by the floor or a stool and thus will *not* exhibit active energy, and the rhythms may break down into two or more systems of strength. A pose where the model sits partially supported by a stool and partially by her legs, with which she braces herself against the floor, may break down into two fairly distinct rhythmic systems: the rhythms of the legs as they carry the weight from the foot to the hips and the rhythms of the torso, shoulders, and head as they express the strength moving up from the buttocks to the head. It's not important that you be able to visualize entirely the pose that I have just described but simply that you get the basic idea of how standing poses represent a simpler and usually more apparent chain of rhythms than do other kinds of poses.

In the second repetition of the accompanying drawing, I have diagrammed with dotted lines the major rhythms of the pose. In the dotted arcs that move up the stresses in the supporting leg, through the hip to the pressured edge formed by the tilting rib

Drawing the Model

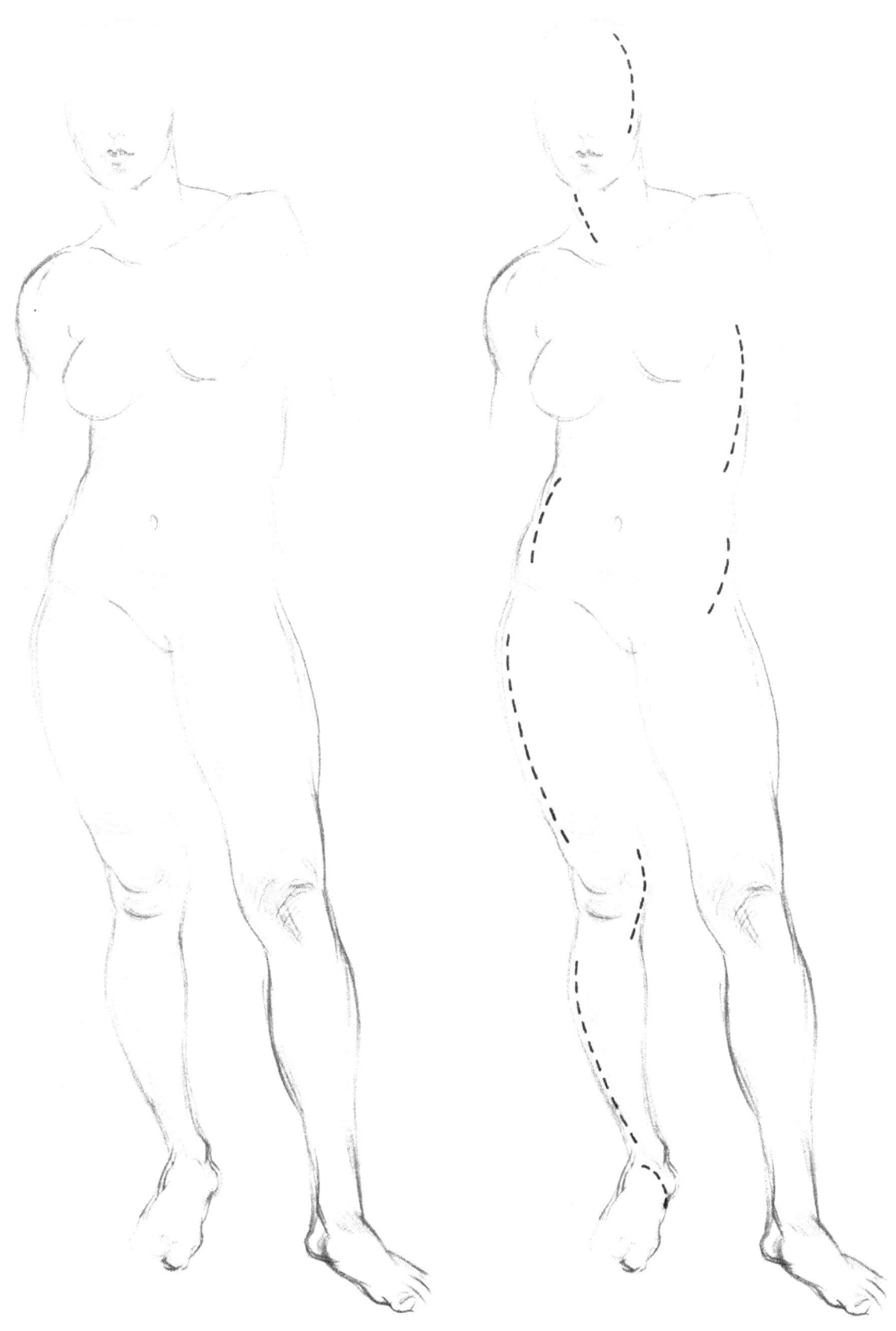

cage, and then to the stretching, pressured side of the neck, you can see the body tilting first one way, then the opposite way, in order to achieve equilibrium. There is another diagram we could make here, of course, which is to superimpose straight lines that would show the opposing tilts of the pelvis and the shoulders, because that, too, is part of this pose. That kind of stick-figure diagraming, however, wouldn't help us to see rhythm, because it would reduce this action to that of a much more mechanical, mannequin-like figure that can tilt or turn at its joints but whose parts never change shape. What we are interested in here is how the complex flexibility of the body makes it possible for parts of the body to *stretch* or *condense* as they move and, by doing this, to create different shapes. What we "read" as we look at the model is the way these subtle differences in the shape of the forms express either the tension or the relaxation of those forms and how the tensed sections in particular create rhythms.

In the last repetition of the drawing, I have diagramed secondary rhythms that are in harmony with the major rhythms I outlined. These secondary rhythms demonstrate that rhythmic energy echoes throughout the body, even in the passive muscles. Many of the arcs I have highlighted almost seem like curving fences around a racecourse to guide the cars through a change in direction, as though the force of their energy and their momentum needs to be contained and channeled. There is, in the rhythms of the body, the implication of containment and redirection of the physical life force. The patterns of emphasis that rhythms create give an almost playful quality to the variations and correspondences that occur. Notice, for instance, that the downward arc of the model's rightknee contrasts with the upward arc of her left knee, like two round babies that roll in opposite directions. Using your wit and your willingness to be delighted will help you enormously to see the body's rhythms.

In this drawing, I have also added dotted lines that don't exactly follow any of the forms in the drawing. These dotted lines describe the implicit rhythms that are created by several forms working together. These kinds of rhythms feel more like interior rhythms or like rhythms that are being created by the mass of the body moving in one direction or another. I add these dotted lines not because you will usually draw these particular rhythms, but because I want you to start to see that rhythmic energy does not just exist in the edges of the body but is implicit in the thrust of its forms. In fact, I don't want you really to draw any of the arcs I have made here but simply to recognize that much of the pleasure we get from rhythm is the sense of the perfect geometry that underlies the much bumpier, idiosyncratic forms we actually see. What we are aiming for is to be able to draw the specific forms of the model and, at the same time, evoke the underlying geometry.

As you look at the photographs of the models posing and at the students' drawings of these models, please bear in mind that the photographs were taken in the early moments of the pose. The students, however, drew the models as they settled into position. This settling in can make a slump or a twist far more obvious than it was in the initial moments of a pose.

Drawing the Model

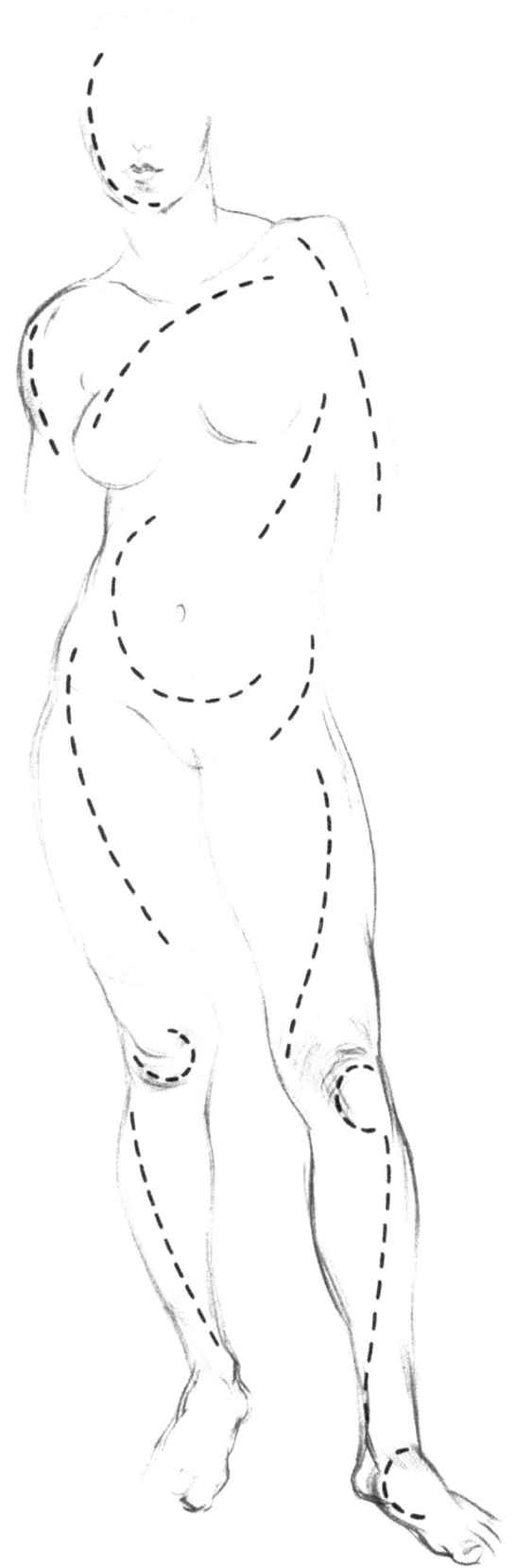

HIGH-FOCUS DRAWING

Finding Rhythm 1. Sometimes, particularly in short poses, we are overwhelmed by our pleasure in the geometry of the rhythm, and part of our enthusiasm for curves goes straight into our drawing, unadulterated by little modifying bumps. This four-minute drawing of the woman with her arms upraised *is* just such a paean to rhythm. I don't need to diagram it, since it is obvious here where the student, John, saw curves arcing against one another in a highly rhythmic way. What I hope is equally obvious in this drawing is that only pleasure in looking, and not any system, led John to this insightful and beautiful drawing.

By checking the photograph of the model, taken from John's point of view, you can see that in the drawing the gesture is slightly overstated; the legs are drawn farther apart than they really were, and they have more sense of stretch to them than the model's. But this is a good kind of "inaccuracy," since it is prompted by the real spirit of the gesture and not simply by a misreading of the pose. In short poses, slightly overstating the gesture in this way is not only pleasurable, it also registers what you feel and see more strongly than if you barely reach the vitality of the pose in your drawing. In longer poses, you will have a chance to deal with the nuances of the model's gesture and to be more faithful to every aspect of her body, but with short time limits, if you are moved to draw the pose 120 percent, you have my encouragement to do so.

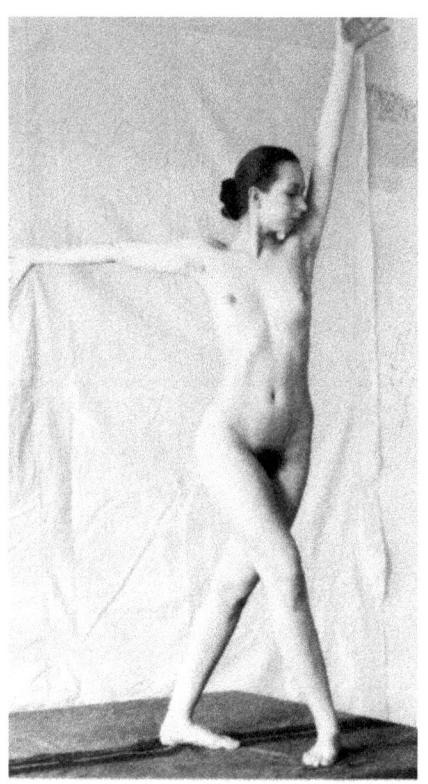

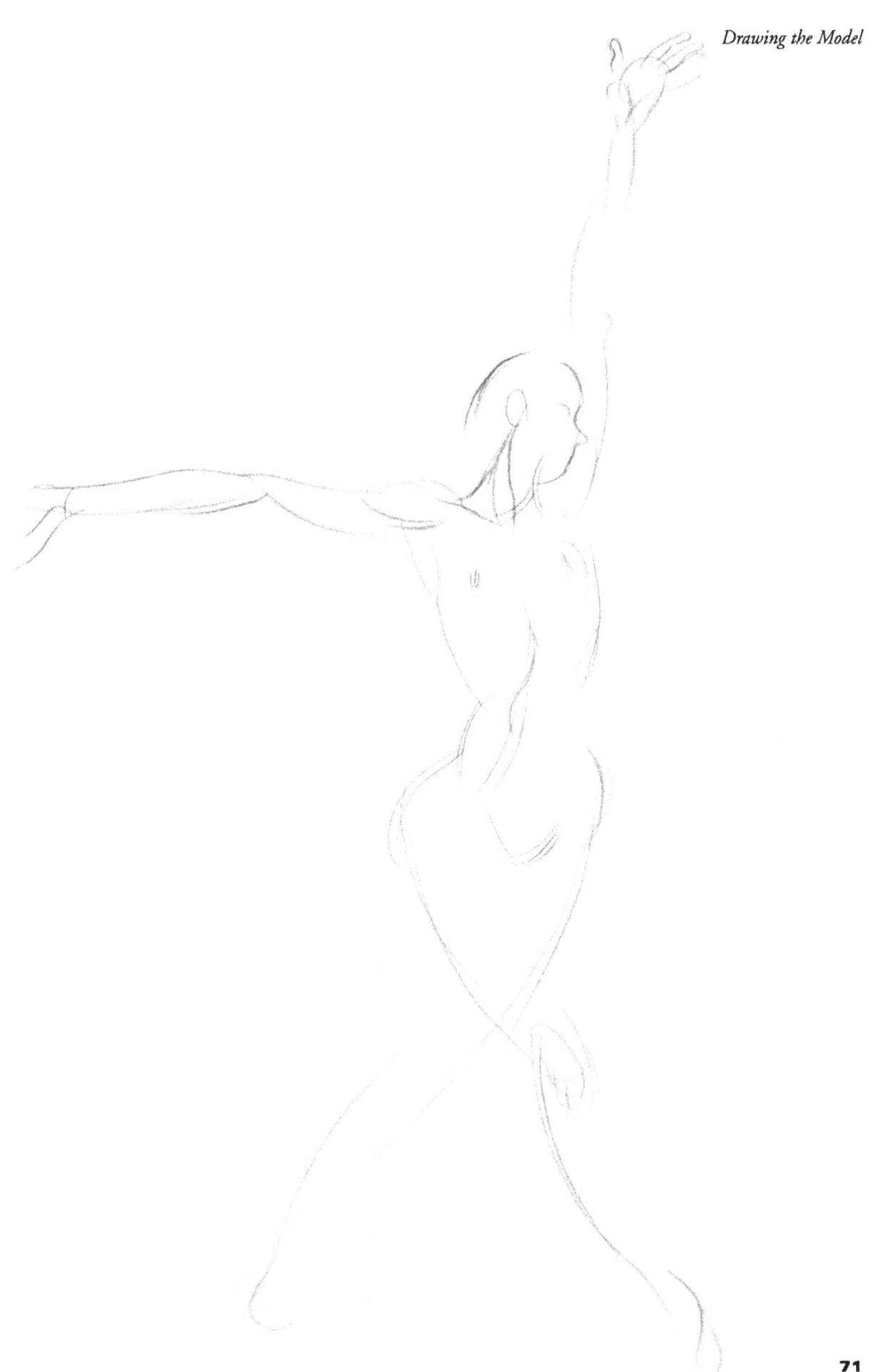

Drawing the Model

Finding Rhythm 2 and 3. The next drawings are by two students responding to basically the same view of the model. Although both students read the rhythms of the right leg fairly well, giving a certain emphasis to the outside edge of the calf and making it clear that the model's left leg is a secondary player, the rhythms in the left hip in John's drawing falter. They don't manage to carry the energy of the right leg successfully up into the torso; we feel an indeterminate quality around the waist in the figure, as though the lines hint at the change in direction but can't quite make up their mind.

This equivocation in John's drawing becomes more obvious once we compare it with Alex's drawing. Here the pencil strokes describing the hip and part of the abdomen get the energy moving, as it were, clearly around the corner and heading us up to the tilted rib cage (more implied than seen under the folded arms) on the other side of the torso. From there the zigzag of energy resolves itself in the compensatory tilt of the head. Alex's drawing demonstrates that the rhythms don't have to be drawn as literal heavy lines. As you can see here (if you ignore my dotted lines), he felt the rhythm strongly enough to be able to suggest it in these soft curves, which don't seem at all diagrammatic. Even the tilt of the head manages to establish the angle of the unseen neck, which we need to feel to complete the balance of the pose.

Even though I am using dotted lines to make these arcs on the figure, I don't want you to think of rhythm simply as a cascading series of linear curves. You have to be able to see and enjoy rhythm as the movement of specific three-dimensional forms and to evoke it in your drawings in whatever way seems natural in that particular instance. The diagrams I have made represent the simplest embodiment of a quality that exists in the figure in much subtler form.

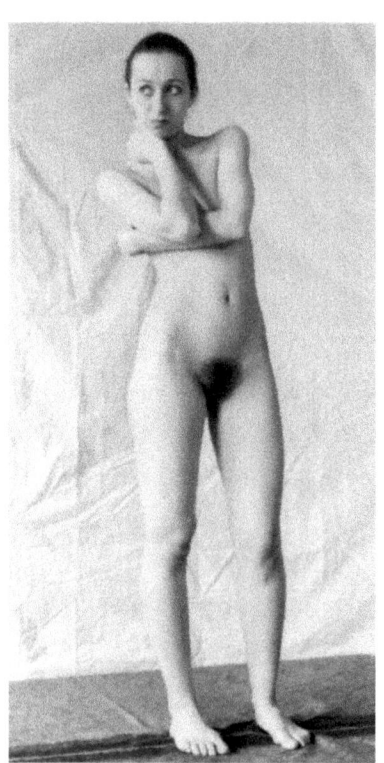

Drawing the Model

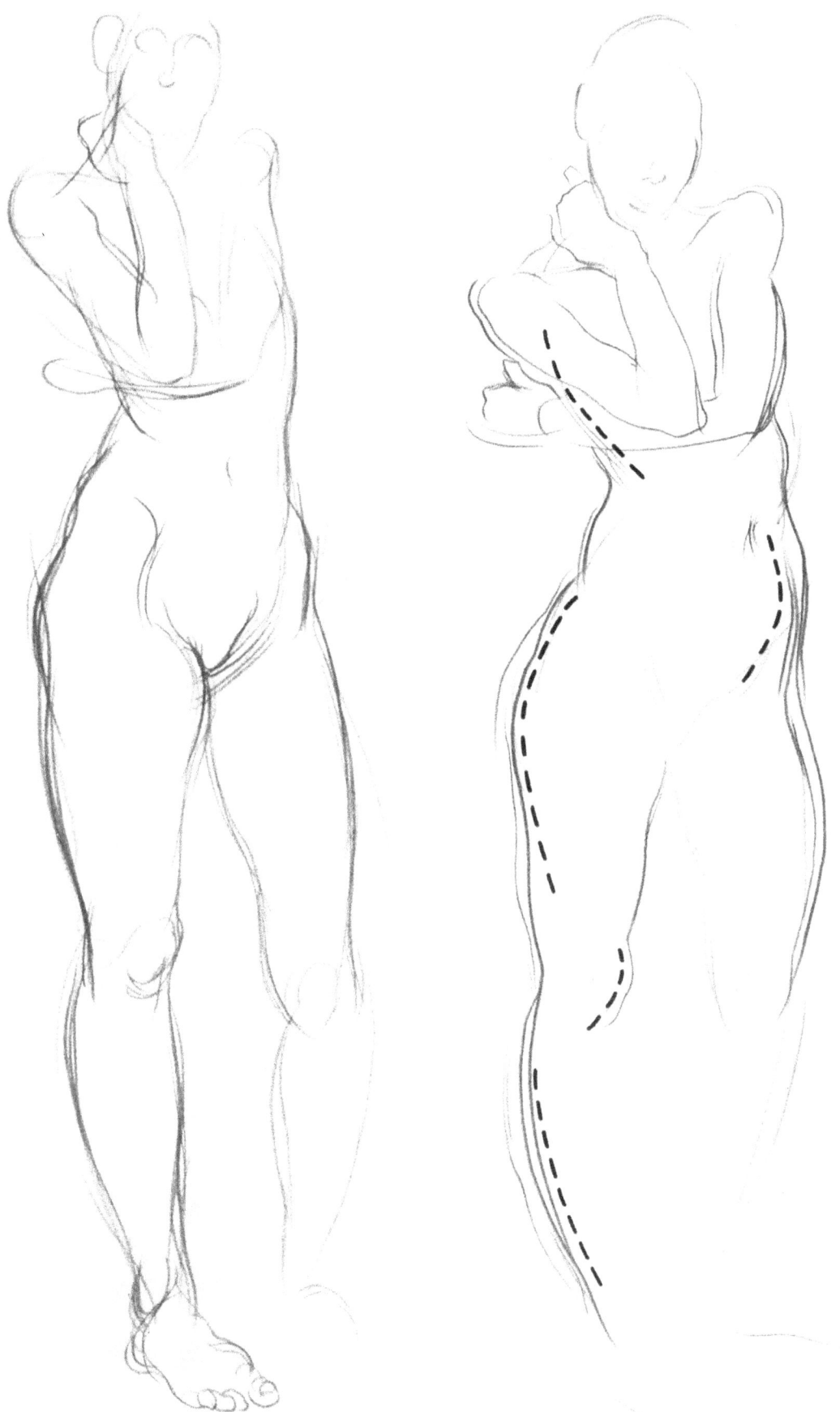

Finding Rhythm 4. For this reason, I have included another drawing by Alex in which he again suggests the rhythm of the figure with soft, "strokey" lines that seem to be a response more to the voluptuousness of the forms than simply to their edges. Continuing this feeling of roundness, Alex has drawn subtle yet eloquent shading lines in the interior of the torso. The belly pushing forward from the downward tilting hips, the upper chest curving back, and the head and neck moving forward are very successfully evoked. Here, the rhythm is experienced not so much in the stressing of the outside edges, as it was in John's drawing number 3, but in the implicit direction of the whole mass of each form as it moves rhythmically in relation to the mass of the other forms. The edges play a part, of course, but if we can imagine the character of Alex's pleasure in looking at this model, it is her roundness more than anything else through which he sees the distinct attitude of her body.

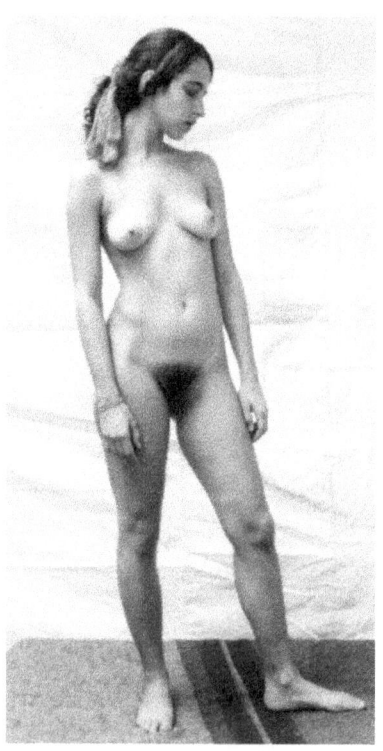

Drawing the Model

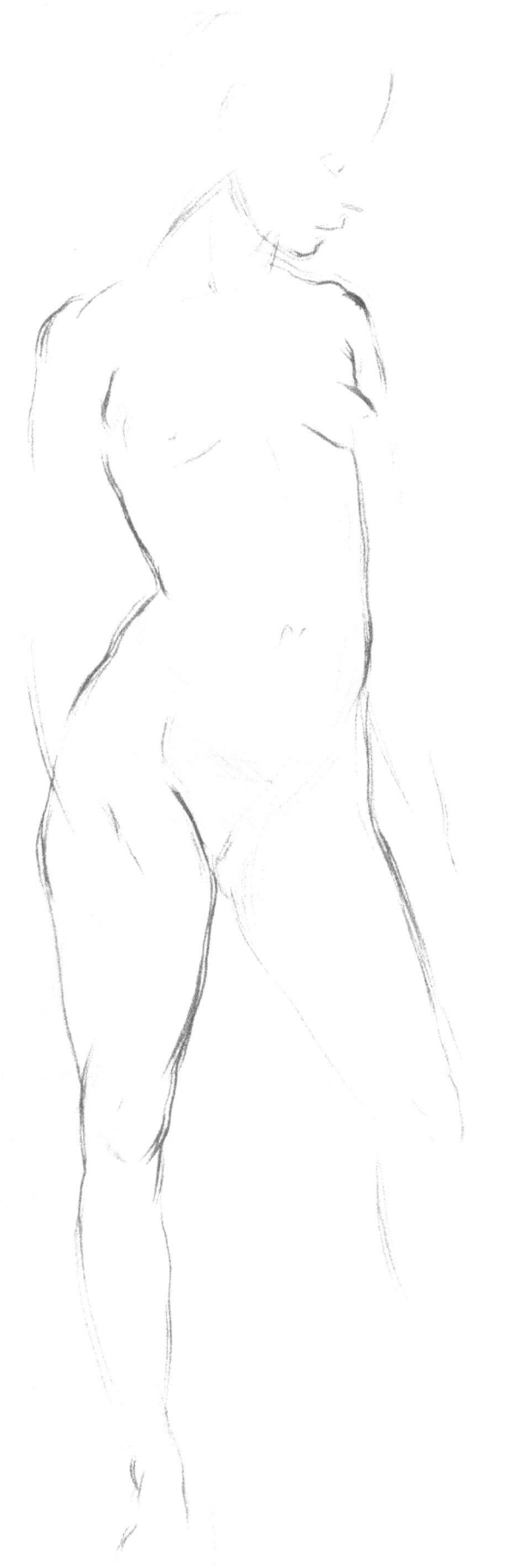

Finding Rhythm 5. This pose has a very lyric appeal it seemed to me. The way the angle of the neck and head gracefully opposes the angle of the torso is very beautiful, as is the bend in the more relaxed right leg. The position of the right leg, in fact, is a good example of a certain kind of relaxed, almost limp quality that parts of a human body can assume which lend it a great deal of poetry. It is connected in my mind to the stylized version of this particular kind of bending which ballet dancers achieve through holding their wrists at a certain angle. In my drawing I have been moderately successful in bringing the rhythm in the right side of the models torso through her left hip and into the supporting leg.

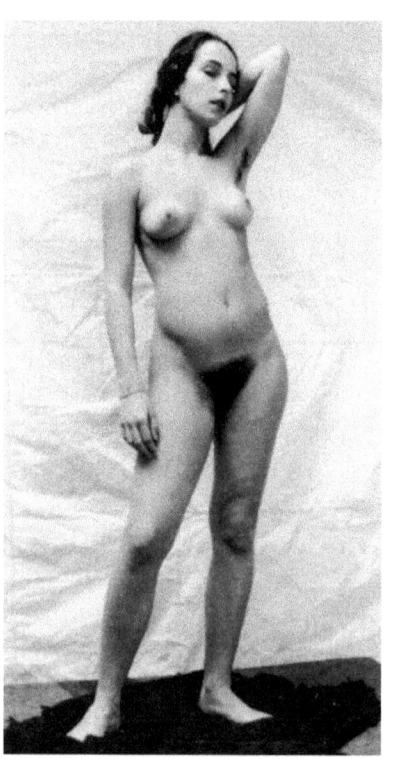

Drawing the Model

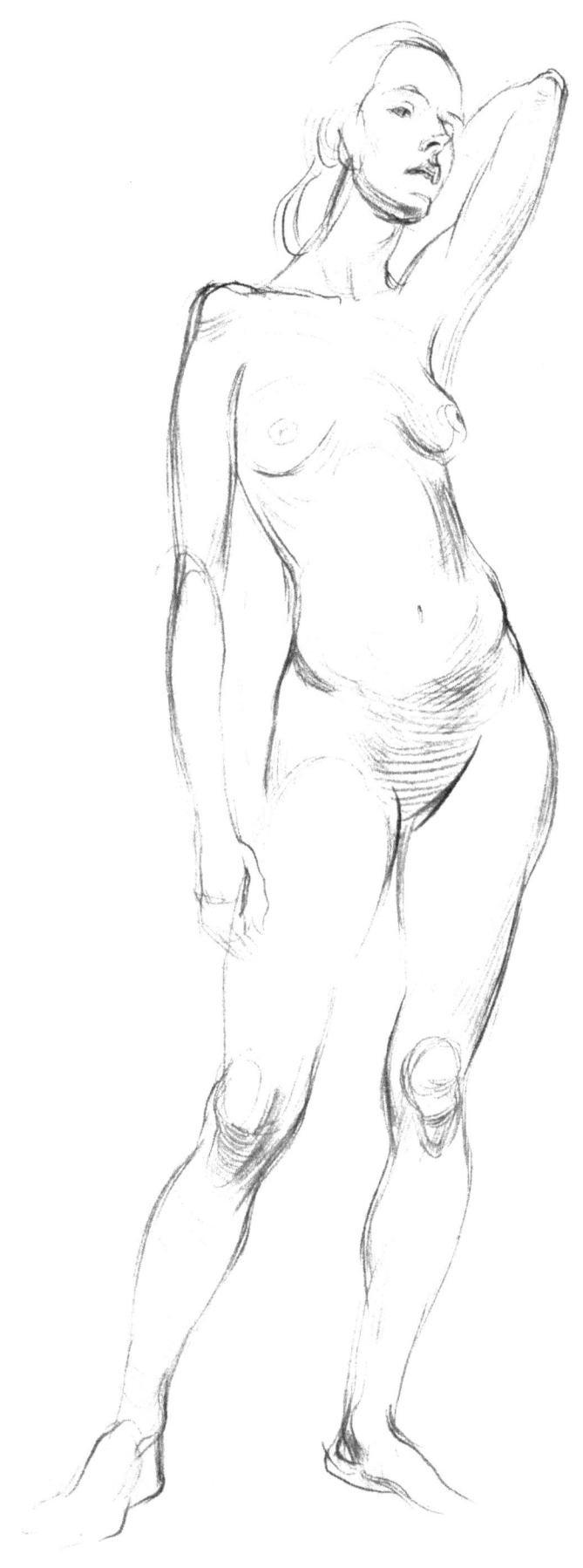

HIGH-FOCUS DRAWING

Finding Rhythm 6. This drawing has a mostly linear, edgy response to the rhythms in the pose, except for the more tonal lines in the abdomen and rib cage, where I felt the rhythm moving up the whole plane of the belly as an emphatic beginning to the big curve of energy that moves from the crotch to the pit of the neck. I found this curve to have a very beautiful relationship to the curve formed by the whole leg as it sweeps from the turned-out foot to the hip. I have made two diagrammatic marks to accentuate the implicit curve formed by the muscles over the rib cage, which, to me, was like an adjunct rhythm that clarified the oval thickness of the torso, as well as providing abstractly satisfying "wings" to the center curve. As in so many poses, the arms form an extension to the other rhythms in a way that is hard to explain but which, I hope you will agree, is undeniably beautiful.

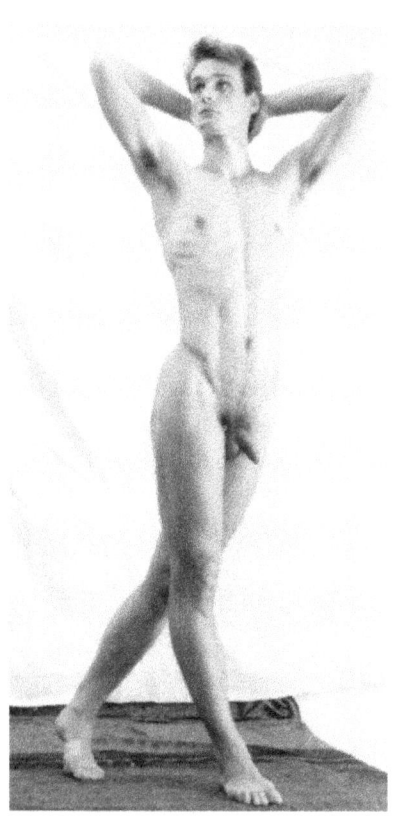

Drawing the Model

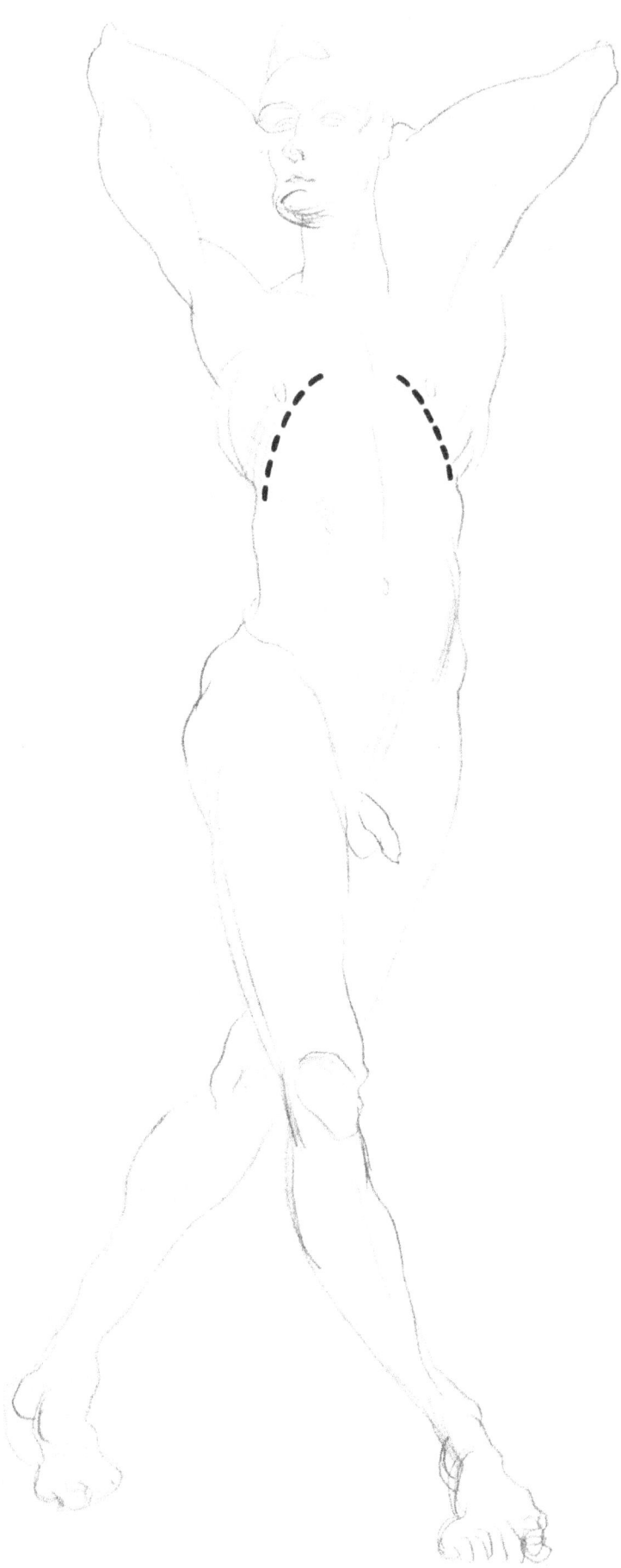

79

HIGH-FOCUS DRAWING

Finding Rhythm 7 and 8. Alex and I drew this same pose from adjacent easels. Apart from the obviously different texture in the two drawings, we found several of the same points to emphasize: the big crease at the waist that helps to suggest how much the model is bending back, the push outward and upward of her buttock (although Alex makes more of this than I do), the tilt of her head, which completes the bending-back arc she is making with her torso, the dramatic tilt of her breasts, which help to explain how much she is tipping the top of her body toward us, and the stretching quality of her lifted arm. In our own fashion, we each drew all of these things.

The two big differences, it seems to me, are in the overall more voluptuous feeling of Alex's figure and the importance I put on the hand position at the end of the supporting arm. To me, the model seemed to be twisting away from the arm and I felt it necessary to draw enough of the hand to show how it pressed against the floor. Her legs, torso, and other arm used the tensed left arm as a kind of Maypole around which they turn, and the left hand seemed to me a crucial detail in setting up this torsional rhythm.

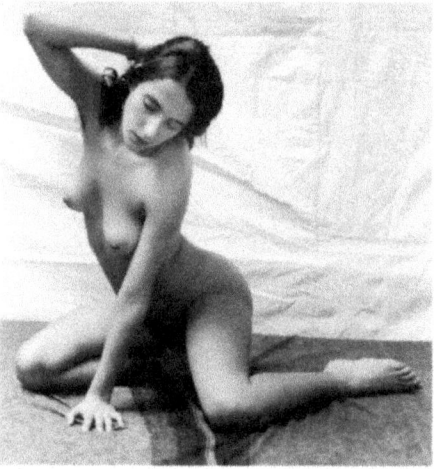

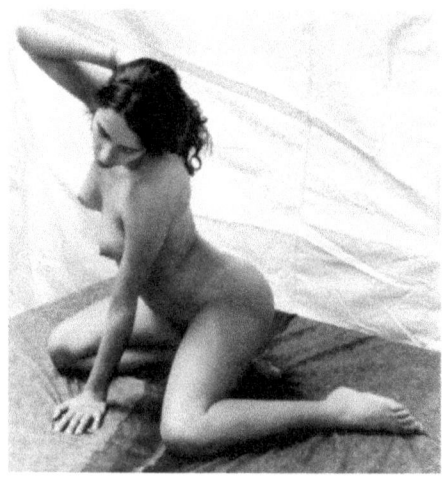

Drawing the Model

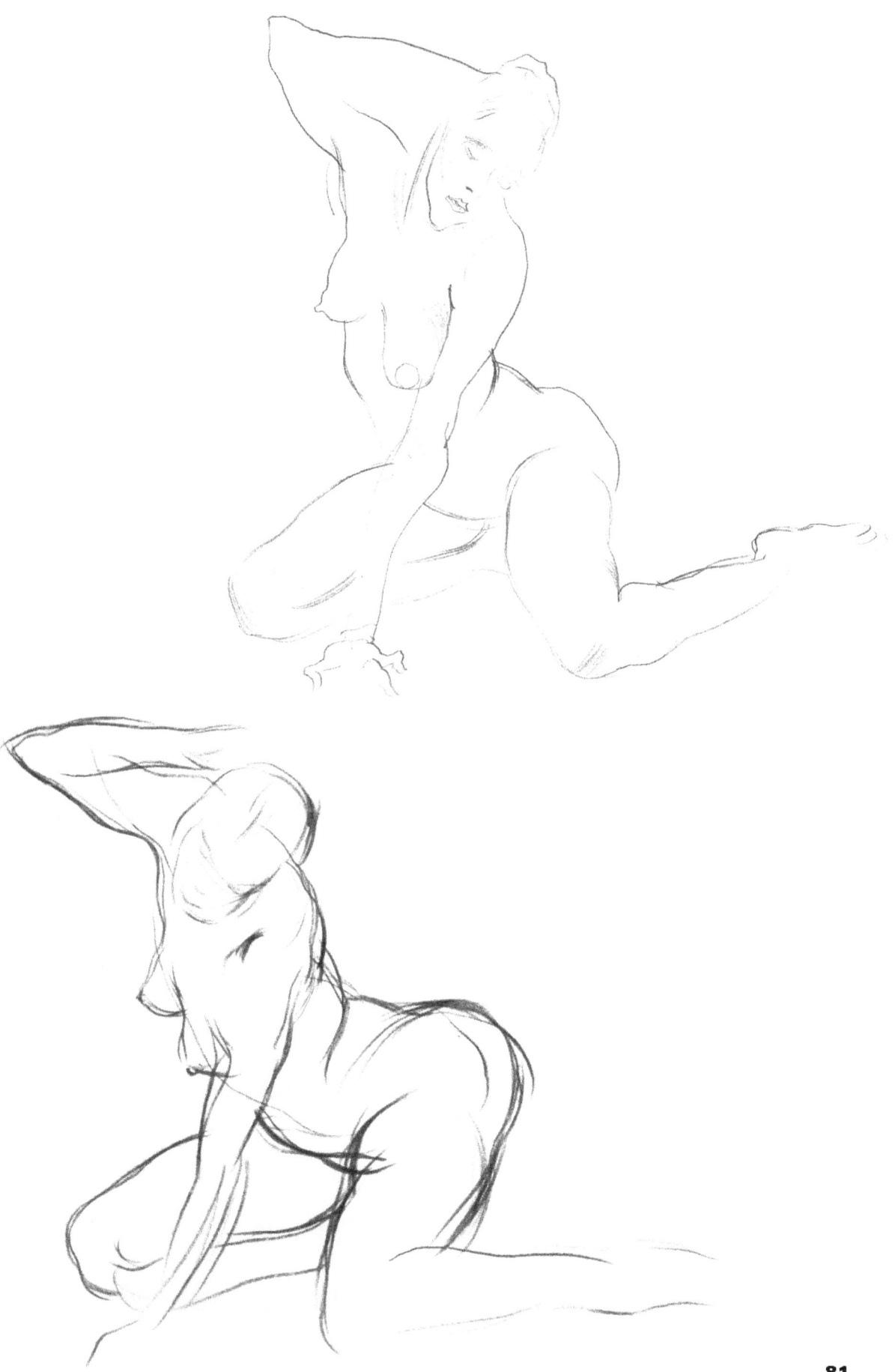

Finding Rhythm 9. This drawing, done from a longer pose, shows how the artist's initial reaction to rhythm is sustained through all of the subsequent development of secondary forms. The student, Gary, has used the tonalities in the back and the legs to strengthen the rhythmic feeling in the drawing. Notice how the curving tonal lines in the model's right buttock play against the series of tonal lines in the right lower back: the pattern of the two groups of lines amplifies what Gary had already established with the movement of the right leg against the left side of the model's back. Gary has probably slightly exaggerated the twist in this pose, but I find it a very agreeable and thoughtful exaggeration. The question to ask regarding whether a drawing's overstatement of gesture succeeds or not is whether, in checking it against the model (or, in this case, the photograph), it makes the real pose clearer. I think Gary's drawing meets that criterion. Another way of looking at that test is to consider whether the exaggeration came from the artist's pleasure in the pose or was in some way a rejection of the pose and the superimposition of an "improved" pose.

I cannot impress upon you strongly enough how much observational drawing is an act of assimilation and how important it is to have a strong opinion about the figure you draw. It is your pleasure and your willingness to decide for yourself what is important in the poses you react to that make it possible for you to make sense of what you see. In a very real way, you must be involved with your subject, and not hang back in an emotional sense from the human connection you have with your subjects.

In Gary's drawing, as in most of the examples in this book, he is clarifying and internalizing his own reactions to the model by risking an overstatement. Don't be afraid, in your own drawings, of using the lines to feed back to yourself a strong (and possibly overstated) notation of what you are discovering about the pose. You learn more in this way, and it is much easier, finally, to modulate a tendency to exaggerate than to fire up a persistently tepid reaction to the models you draw.

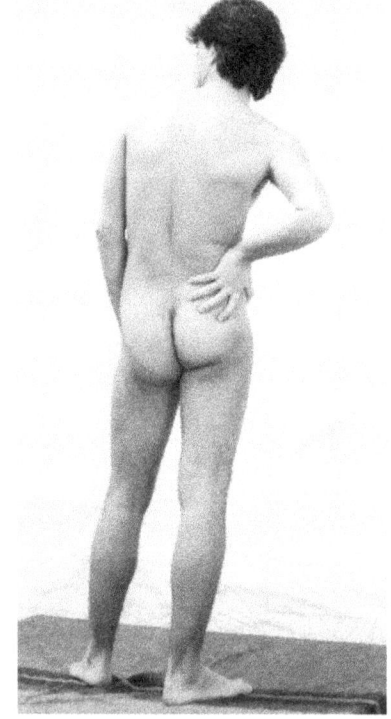

Drawing the Model

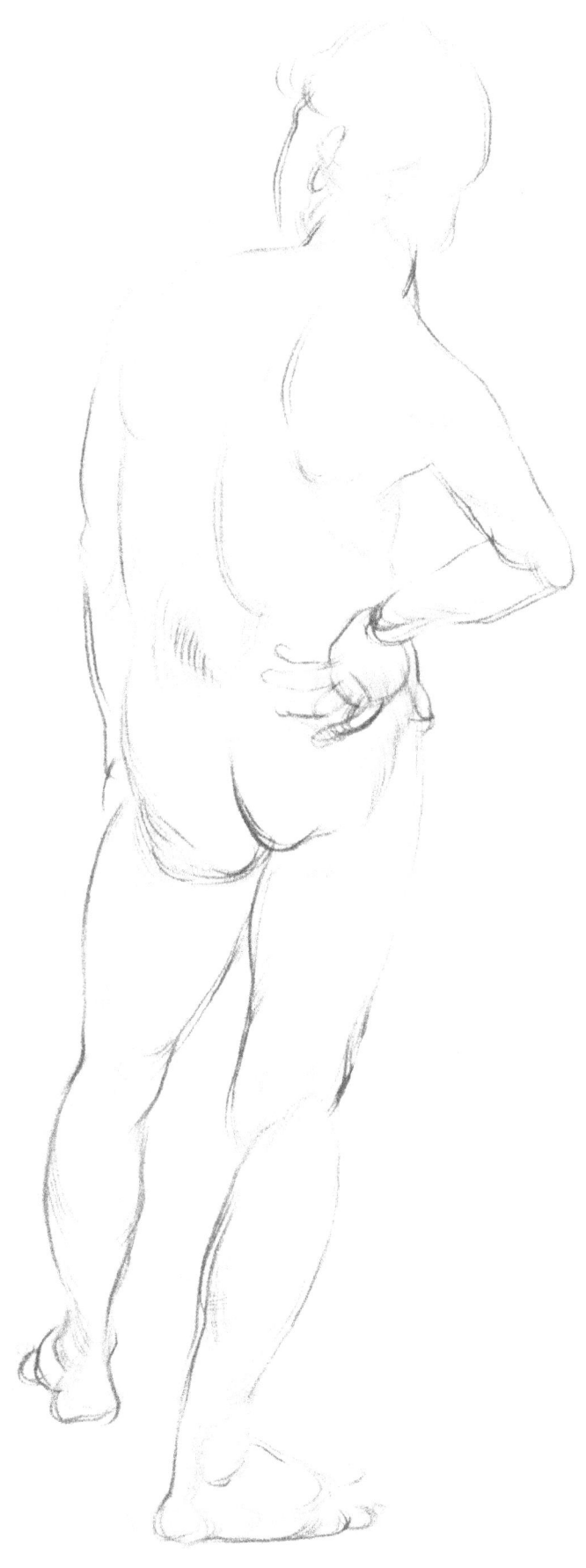

HIGH-FOCUS DRAWING

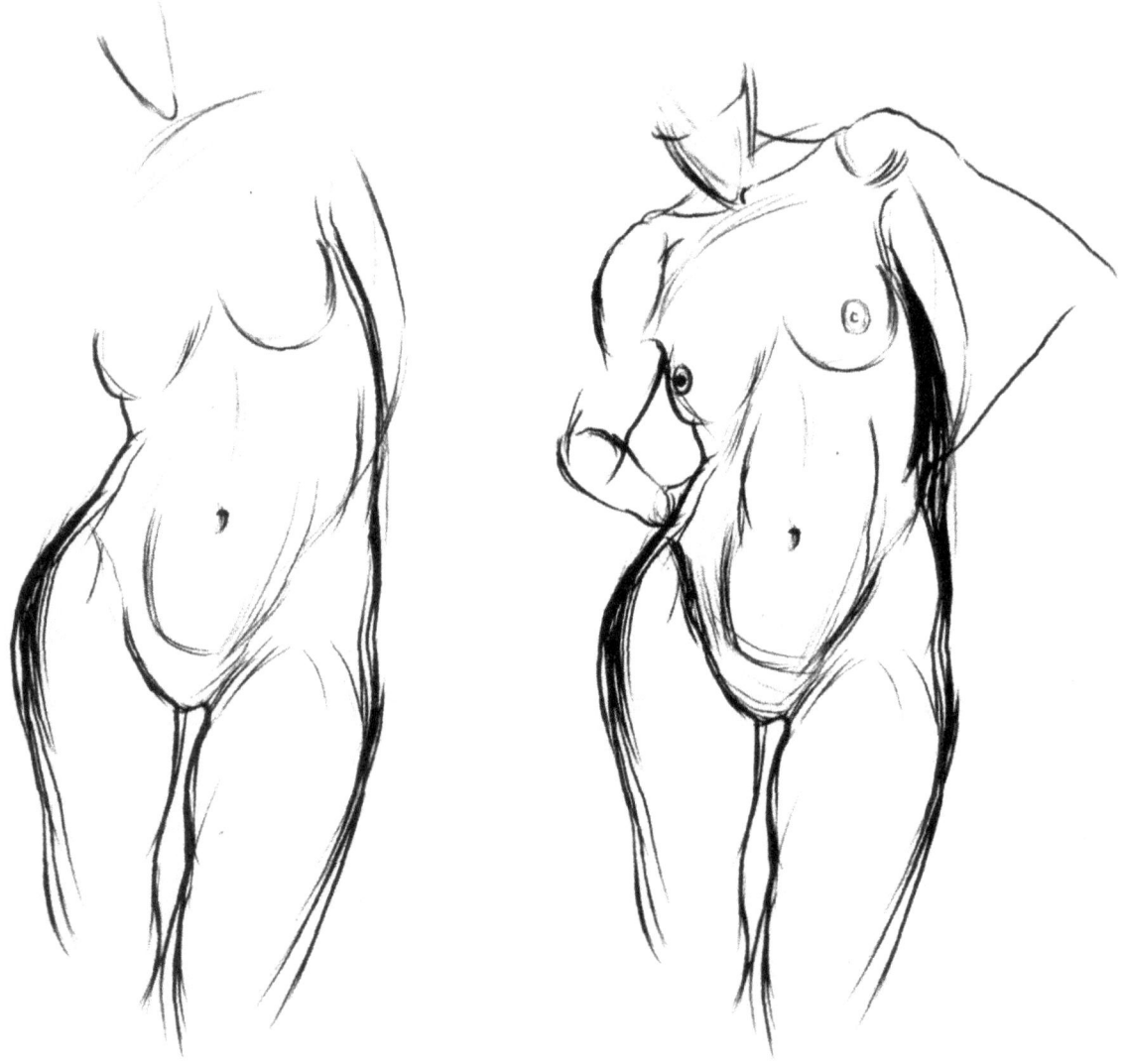

Finding Rhythm 10. We have dealt with the legs so much in our discussion of rhythm that I think it would expand our understanding to see a drawing in which the student, Mike, felt the rhythm operating strongly in the middle of the body and chose to start his drawing there. As you can see from the first stage of the drawing, Mike concentrated on the curvy relationship between the model's right hip and the sketched-out side of her left rib cage. He spent quite a bit of time on this area before moving on to the legs, and although I generally recommend establishing more of the body earlier than this in a drawing, Mike manages to draw the legs so that they successfully continue the rhythms of the torso. His slightly risky approach of spending so much time with one area before going on to the rest of the figure demonstrates that enthusiasm for the personality of the pose (and for rhythm in particular) can keep you focused on the big picture of the pose even when you become obsessed for so long with one area.

Drawing the Model

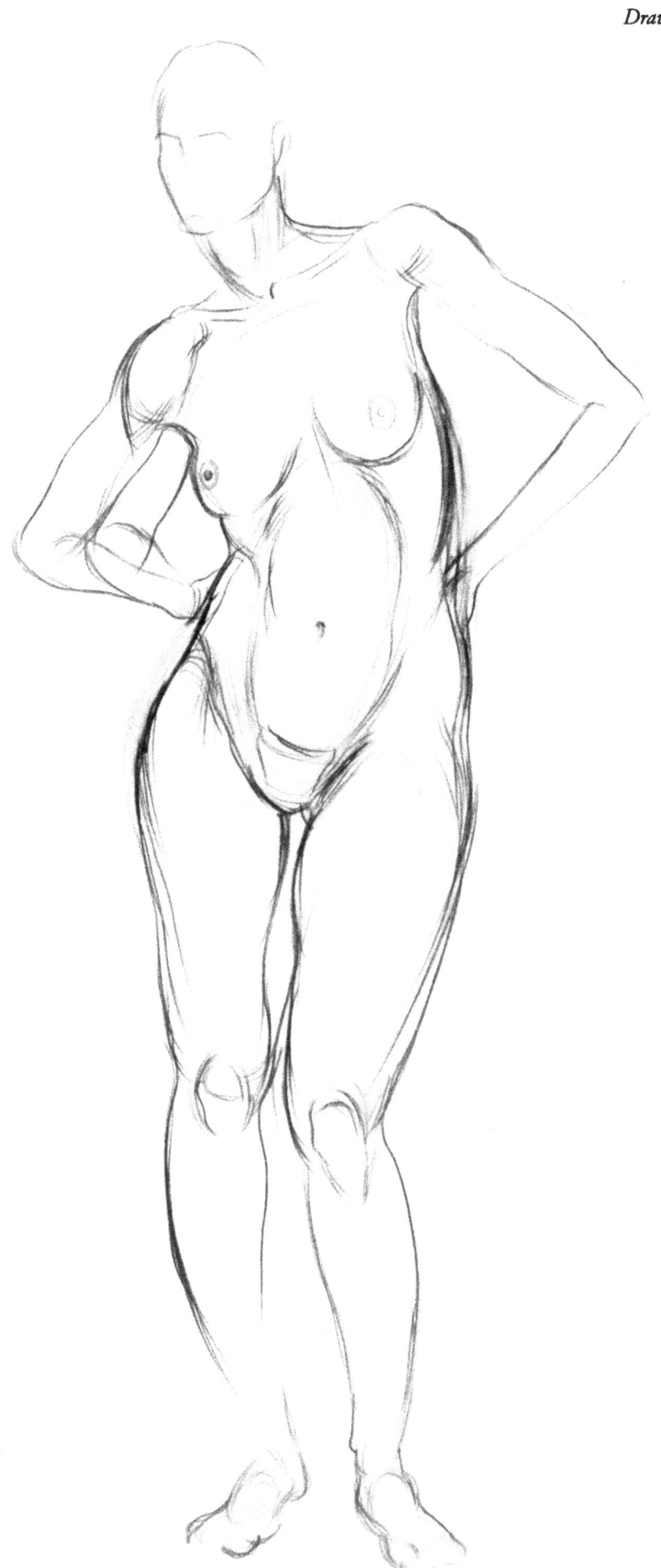

Actually, Mike's obvious pleasure in drawing the abdomen and hips of this model brings up a technique you can use when you are having trouble finding pleasure in a pose, making sense of the rhythm, or connecting to the intuitive side of observation. When this happens to you, in the beginning because you are not used to seeing the model in a particular way, or on a day when your chemistry and that of the model don't happen to click, try finding just one area of the body that you like or, if that's going too far, that slightly interests you. Forget, for the moment, about drawing the whole figure and make a drawing only of that one part. Try to communicate in the drawing what it is about that section of the body that caught your eye. Pretend that the drawing is an illustration that you are using to explain to a friend who can't see the model the quality you found in this part of the body. Correctness and proportion are not the point here as much as making a drawing that really brings out the special virtues you saw. This little detour has worked very well in my classes to unblock many students, and it may help you to experience your drawing as a clarifier and amplifier of your own reactions.

I hope that in this section on rhythm, you have been able to identify for yourself what this quality is in the movement of the human body, and that you not only can find it in the models you draw but are also beginning to experience the pleasure of seeing it and evoking it with your drawing lines.

Some Things to Try in Experiencing Rhythm:

1. Make a drawing in which you chart all the tense edges.

2. Make a drawing that describes the strength of the body without any of the lines connecting.

3. Make a drawing of just the hands and feet, particularly trying to evoke the angles at which they exist in space.

4. Ignore the face and concentrate on the body from the neck down.

5. Make a drawing of just the active edge of every form and try to describe the back-to-front space the model occupies with these lines, which, as in number 2, will mostly not connect.

6. Ask the model to show you several poses, until the rhythm of one of them becomes apparent to you.

7. Have the model imitate the pose of Michelangelo's statue on page 65. Describe the major contrapuntal rhythms through your drawing.

8. Copy any drawing in this book that seems to you particularly rhythmic.

9. Ignore these suggestions, relax, and enjoy the model's rhythms.

Where to Start

The section on rhythm preceded this section on where to start a drawing because recognizing the rhythm of the figures we draw is the principal quality we use in deciding where to begin. As you saw in the last example, Mike's strong reaction to the tilting, twisting rhythm of the model's torso decided for him the beginning of his drawing. It not only led him to a place where he made his first lines, but it was also, for him, a logical starting point in pursuing the "big idea" of his drawing. We can make a rough verbal description of Mike's big idea, yet it will always fall short of what we can figure out by simply enjoying his drawing, because for him, and for us in our own drawings, those big ideas are arrived at more through intuition and pleasure than through schematically analyzing the components of the pose. Part of his big idea was that he saw the tilt in the hips and shoulders, but it really had much more to do with the model's firm, round belly swelling out in the center of the torso and curving from the breasts to the crotch, and how these generous forms specifically adapted themselves to the tilt. What Mike loved, and what made it possible for him to see everything working together, was *this* model and how *her* body made these moves. If all he could have figured out was the simple mechanics of hips tilting against shoulders, his intuition would not have become engaged and he would not have been able to make decisions that kept his drawing going, building, making more and more sense.

That is what we want when we decide where to start our drawings: a point from which we can begin to *build* our intuitive understanding of the pose. Those first lines should seem an important part of what we have decided about the character of the pose, and they should lead us to more and more understanding. What we want from our progression in drawing is that it becomes easier and easier (or clearer and clearer) to decide what the next line will be. The hallmarks of this kind of progression are (1) that the artist starts different drawings in different places, (2) that he or she is willing to make strokes out on the white paper that are not connected, at this stage, with the drawing that is already there, and (3) that a strong sense of growing coherence distinguishes the drawing. The opposite of this kind of progression is that the artist starts every drawing in the same place, that no line is ever made that is not connected to another line, and that as the drawing grows, it doesn't make more and more sense in terms of its central character but simply explains more and more pieces of the body.

HIGH-FOCUS DRAWING

Where to Start 1. Alex started his drawing with lines that established the sweeping curve of the bottom half of the torso—I suspect these were his very first lines—and the right thigh pressing back up against this curve and the head and neck turning back. He wanted quickly to get to what he saw as the central issue of the pose, the big curve of the torso. He was willing to generalize his first lines slightly in order to establish the rhythm of the curve. You notice that he draws the lines through the left arm and he doesn't try to get every nuance of the area about the model's navel, although it is obvious that he saw them, in the interest of keeping the thrust going in the lines. What he wanted from these lines in particular was to register in his drawing the spirit of his reaction to the curving body. What you feel in all these lines is that he has taken charge of his drawing; we can already see the nature of Alex's opinion about the pose.

Often, a good beginning in a drawing has the quality of saying a great deal with very few lines, and I think that is the case here. For instance, Alex tells us (and himself) so much about the angle and even the slightly straining quality of the head with a very minimal description. I like particularly the little line at the front base of the neck, which manages to add the feeling of the column of the neck curving back against the direction of the clavicle. In fact, every line at this stage of the drawing contributes strongly to the main core of the pose; nothing seems to have been drawn simply "because it was there." Alex is like a detective who identifies his case ("The Woman Who Twisted Away from Her Pelvis") and then finds the clues to solve the mystery ("Hmmm...belly curved, groin squeezed, back bent, throat stretched...pose revealed!").

In the second and final stage of Alex's drawing, you see him building on the foundation he laid in the first few lines. The drawing becomes a stronger and stronger version of what was suggested from the very start. The few weak parts of the drawing—the legs not quite evoking the sense that they are pushing against the floor and the arms not quite resolving their strength in supporting the upper body—are parts of the pose that weren't dealt with in the early stages and which, I suspect, Alex never quite reacted to clearly enough.

Drawing the Model

Where to Start 2. In my own drawing of the same pose, my progress was photographed at a slightly later stage than Alex's, but as I remember working on this drawing, my first lines were also the bottom curves of the torso. Then I moved to the curve of the hip and buttock, to the top curves of the left leg, to the throat and head, to the lines of the two arms. If you can follow that order, you will see that I went from one edge to an edge that in some way opposed it. It feels like encapsulating the energy, in a way: the lines of the abdomen get the energy going in a certain curve, the lines of the hip and buttock slightly oppose that curve, and stop the energy from zooming off in a southerly direction; the lines of the thigh push up against the curve of the belly and challenge that energy in a different way; the curve of the neck continues the energy of the abdomen, but that affiliation is interrupted by the direction of the shoulder. When you begin to see how forceful and directional the edges of the body are, it becomes easier to see them as players in this game of energy and how certain edges or forms are more important players, in one pose, than others.

The later stage of my drawing shows how I amplified certain aspects of my first thoughts on the pose, how I put tonal emphasis on the back and shoulders to give them more push, and how some arcs, such as the hip and buttocks, got very little further development.

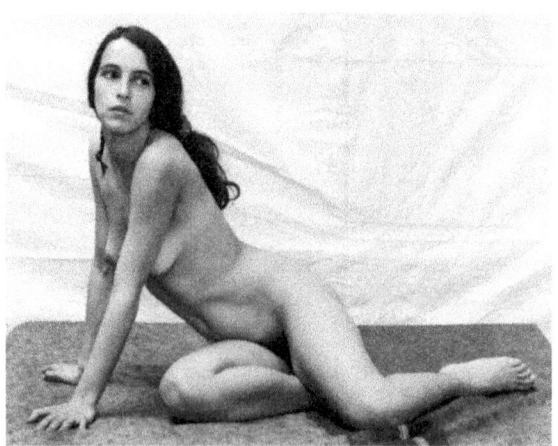

Drawing the Model

Where to Start 3. Your first impression in looking at Gary's drawing next to the photograph of the model is that he completely missed the tall, skinny proportions of the man who posed. Nevertheless, this is a very intense, interesting drawing that investigates the pose truthfully even though Gary couldn't quite come to terms with the 6'3" height of Elmar, the model.

It was the particular locked-in, pushed-forward character of the model's hips and the turned-out position of his legs that Gary tried to catch in the first stage. Gary draws a curving line at the back of the hip, and shading lines describing the lower abdomen, which together with the angle of the lines in front, start to establish this area pushing forward. One can tell from the character of the curve he uses to describe the buttock that he saw its "clenchedness" as part of the push in the hips. The curving lines in the legs evoke their slightly twisting rhythm, and he sees that it was important to emphasize the top of the instep to suggest the tension caused in the foot, not just by the body's weight pressing down but also by the foot being turned sideways as much as it is.

Gary makes the hip area very much the centerpiece of his drawings, and although he evokes his enthusiasm very successfully in the drawing, he pays a slight price for this. I can't get over the impression in looking at the final stage that the legs are flowing *down* from the hips rather than supporting them from the floor. I make this criticism because I think it is important to look candidly at the results of any of our choices in drawing, while at the same time I am delighted when any of my students can create a failure as rich as this one. Gary reacted to the hips and abdomen so much that they lost part of their functional relationship to the rest of the body, but the important thing is that he *reacted*, and that is always good.

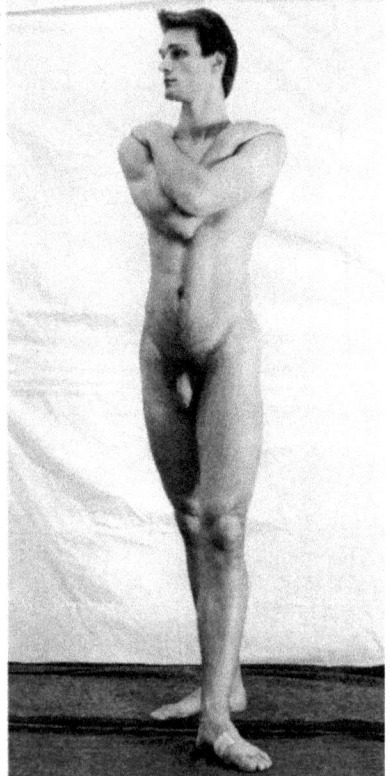

Drawing the Model

Where to Start Illustration 4. There is a certain tradition in drawing to start with the head, the argument being that it gives the artist an immediate element with which to scale the rest of the figure. I don't buy either the argument about scale—since people who are going to make mistakes in scale will make them no matter where they start a drawing, or, for reasons I have already made clear, the theory that any part of the body is the place *always* to begin.

That being said, there are times when the head *is* the place to begin a drawing, as John, in this case, seems to agree. By comparing the first stage of John's drawing with the last, you can see that from the start he had a clear idea of the rhythm he was after in the whole figure. Looking at the beginning of the head, we can already see, in the rhythm of the neck, the beginning of the twisting rhythm that will eventually course through the bellowing torso, the cocked hip, and the locked-back right leg. Guessing at what John's reasons were for starting with the head, I would hazard the opinion that he saw in the model's resolute stare both an anchor for this sinuous stance and the emotional equivalent of her head saying, "What do you want to make of it?" The pose has a certain challenging sauciness to it, and John might have felt that he couldn't find a better place than the head to begin evoking this attitude. Also, the head, cocked to the side and, as it were, sitting out in space, is a dramatic punctuation to the feeling of parts of the body being thrown strongly first to one side and then another, forming a large S-curve. I speculate on John's choice because I think these emotional, almost storylike aspects of our first reactions are powerful motivators in choosing a place to start. Whatever his reasons were, John saw the role that the head played in his understanding of the pose, so he was able to draw it first, establishing, in its tilt and character, the beginning of the body portrait he was about to make.

Drawing the Model

Where to Start 5. As I first looked at the model in this pose, I was impressed by the cylinder of the torso caged by the angular arms and legs. The torso had a fairly static up-and-down axis, but the rhythm of the arms and legs was complex. I first made the curvy lines around the midriff and two lines at either side of the torso to establish this central core and then, because I liked their play of rhythm, I drew a line for the top of her right thigh, one for the front of her left lower leg, one at the top of that leg to define where the trunk met the groin, then the lines describing the foot.

The foot may seem like a small detail at so early a stage in the drawing, but seeing that it was turned the way it was and that we were looking at its sole, I thought it offered a possibility to express a great deal about the pose. We are, of course, talking intuition here to a large extent, and not everyone is as interested in the angles of hands and feet as I am.

After establishing the foot, I made the lines for the arms, which felt to me like rhythms that enclosed the mass of the torso. As you can see from the second stage, I was very involved in reinforcing the tubular quality of the torso that I had begun with. As much as I added lines, I was never satisfied with the sense of gravity weighing down the forms of this part of the body. In terms of gravity, I was more successful in getting her right leg to look squeezed and pushed against the floor.

Drawing the Model

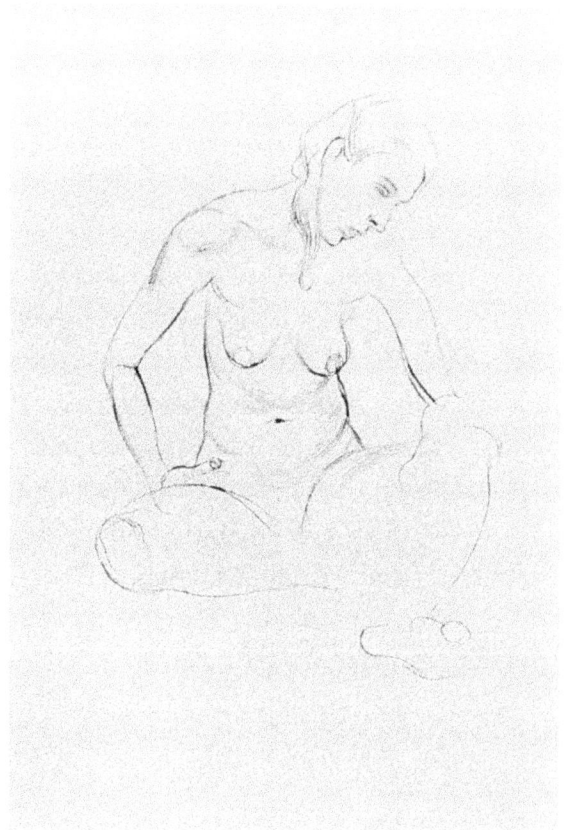
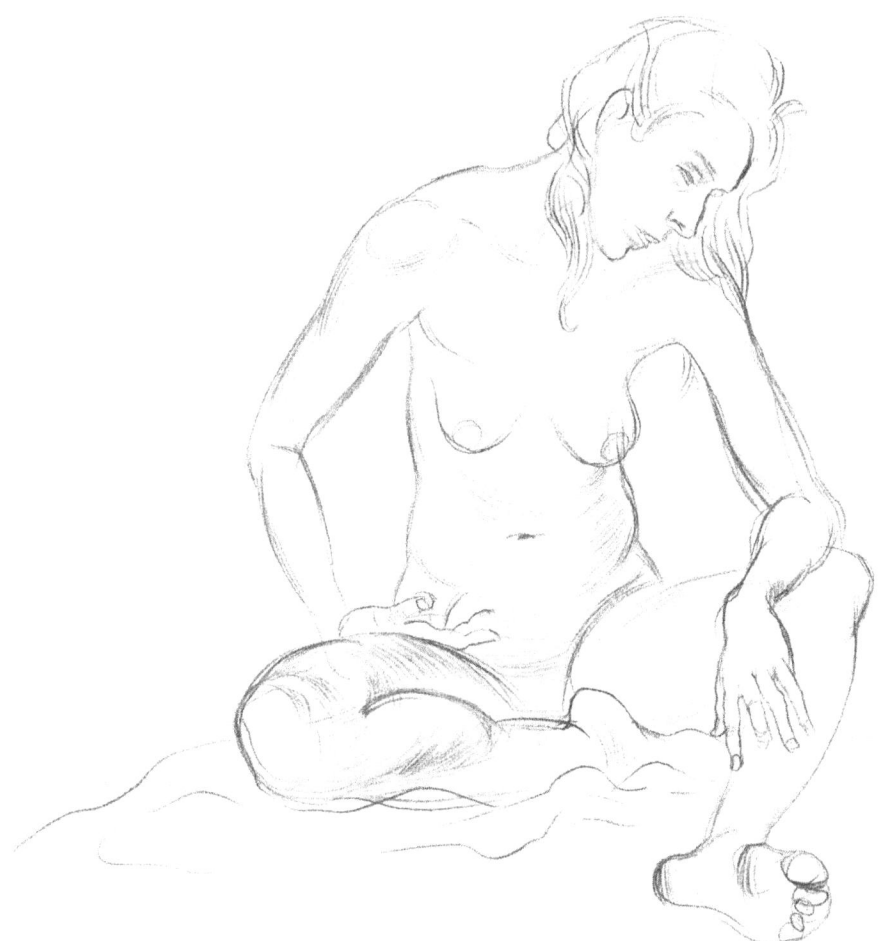

97

Some Things to Try in Starting Your Drawings:

1. Ignore the head. Start somewhere else.

2. Ignore whatever part of the body is closest to you; begin with another part of the body.

3. Ignore whatever is darkest or most shadowy and begin somewhere else.

4. Ignore the breasts. Start somewhere else.

5. Look for the area in the body that is working the hardest and start there. Next, draw the area that seems most to support this hardworking area and proceed in this way to the third most hardworking area, and so on.

6. Start at the feet and think about how the legs support the hips and how the hips support the trunk, the shoulders, the neck, and the head.

7. Start near the hips and think about how the energy of the legs gets successfully transmitted into the torso.

8. Ignore all these suggestions and start where the beauty of the pose makes your feel it is imperative to do so.

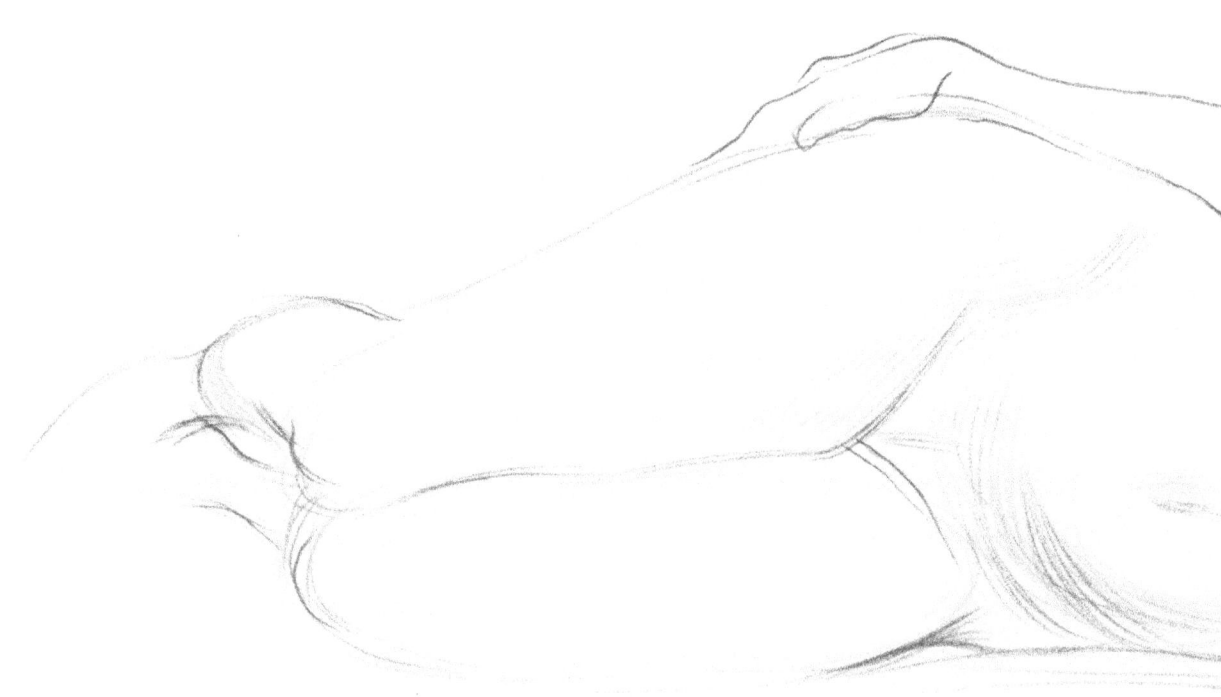

Drawing the Model

Roundness, Gravity, and Resolution

Now that we have talked about rhythm both as a central aspect of seeing the energy in the poses we draw and in helping us decide where to start our drawings, we can discuss three other qualities that we want in our drawings: roundness, the sense of the body responding to the force of gravity, and the feeling that everything falls into place and hangs together, or resolution.

In a way, we are introducing the necessary other-side-of-the-coin here. Roundness in the body implies its heft, its substance, the actual poundage that the energy of the body has to move around. Gravity is the force that is always keeping us rooted to the ground. Resolution is the quality that we get when the conflicting forces have been balanced. In truth, rhythm is formed by these opposing forces; our ability to move and to articulate our bodies is contained and shaped by gravity, and much of what we experience in recognizing rhythm is the beautiful tensions that result from the energy in the body both resisting and giving way to the force of gravity.

Roundness is by far the most straightforward of these three qualities and one that few of you will have trouble recognizing and, I hope, evoking in your drawings. Certainly the start of roundness is the use of intersections, which I introduced in the last chapter, on page 36. It comes in the beginning from seeing how much forms are in front of other forms in the body and how much the forms interlock with one another. Roundness is further developed in drawing by being able to use tonal shading in response to your enjoyment of the round forms.

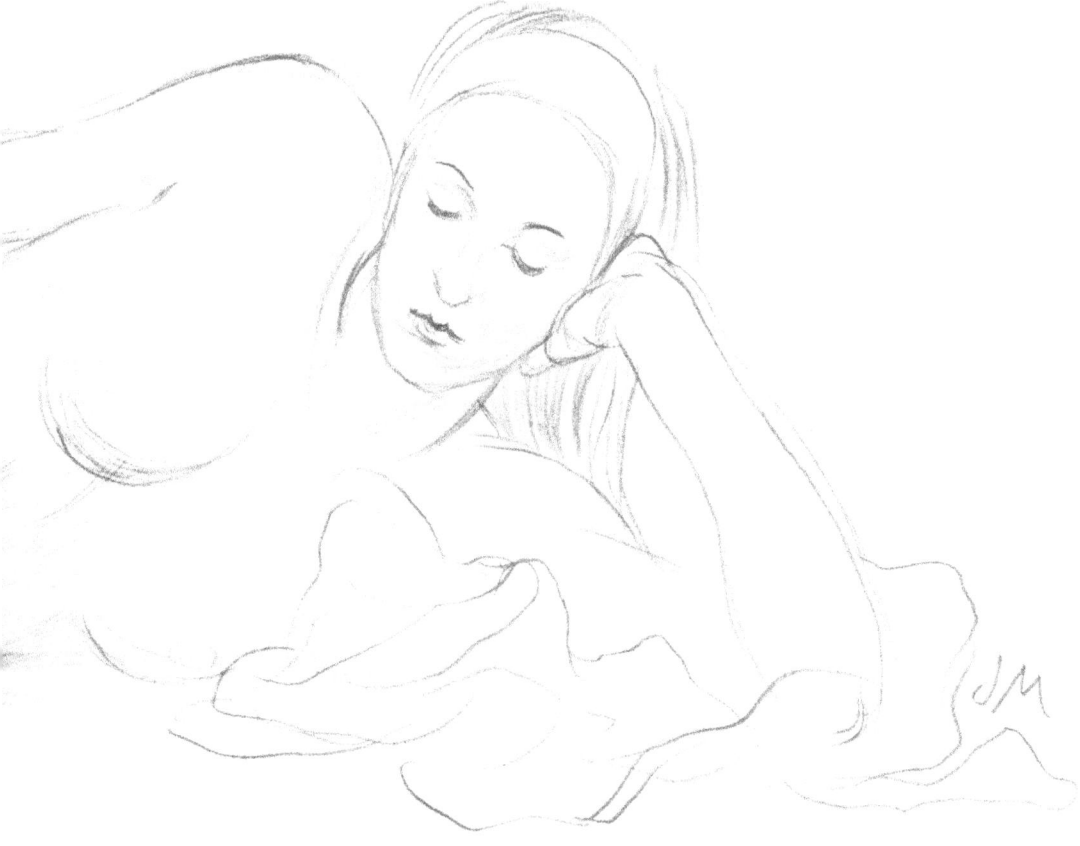

Roundness 1. It helps, of course, to start by choosing a model whose body especially provokes you to see roundness. I am showing you my own drawing and one by John of the same model, a model who meets the qualifications of roundness. As you can see, Marcello is in no way fat, but his body seems sturdy and very three-dimensional.

What I responded to in the model was not only the clear roundness of his body but also the sensation that the forms were advancing toward me. You could also say that some of them were retreating from me, but my stronger feeling was that the stomach, the right kneecap, and the foot on the front leg had a kind of spatial presence; that they were bumping out toward me. You can see in the abdomen and chest the lines I used to try to describe this quality and, I think more successfully, the tonal lines in the legs, which suggest the roundness as well as the strongly interlocking nature of those forms. The model seems fairly round, but I think even more, he seems related to the ground. I feel a certain amount of weight in this drawing and a degree of resolution. The drawing feels as if it is of a whole man, all the forces adapted to his actual three-dimensional existence.

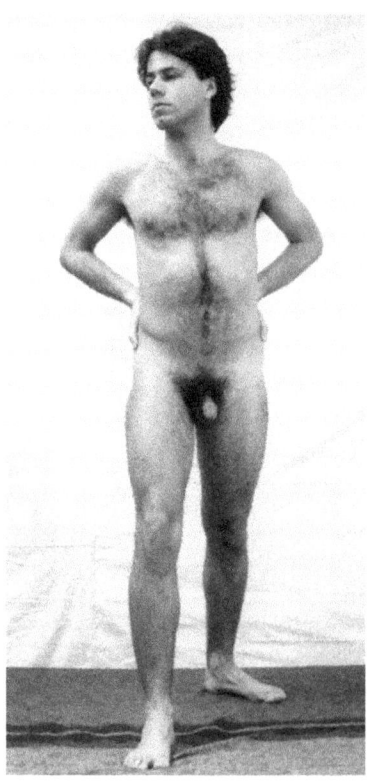

Drawing the Model

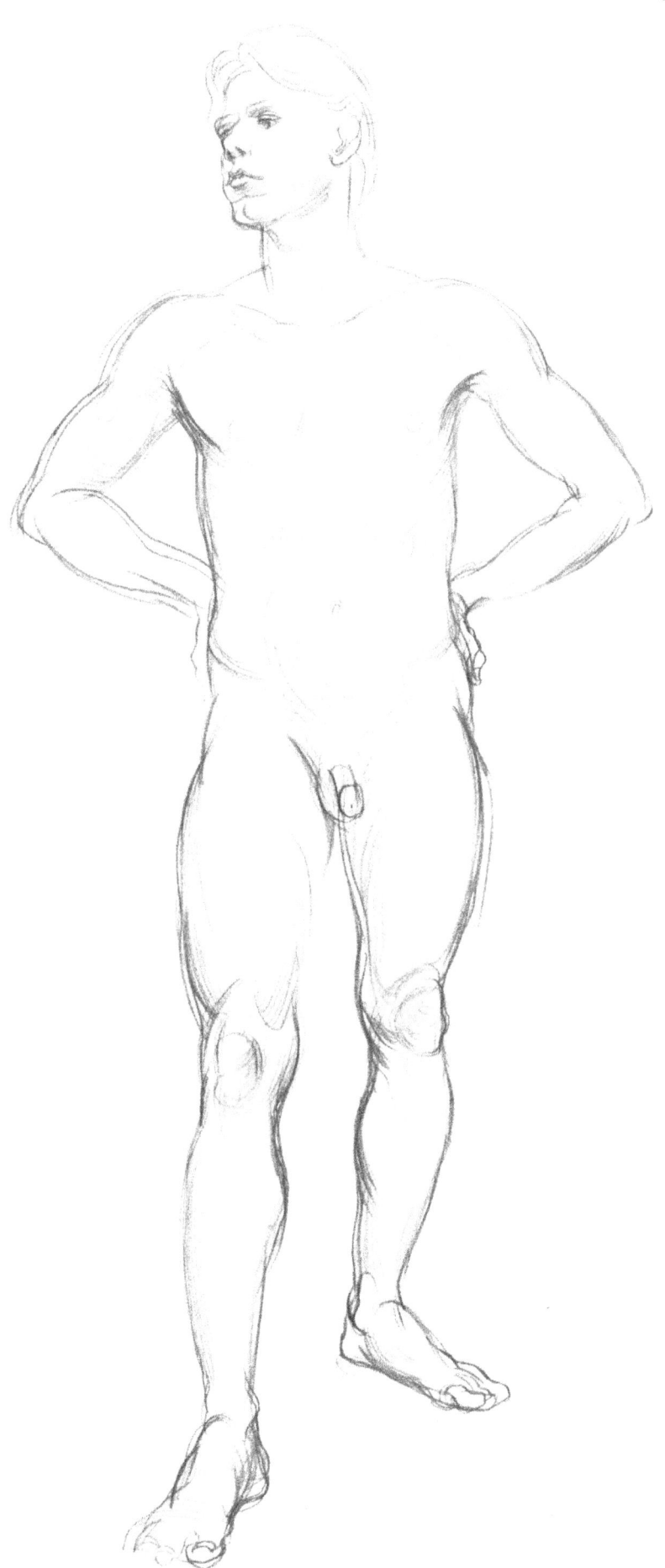

Roundness 2. John's drawing has all the qualities I have just described. His investigation of the forms interlocking in the stomach is complex and interesting, and I admire how much he suggests the expression of the head without really drawing all the features. Again, this drawing has the satisfaction of wholeness, roundness, and the resolution of the energy in the body.

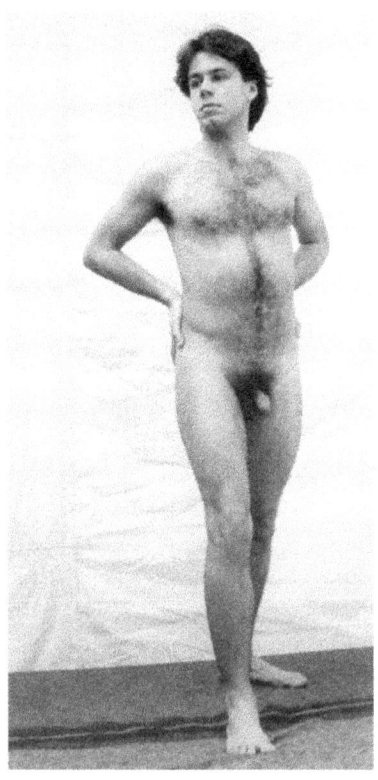

Drawing the Model

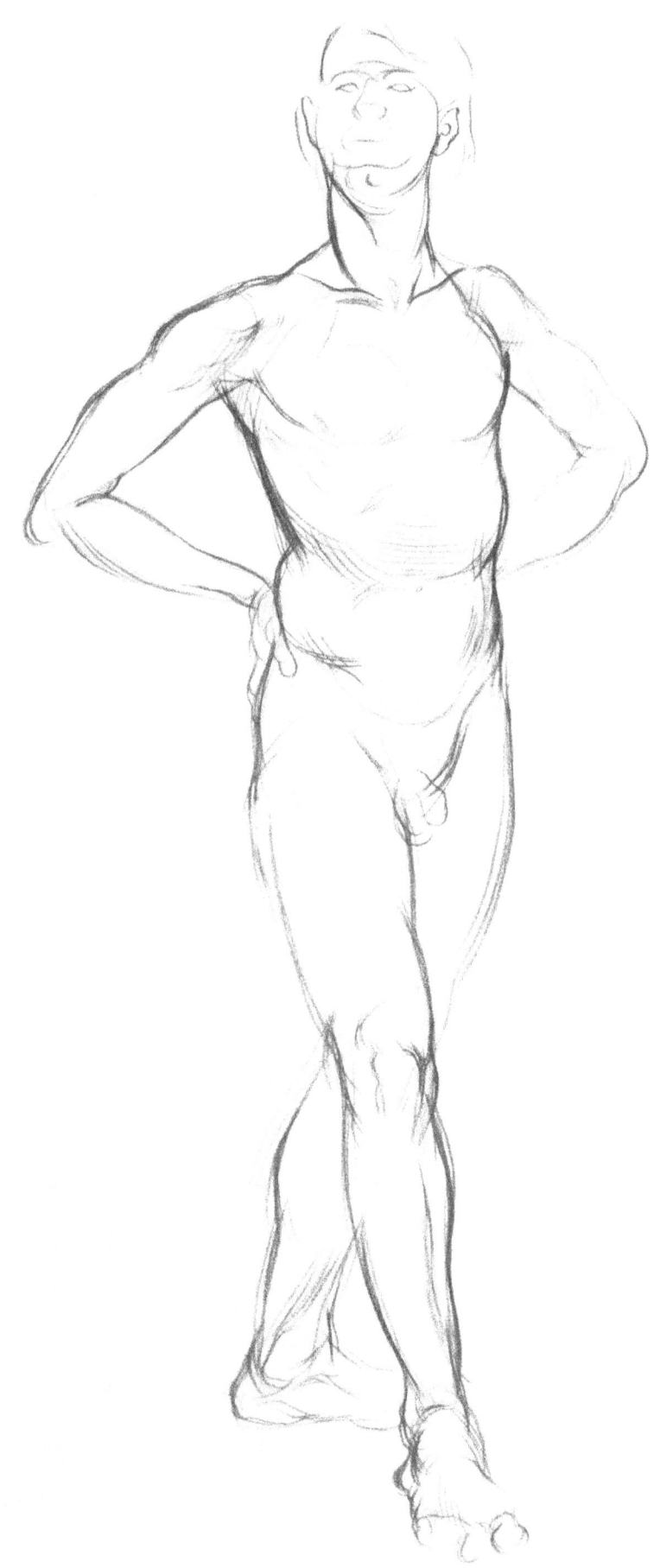

HIGH-FOCUS DRAWING

Roundness 3. In my drawing of this seated model, the sense of resolution comes mostly from the fact that he convincingly sits. One of the earliest lines I made in this drawing was of the stomach folding back into the upper abdomen, and I am struck now by what a major role that one line plays in suggesting his buttocks rolling back on the unseen stool. I have rather minimally suggested the roundness here, but since I was feeling it strongly, the implication of roundness is evident. My tonal working of the head and neck help to set up the illusion of roundness elsewhere, as does the meatiness in the drawing of the forward-pointing thigh. I wanted to show you a drawing that wasn't of such a sturdily built model in a standing pose to illustrate that roundness occurs as much from thinking about it as you draw as it does from forcefully emphasizing the forms. And the sense of resolution comes also from thinking about it: "This guy *will* sit in my drawing!" or "This woman *will* stand!" must be constantly part of the dialogue you have with yourself as you draw.

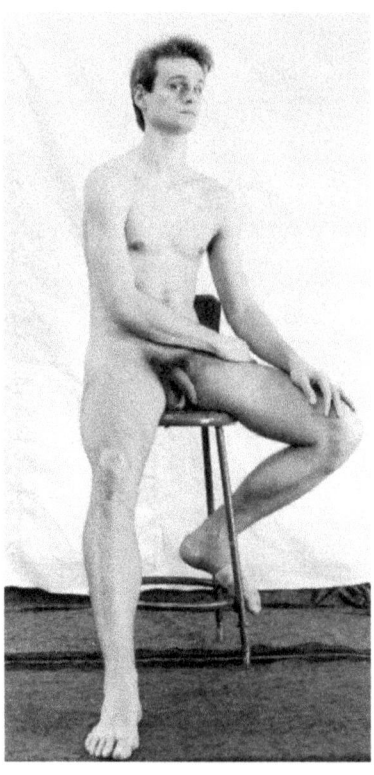

Drawing the Model

Roundness 4. John's back view of this model manages to suggest, with very few lines, the roundness of the torso and the solid fleshiness of the forms around the shoulders. I like the fact that the slight fleshiness of the face is emphasized, too, as a way of connecting it to the forms below. The model's right shoulder, arm and hand echo the emphasis in the right hip and leg and help to locate where most of the weight and stress in the pose is falling. This is a very successful evocation of forms that, while having a surface softness, nonetheless suggest the underlying strength of the muscles and bones.

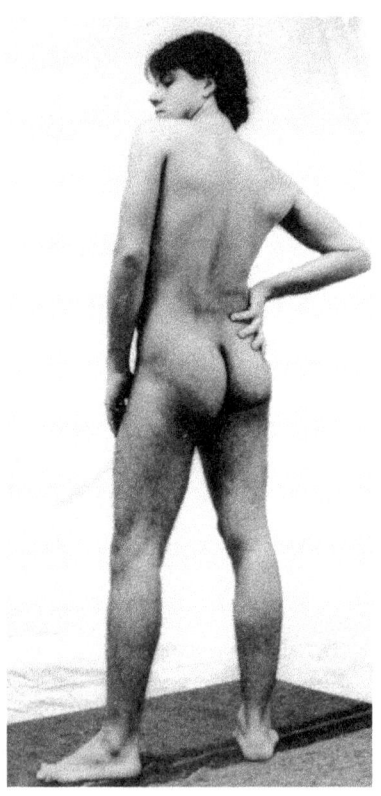

Drawing the Model

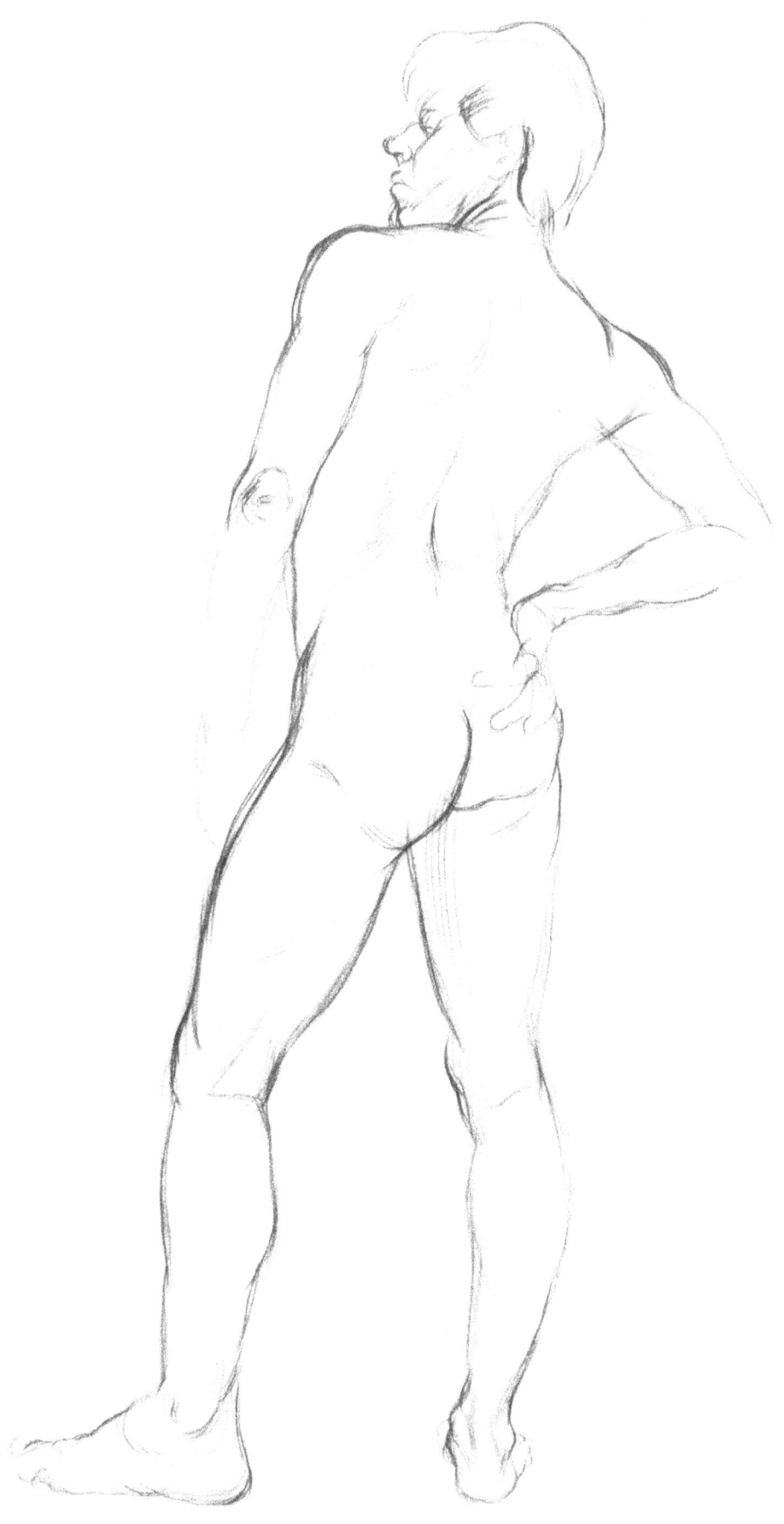

HIGH-FOCUS DRAWING

Roundness 5. John has certainly enjoyed the roundness of the model and the way that the curve of the torso locks satisfyingly into the hips. The model's right leg sits a little more convincingly in space than the left. But the overall impression here is of sturdy legs, rooted to the modeling stand. One of the nicest aspects in the drawing is the way the rhythmic shading under the near arm plays against the angle of the neck and the hidden head. In fact, all the shading in the torso seems particularly harmonious.

Some Things to Try in Achieving Roundness, Gravity, and Resolution:

1. Try to sense how big a part the area around the hips and abdomen play in resolving the balance of the pose.

2. Make your intersections stronger.

3. Think about the geometric form that underlies the complex form you are seeing.

4. Think about all the places where the body changes direction, like the thigh from the hip, or the foot from the ankle, and try to explain those changes as hinges or joints.

5. Think about the part of the torso that is nearest to you and emphasize that part in your drawings.

6. Pay particular attention to all the places where the body rests on the supporting surface—for example, the foot to the floor, the buttocks to the chair—and try to evoke as much pressure in those areas as you can.

7. Imagine how it would be to hold the model's pose yourself and where your own body might feel the strain first.

8. Ignore all these suggestions and simply respond in your drawing to the roundness and heaviness in your model.

CHAPTER 4

Student Progress

An inevitable question in your mind as you begin to use this book to guide you in your drawing sessions is "How quickly should I expect to improve?" As you have already ascertained, I'm sure, this book offers no quick fixes. What it encourages you to aim for is a high level of perception and hand coordination. For that reason don't expect a huge breakthrough in one or two sessions. Rather, accept the fact that the improvement will come in small, steady increments, with, I would guess, a big jump in insight or in hand skill occurring about the eighth or ninth three-hour session—that is, if you keep up the momentum by drawing from the model at least once a week. If you can draw still life objects as well, using the same high-focus principles (as described in the exercises in Chapter 2), it will also help you.

In order for you to get as much insight as possible from the series of student drawings included in this chapter, I will describe typical stages in student progress. When I first started teaching high-focus drawing at the School of Visual Arts in New York, I spent a lot of time in the early part of the semester convincing people to stop worrying about their "personal style" and to simplify their approach so that it became a way of thinking about the model and figuring out the pose. During the early days of the class I also had to deal much more than I do now with arguing against whatever method the student had previously learned, since what I was teaching usually was in conflict with these other methods. I knew that once they had experienced the naturalness and the clarity of high-focus drawing these other construct-the-figure-like-a-house or do-your-own-thing or turn-the-figure-upside-down methods would seem like children's games and not what an artist should be doing. Now that the classes have been going on for many years, most of my students come into the class having had it recommended by another student and they don't waste as much time with these kinds of arguments.

Since some readers of this book will have had considerable art class experience, this tension between high-focus principles and the methods of drawing they have already studied may create some difficulty at first. It is hard to let go of a way of drawing in which you have invested time and achieved some competence. Obviously, the personal decision to really let go of these previous approaches depends on being convinced by this book of the solidity of high-focus ideas. I hope that the text and the

meaning of the examples has given you sufficient reasons to trust the worth of this philosophy. The only other encouragement I can add is that whatever you can do now is not lost by practicing high-focus drawing—you can return to it whenever you want.

The first drawing in the series reflects the student's prior experience with drawing, usually with a class that stressed a particular kind of mark making, proportion as the main goal, or some concept, like shape, or fashion imposed on the drawing. These first drawings tend to be relatively self-conscious both in their style and in the idea that what is being made is a "line drawing"—line drawing in this context meaning that the lines should be consistent in pressure and texture and that they should limit their description to the forms in the body that have clear edges.

The next stage I have usually chosen in the progress is the first drawing where the student begins to have opinions and preferences in what he sees and to reflect those in the drawing. Usually the drawing will begin to be less even in its pressures and to be less complete-looking, reflecting that the student has been able to break away, at least partially, from applying a standard solution to the pose. This is a big step, since it involves trusting that it is possible to let go of the generalized figure he can draw, control, and complete, to try to draw the more complex figure in front of him. By the second drawing example also, the student usually has discovered rhythm and will be much more willing to make darker lines in the interior of the forms or at least to draw intersections more vigorously in order to emphasize the rhythm he sees.

In the subsequent drawings in the series the changes become more subtle. The student becomes more enthusiastic in his discoveries or his decisions, and his lines become more sensuous. There is both more confidence in the lines and more risk in the thinking—the student evokes subtler and more complex relationships in the forms of the body and there is a growing ability to see and to draw a specific human being. The student is also willing to make lines or series of lines that describe extremely subtle form relationships, and which don't relate exactly to the clear edges or shadows of the body. In other words, he is willing to use the drawing to describe his mental dialogue with himself about the figure and not simply its photographic reality.

As you will read in the captions for each drawing, different students have slightly different ways of reaching these steps on the ladder. In some cases the hand skills start out strongly and in other cases the hand skills have to catch up with the thinking. Notice, too, that although all of these students have reduced their drawings to similarly simple lines, the drawings, nevertheless, have a very personal and identifiable quality. It is as though in this simplicity we actually get to see the kind of opinions each artist has, and we certainly get to see the way each physical nervous system colors and distinguishes the marks the students make.

Seung's Progress

Seung progressed in an interesting way. He came into the class with very high-level skills—his lines were sensuous and evocative, his eye for proportions was excellent, his ability to tackle relatively complex interior forms was advanced, and he obviously loved to draw.

The one important thing I could help him with took a surprisingly long time to accomplish. Seung tended to impose a more robust, more muscular figure onto the figure he was actually looking at, and he tended to want his drawing to look finished and impressive. What this meant was that although the drawings always looked good on his pad and away from the model, they didn't look as good when you had the model to refer to. What I had to convince him to do was to get more from the idiosyncrasies of each model and to let the process of drawing become more of an exploration and less of a performance. His emphasis on always finishing the figure off meant that he went through the same steps in pretty much the same way to be sure that the drawing got finished or nearly finished. From my point of view there was too much repetition of a certain kind of leg, the same amount of rendering in the abdomen, and the same emphasis occurring overall.

Seung was always an industrious worker in my class, a student who wanted to improve his drawings, but it was hard for him to really let go of the skill that had brought him so far. He understood intellectually that he couldn't break through to a higher level of response to the model without giving up the heroic figure in his head, but it was emotionally hard to do. He finally did do it, however, thereby opening a door in his thinking that will make his art, all his art, more various and more truly interesting.

Student Progress

Seung 1. This drawing of a ¾ back view female shows Seung's preoccupations in drawing in the first few months in my class— delineation of details distributed fairly evenly through the figure, giving each part of the body a robust energy, and a priority on completing the perimeters of the drawing. I encouraged him to try to see which parts of the body were working hardest and to let the drawing develop following these hierarchies rather than as an evenhanded completion of each segment.

HIGH-FOCUS DRAWING

Seung 2. Seung's drawing of this male back still has most of the characteristics of the first drawing but with more animation in the pose. He has given the model's left leg the clear responsibility for supporting the body's weight. At this point in the class I kept the pressure on him to respond to the specific forms of each model and not to use "standard" muscles from his memory of anatomy books or the drawings of old masters.

Student Progress

Seung 3. In this drawing Seung successfully breaks the hold of his muscular preconceptions and draws a very specific man. The muscles in the leg, for instance, are longer and skinnier than the bulging formulaic muscles of the previous two drawings and in the head and the forms of the abdomen there is a strong sense of this being a real person.

HIGH-FOCUS DRAWING

Seung 4. Although this 4-minute drawing doesn't have the specificity of the previous 20-minute drawing, it does have a strong sense of the rhythms of the body working together to form the dynamic of the whole pose. Whereas Seung had depended previously only on his good eye for proportion to bring the pieces of the body together, you can see him here understanding how the stresses in the model's right leg set up the rhythms in the belly and the twist in the upper torso and head. Compare this drawing to number 2 in the series and you will see the difference between assembling the body depending mostly on the eye and as in this case responding to the underlying rhythms of everything working together.

Student Progress

Seung 5. In this drawing Seung continues to strengthen his responses to the rhythms in the body and to integrate muscular details, like the complex forms of the lower back, into the larger movements of the whole back. All the pieces seem to work in harmony, and the drawing is filled with a new absorption and delight in what the model presents to Seung.

HIGH-FOCUS DRAWING

Seung 6. These three quick drawings, done consecutively, show how strongly Seung responds to the beauty of the poses and how well he analyzes the significant forms and the way they play against one another. These drawings demonstrate that he has moved away from his previous approach—seeing the body as an arrangement of muscular details—and now uses intuition as well as his eye for proportions, to see the powerful forces that together create the pose. The next level of his progress will probably

entail achieving these rhythms through a more specific delineation of the forms. Seung in these last drawings is holding on to his strong reaction to the pose by drawing quickly and with a certain amount of generalization. With more experience he will be able to mentally "hang on to" these big ideas while he draws more slowly and with more subtlety. At this stage, he is a little leery of slow drawing and of too many details, because he feels he may slip back into his heroic, assemble-the-pieces mode.

HIGH-FOCUS DRAWING

Jayne's Progress

Jayne 1. One thing I notice in looking at Jayne's first example is an overall seriousness in the drawing and an ability to use intersections to suggest the dimensionality of the figure. These are two promising attributes to start with, for they signal that Jayne likes the animation of the figure and its roundness. At this stage the figure still seems a little rubbery because she doesn't have a strong enough idea about rhythm in the body to get the strength of the legs moving convincingly through the pelvic area and into the torso. But this is a very good start. And, along with her enthusiasm, she also exhibits good hand control. The limbs are sure and relatively voluptuous; they just need to be given more to do.

Student Progress

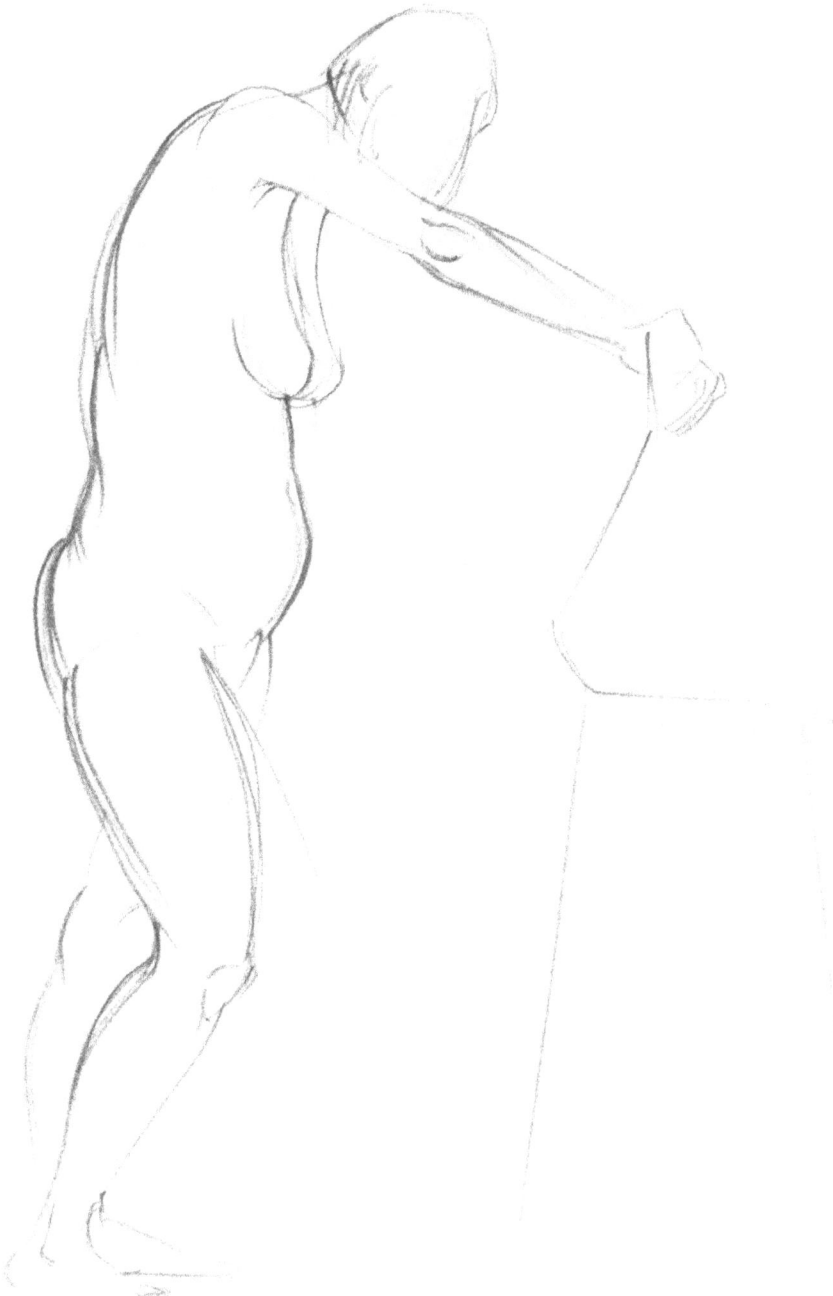

Jayne 2. At first glance this is a less interesting drawing than the first because it lacks some of the complexity in the delineation of the interior forms. Although it seems more generalized, this drawing, nevertheless, represents a step ahead for Jayne. Here for the first time, she sees the rhythm in the overlapping curves of the woman's back and how these curves play against the curve of the stomach. Jayne explores an idea about leaning, about hanging one's head, about resting on the left leg, which is her reward for seeing the large rhythms in the pose. In this drawing the strength does move convincingly through the legs and into the upper body. Her challenge now is to achieve this wholeness in the pose while also evoking the subtlety and specificity of her models.

HIGH-FOCUS DRAWING

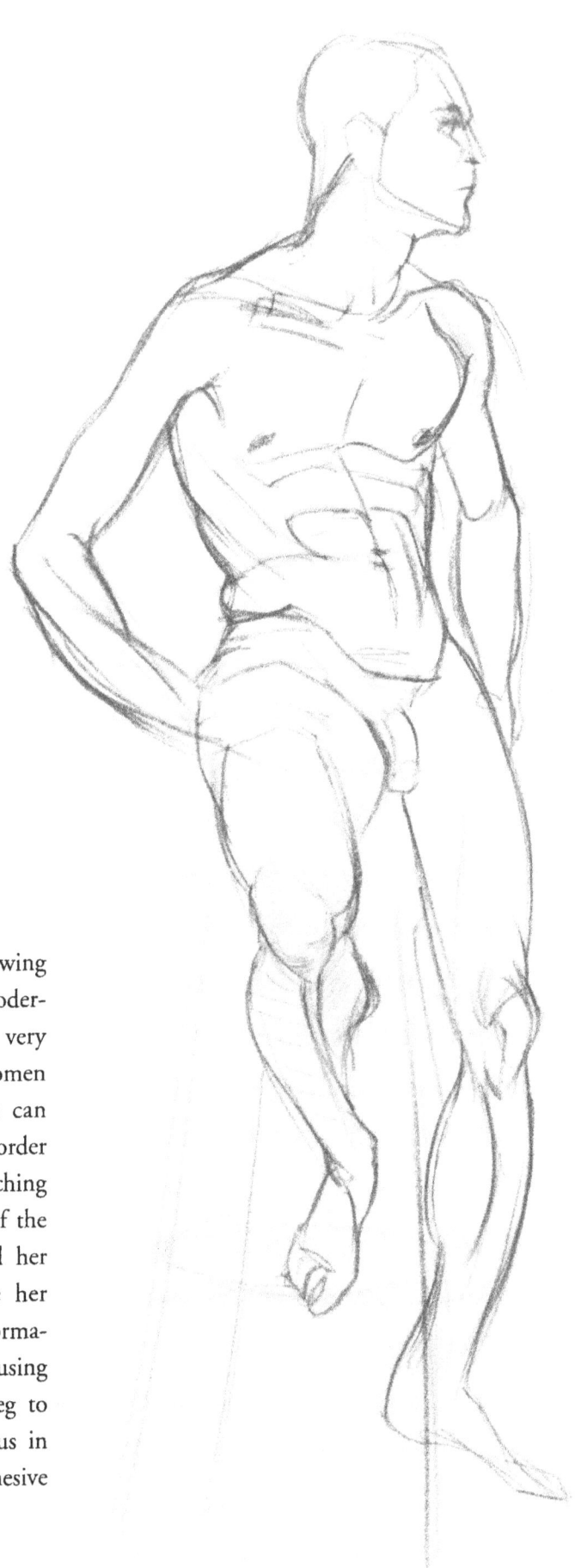

Jayne 3. In this drawing of a seated man, Jayne achieves moderately successful "sittingness," and a very successful sense of the man's abdomen folding back into the chest. We can really feel how the back curves in order to accommodate this slightly slouching posture. She has used the details of the stomach muscles very well to tell her story about the pose. We sense her enthusiasm for decoding this information as we sense her enthusiasm for using the details of the model's right leg to convince us of how it points at us in space. This is an intelligent and cohesive drawing.

Student Progress

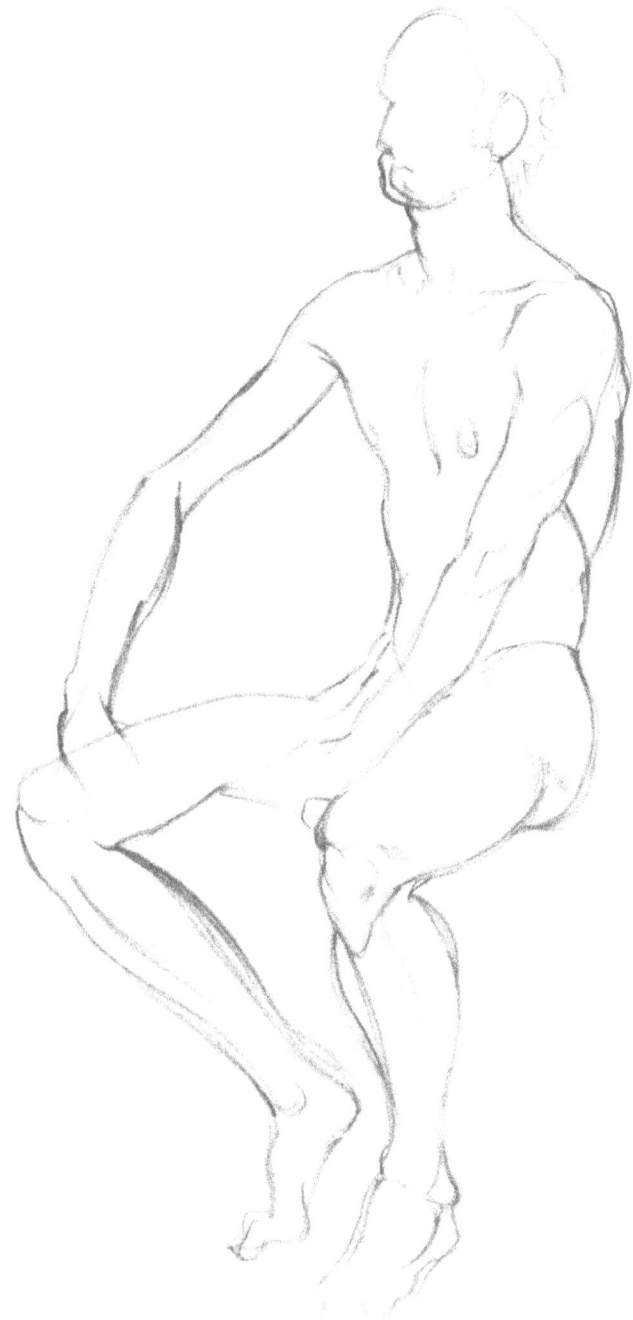

Jayne 4. In comparing this drawing to the last, I am moved to say "less is more." This one somehow manages to evoke more personality in the pose with fewer lines. Drawing number 3 seemed a little bit like a generic muscular man, while in this drawing, Jayne has been more affected by the model and more able to give us a record of a singular body moving in a particular way. There is a growing confidence in the drawing, particularly in the shoulders and arms and in Jayne's ability to suggest much about the set of the head and neck with relatively few lines. Jayne's future development will probably involve even more variety in her line-making skill and more attention to the role of small muscle groups in the larger action of the body.

HIGH-FOCUS DRAWING

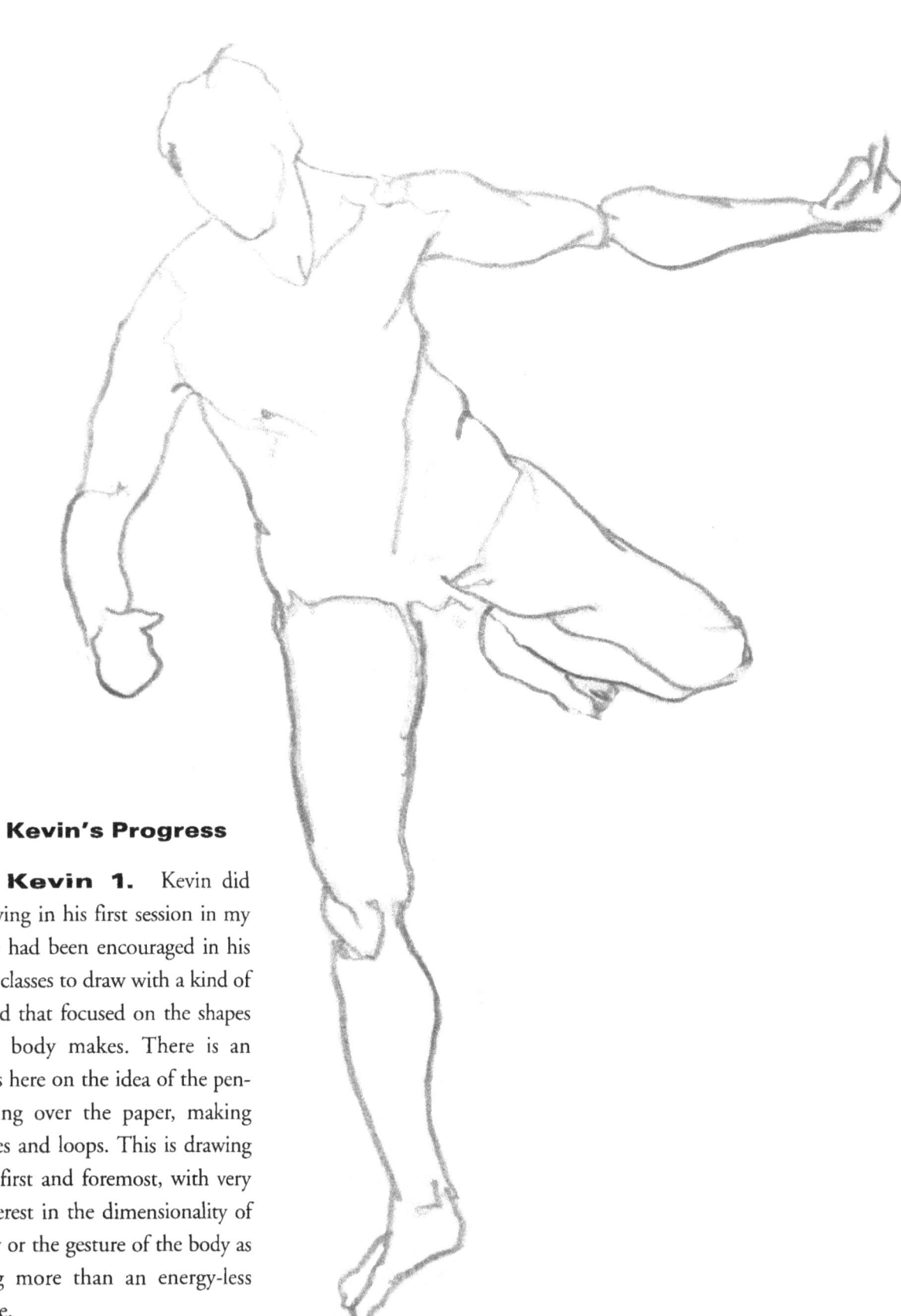

Kevin's Progress

Kevin 1. Kevin did this drawing in his first session in my class. He had been encouraged in his previous classes to draw with a kind of shorthand that focused on the shapes that the body makes. There is an emphasis here on the idea of the pencil flowing over the paper, making fluid lines and loops. This is drawing as style, first and foremost, with very little interest in the dimensionality of the body or the gesture of the body as anything more than an energy-less silhouette.

Kevin 2. Nine classes later Kevin is able to see that the energy in the body is not evenly distributed but creates certain visible areas of emphasis. In order to evoke this, he has learned to make curving lines that have the real tension of muscles operating to move the body. It is also apparent in this drawing that he is enjoying the rhythmic interplay between these lines, particularly the two long curves that describe the side of the torso and the belly and their relationship to the strong thrust of the hip. The slight turn-in of the feet also helps the gesture suggest the twisting effort of the top of the body, even though we can't see one arm, the shoulders, and the head. It would be easy to believe that this is a drawing of someone about to hurl a shot.

HIGH-FOCUS DRAWING

Kevin 3. Kevin is able now to see the rhythms while at the same time giving more details about the body. He has managed to give this simple standing pose some oomph in the protrusion of the belly and to suggest the rhythmic relationship between the buttocks, the abdomen, and the shoulders. The drawing has a good sense of developing as Kevin thought about the pose and, in fact, changing and adapting as he understood more and more. His next level of achievement will be to bring greater specificity to his drawings and to move beyond the slightly offhand and scribbled quality of some of the lines.

Student Progress

Brian's Progress

Brian 1. This drawing was done early in Brian's first semester. He has accepted the idea of rhythm and of trying to see the pose in terms of large forces. At this point his success in seeing rhythm is intermittent. The thrust of the shoulder and arm and their interesting relationship to the dipping, turning position of the head is coming through to him, as is, to some extent, the stretched-out arc of the rib cage. In the legs, however, he confused the roundness of the forms in the calves with their rhythm, which exists in a more complex way. There is, nonetheless, an enthusiasm for rhythm that you can see in this drawing, which will pay off once Brian accepts that rhythm reveals itself in a less generalized, schematic way.

HIGH-FOCUS DRAWING

Brian 2. Already this drawing is showing a more complex reaction to the idea of stressed moments in the pose. The drawing is fairly evocative of the strength in the pose even though the lines are still too similar to one another and done in too much of a hurry. What I see in this drawing is a student whose mental understanding has leapt ahead of his line-making skills and whose hands are rushing to catch up with his head.

Student Progress

Brian 3. The lines have calmed down somewhat in this drawing and exhibit more range in their pressure. Notice the lighter, gentler lines over the hip and those describing the muscles of the back. Also there is more sense here of the drawing bringing the forces together so that the lines of the back and buttocks seem more in sympathy with the abdomen, breasts, and shoulders.

HIGH-FOCUS DRAWING

Brian 4. Now Brian's hand skills are catching up with his enthusiasm for the energy of the poses. He has made remarkable progress in this drawing in being able to describe subtle modulations like the ones in the muscles around the hip, buttocks, and knees. The lines seem much more sensuous and under his control.

Brian 5. This study of a man shows great sensitivity. There is no stressing of the idea of rhythm any longer—it simply exists in the harmony of the parts of the body. Brian has opened himself up to his subject so that some unifying spirit seems to connect the nature of the feet to the legs, the legs to the buttocks, the buttocks to the back.

HIGH-FOCUS DRAWING

Alex's Progress

Alex 1. In this early drawing Alex seems to be attacking the figure. The vigor of his lines is too impetuous and rushed to allow a calmer contemplation of how the parts of the pose interact together. It looks as though he is lead in his choices primarily by what is most shadowed so that there is an overall sense of disconnection between the areas that he emphasizes. For instance, because the vertebra in the center of the back emerges so suddenly as a little patch of detail they do not suggest the rest of the spinal column implicitly extending from the head to the top of the buttocks. There is an air of impatience or even bravado that probably covers his confusion at this stage of the game. His eye for proportions is pretty good and there is hope in his variety of line that in the future his drawings will make better use of this graphic diversity.

Student Progress

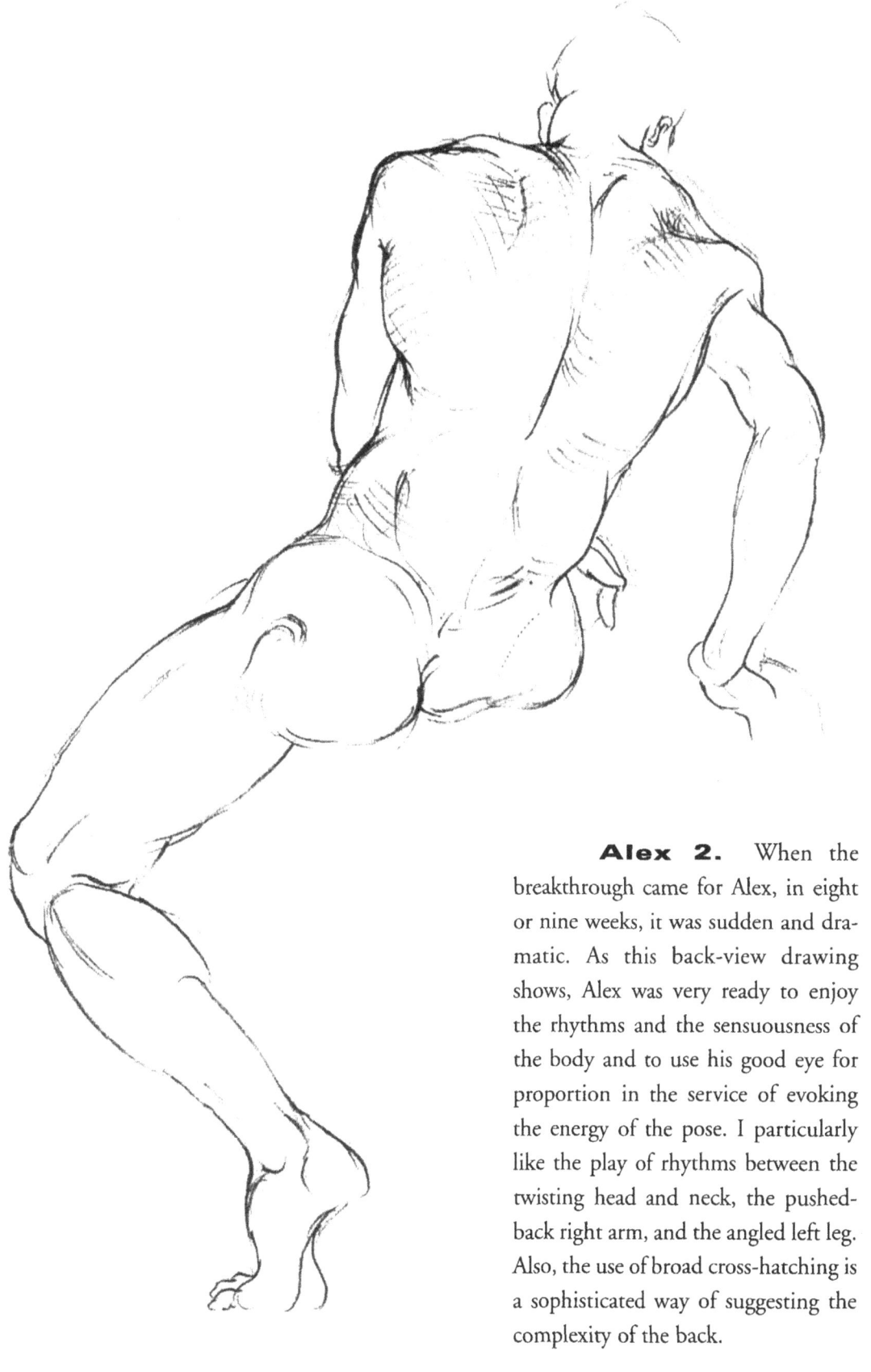

Alex 2. When the breakthrough came for Alex, in eight or nine weeks, it was sudden and dramatic. As this back-view drawing shows, Alex was very ready to enjoy the rhythms and the sensuousness of the body and to use his good eye for proportion in the service of evoking the energy of the pose. I particularly like the play of rhythms between the twisting head and neck, the pushed-back right arm, and the angled left leg. Also, the use of broad cross-hatching is a sophisticated way of suggesting the complexity of the back.

HIGH-FOCUS DRAWING

Alex 3. The kind of cross-hatching we saw in the last drawing has more variety in this drawing and suggests a wider range of forms, muscle tensions and three dimensionality. There are more false starts and second guesses here, all of which imply that Alex has really accepted drawing as a process of exploration. Given that most of the head, the arms, and the bottom of the right leg are missing, this drawing, nevertheless, has a surprising sense of a complete figure. The almost odd lines Alex draws behind the left knee don't really seem to be in response to a tonal change he sees in that area, but rather an evocative way he found to notate the pressure he recognized operating in the locked back leg.

Student Progress

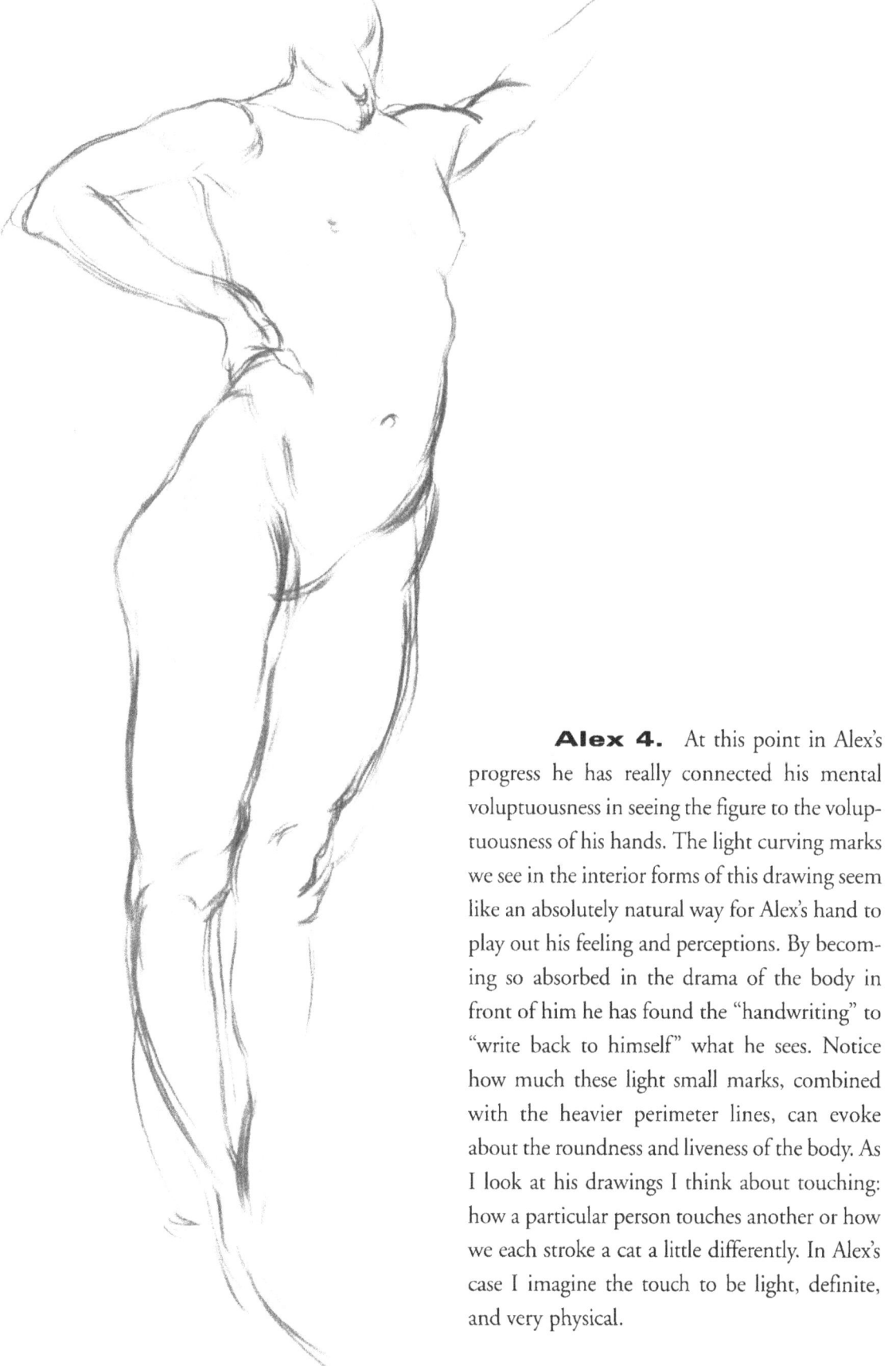

Alex 4. At this point in Alex's progress he has really connected his mental voluptuousness in seeing the figure to the voluptuousness of his hands. The light curving marks we see in the interior forms of this drawing seem like an absolutely natural way for Alex's hand to play out his feeling and perceptions. By becoming so absorbed in the drama of the body in front of him he has found the "handwriting" to "write back to himself" what he sees. Notice how much these light small marks, combined with the heavier perimeter lines, can evoke about the roundness and liveness of the body. As I look at his drawings I think about touching: how a particular person touches another or how we each stroke a cat a little differently. In Alex's case I imagine the touch to be light, definite, and very physical.

HIGH-FOCUS DRAWING

Alex 5. Because this drawing was done in four minutes it doesn't have the same kind of voluptuousness as the two previous 20-minute drawings, but in its confidence and expressiveness it exemplifies another stage in Alex's progress. Alex reacts so strongly to the pose and to the elements which make it work, that he can use a kind of shorthand that would have been chaotic if he had tried it at an earlier time of his development. Compare the scribbly, yet evocative lines under the right thigh with the lines he used in drawing the left thigh of the first example. In the earlier drawing, although the lines suggest shadow, they don't seem to have any special imperative, whereas in this drawing the lines contribute to the leg moving forward and to overall urgency about the whole pose. In this drawing it is as though we can see Alex thinking.

Student Progress

Alex 6. As the culmination in this series of Alex's drawings I have chosen this male reclining figure because, along with showing his skill, this drawing shows how Alex has achieved an extraordinary spirit inspired by the model. He has not only reacted to the forms for their anatomical sense and their liveliness but also for an almost abstract surging rhythm. The left leg, which is not simply raised but "elevated," has a curious sympathy and interplay with the heaving abdomen. This shows a restless kind of reclining, and is very convincing. Whether it is entirely "realistic" in terms of what the model was doing is finally beside the point: Alex was impelled to this degree of fervor in the drawing by the specific body in front of him.

HIGH-FOCUS DRAWING

John's Progress

John 1. Despite the awkwardness of the drawing John made when he first came into class, there is a certain fluidity in the lines of the arms and an obvious interest in getting something about the pose, maybe the tense way the model supports herself with her arm.

Student Progress

John 2. There is more sense of the body holding together here than there was in the first drawing of the series, and John is beginning to explore the meaning of the intersections in a more interesting way. I suspect that the slightly geometric feeling of the curves was John's first response to what I was saying in class about rhythm. Like many students in the first stages, he wants rhythm to be more like a system than it actually is. Nevertheless, considering the eventual outcome, this stage served its purpose.

HIGH-FOCUS DRAWING

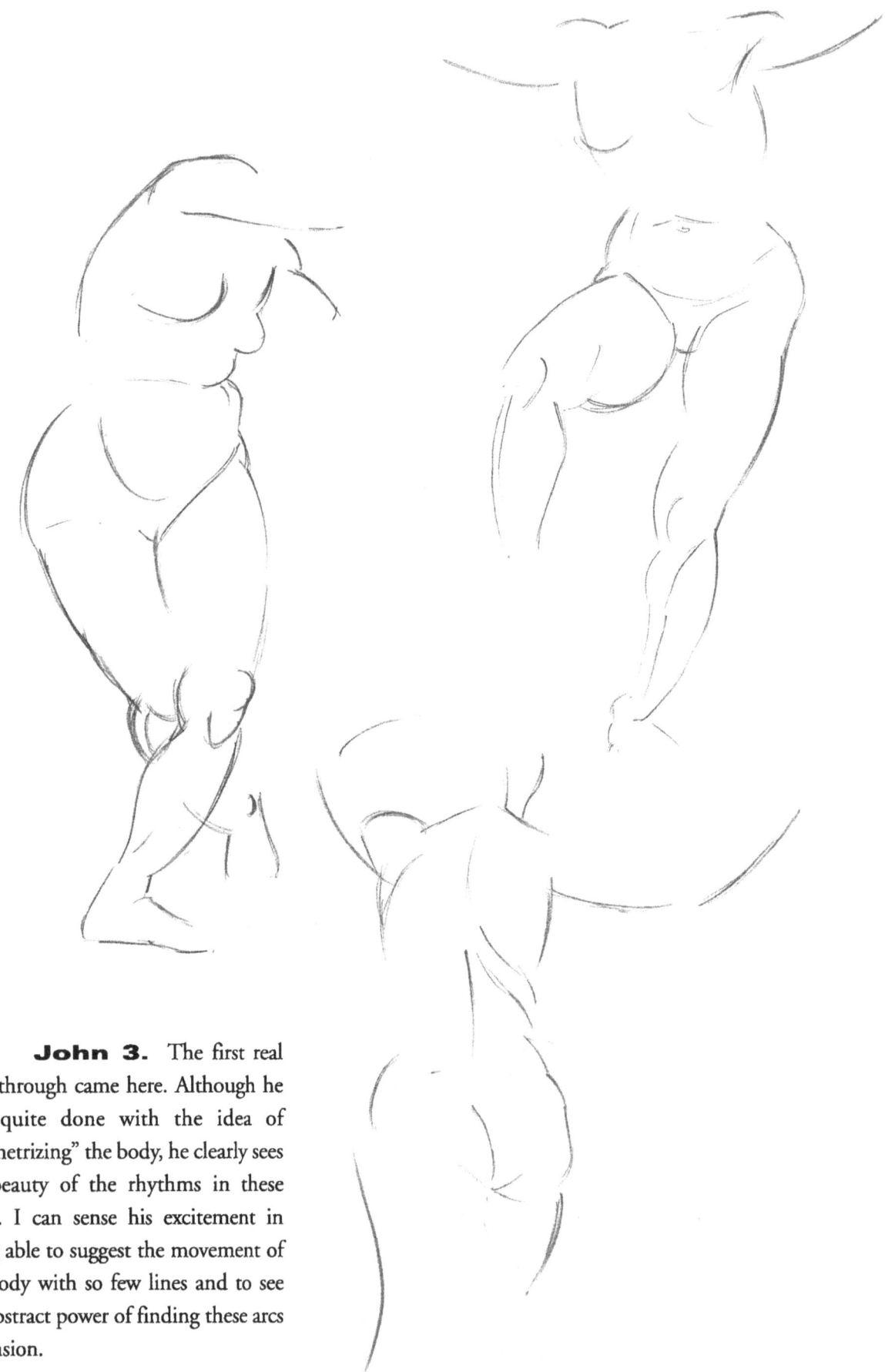

John 3. The first real breakthrough came here. Although he isn't quite done with the idea of "geometrizing" the body, he clearly sees the beauty of the rhythms in these poses. I can sense his excitement in being able to suggest the movement of the body with so few lines and to see the abstract power of finding these arcs of tension.

Student Progress

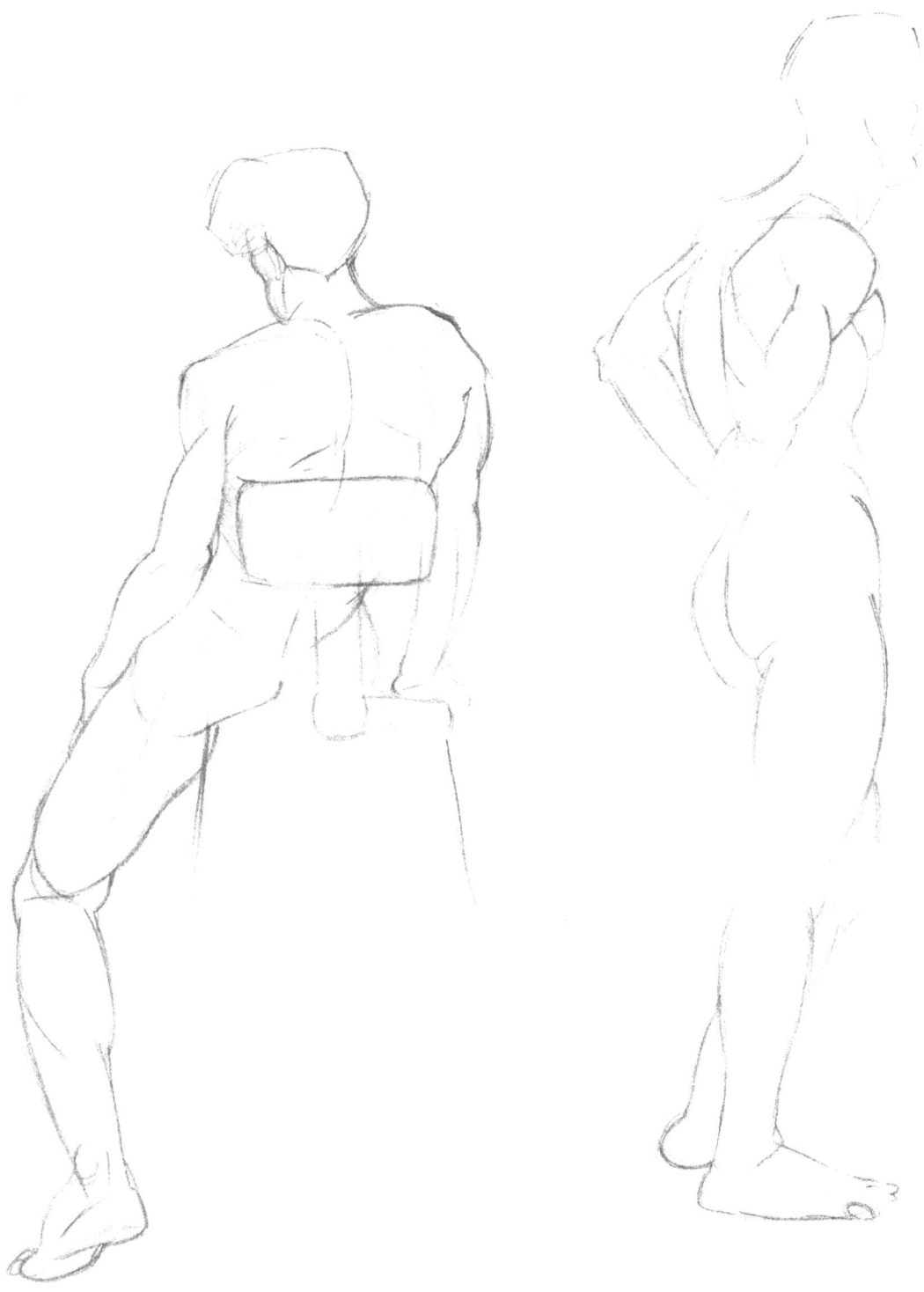

John 4. In these two drawings John is beginning to bring together the idea of rhythm and the solidity of the forms. He can already see that the specific shapes in the body can convey the large forces of energy—even if, in these examples, the forms still feel a little angular and theoretical.

HIGH-FOCUS DRAWING

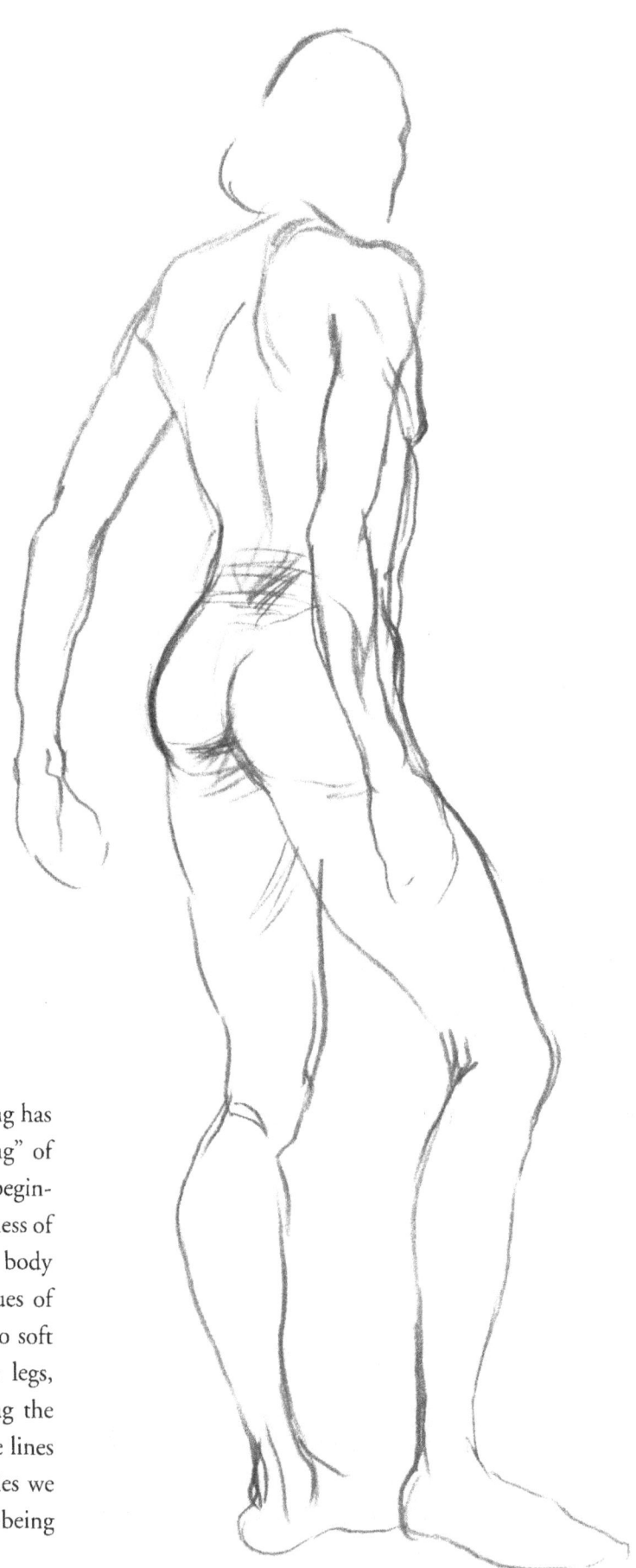

John 5. This drawing has lost the self-conscious "geometrizing" of the previous figures, and John is beginning to trust the inherent sensuousness of mimicking the actual edges of the body while thinking about the large issues of the pose. The drawing is a little too soft and uncertain, particularly in the legs, but for the first time we are seeing the quality of his nervous system in the lines he produces. In the rest of the series we are going to see the same soft line being used to greater and greater effect.

Student Progress

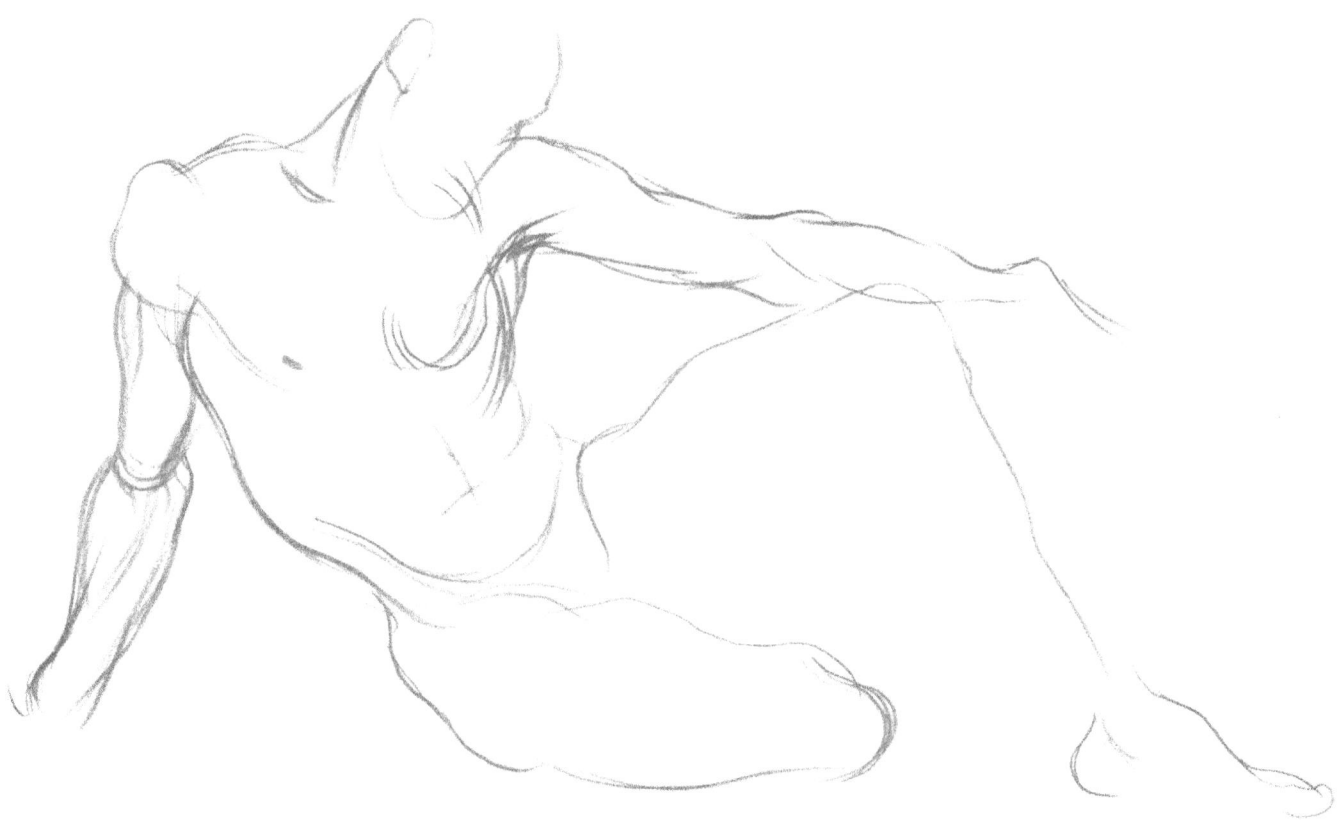

John 6. Suddenly, it seems, John is taking charge of his drawings. The lines become a clear voice with which he describes what he sees and thinks about the pose. We no longer have to guess what he had in mind—here we see that he has chosen the pressure in the arm as a main issue in the pose and that many of the other details play off the arm's importance. Because so much of John's own sensuousness has been released in the way he makes the lines, the drawing really feels like muscle and flesh.

HIGH-FOCUS DRAWING

John 7. To the authority of the last drawing John now adds a wider range of line pressure. You feel him really beginning to exult in the power of simple pencil lines to convey complex forms and energy. This drawing is fueled more than ever by his pleasure in opening up to the singularity of the model. As I look at the forms around the waist or the relationship of the breasts to the upraised arms, I can almost hear John exclaiming, "Isn't she fantastic!"

Student Progress

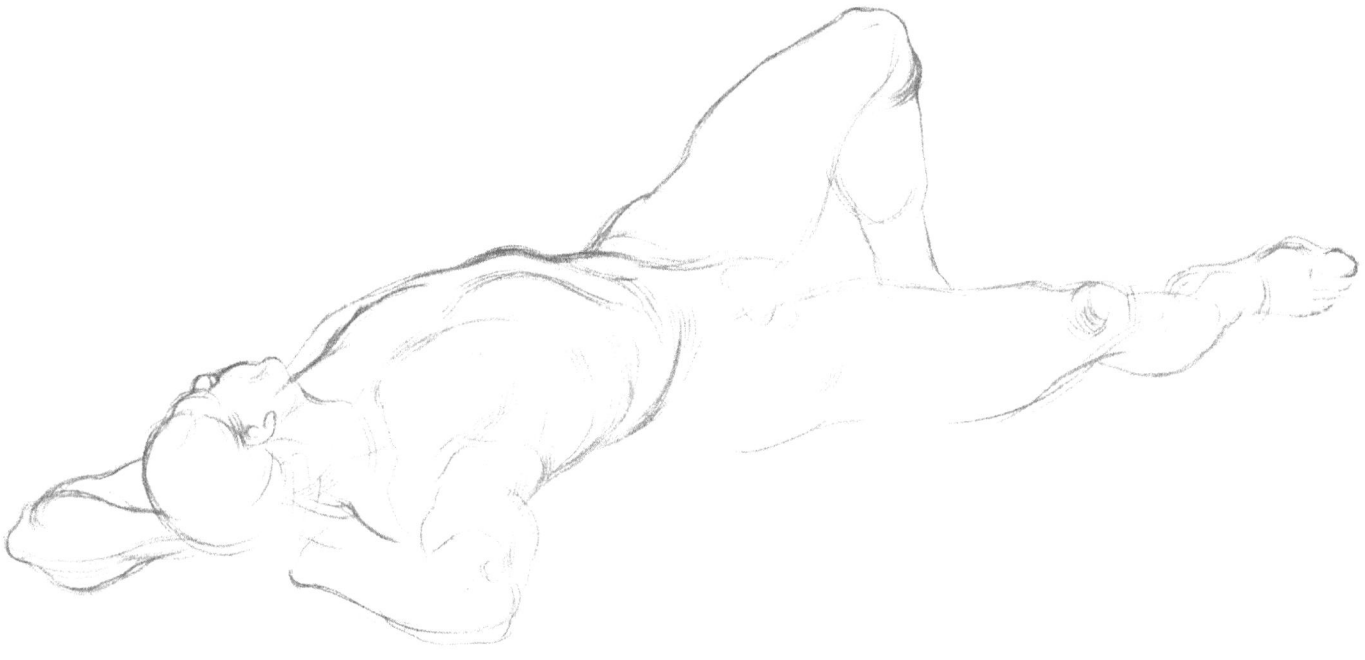

John 8. Out of many drawings that John has made in this recent stage of his development I have chosen this one because of its subtlety and the way it captures the coherence of the whole body. These kinds of stretched-out reclining poses are difficult to do, since the body in the drawing often tends to float rather than lie against the floor, and it is a measure of John's skill that in his drawing the model lies heavily against the floor.

HIGH-FOCUS DRAWING

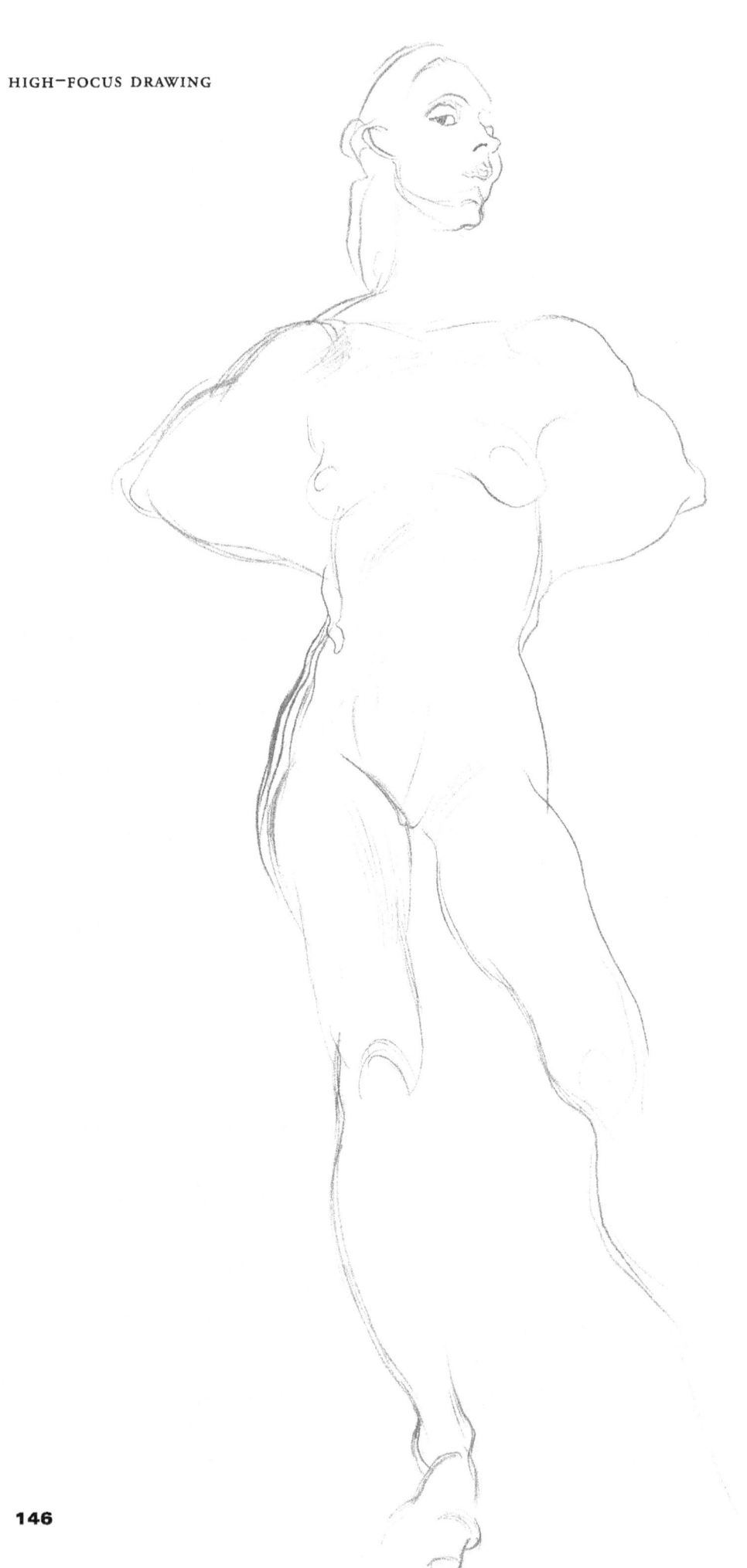

146

CHAPTER 5

Enjoy Yourself

In this final section, I have included some of my drawings and some of my students' because I think they especially express the pleasure of responding wholeheartedly to the personalities of the models and the spirits of their poses. They are mostly drawings done in 5 minutes or less, and although they are very "released" in spirit, they still feel focused. The attributes of rhythm or roundness or gravity no longer exist in these drawings as separate principles but have simply become absorbed in the artists' overall enjoyment of evoking the model.

In some of the drawings, a quirky detail, such as the knotted muscles of the stomach or the direction of the model's gaze, becomes an intuitive key for the artist—something that clicked as being central to the character of what the model was doing. I think these drawings demonstrate the enormous role intuitive reactions play in the way an artist makes sense of what he is observing.

I hope that in your own journey in drawing you will reach the point where playfulness and wit will heighten your response to the model. I think good drawing is always essentially sympathetic to its subjects, but that should not rule out using your sense of humor or irony or any of the other slightly oblique senses that you employ to temper your own human condition.

If wit takes you off dead center in viewing your subjects, it may be one of several things that helps you decide where you want to go in relation to observational drawing. You may want to proceed in the same direction, finding deeper and deeper levels of emotional response to your subjects, as Lucien Freud has done. You may decide to concentrate on drawing and painting one person by finding your own Helga. You may transfer your curiosity from people to bottles, as Morandi did. Your mischievous self may come to the fore to demand that you do nothing but caricature. You may follow the geometric implications of rhythm by becoming another Fernand Leger.

Now that you have found a higher level of focus in drawing and disciplined your hand reflexes to echo the way you see and experience your subjects, you will probably find you can put your reflexive drawing movements on a longer leash. At this point, "letting go" a little bit in your attack on a drawing will have more intelligence to

HIGH-FOCUS DRAWING

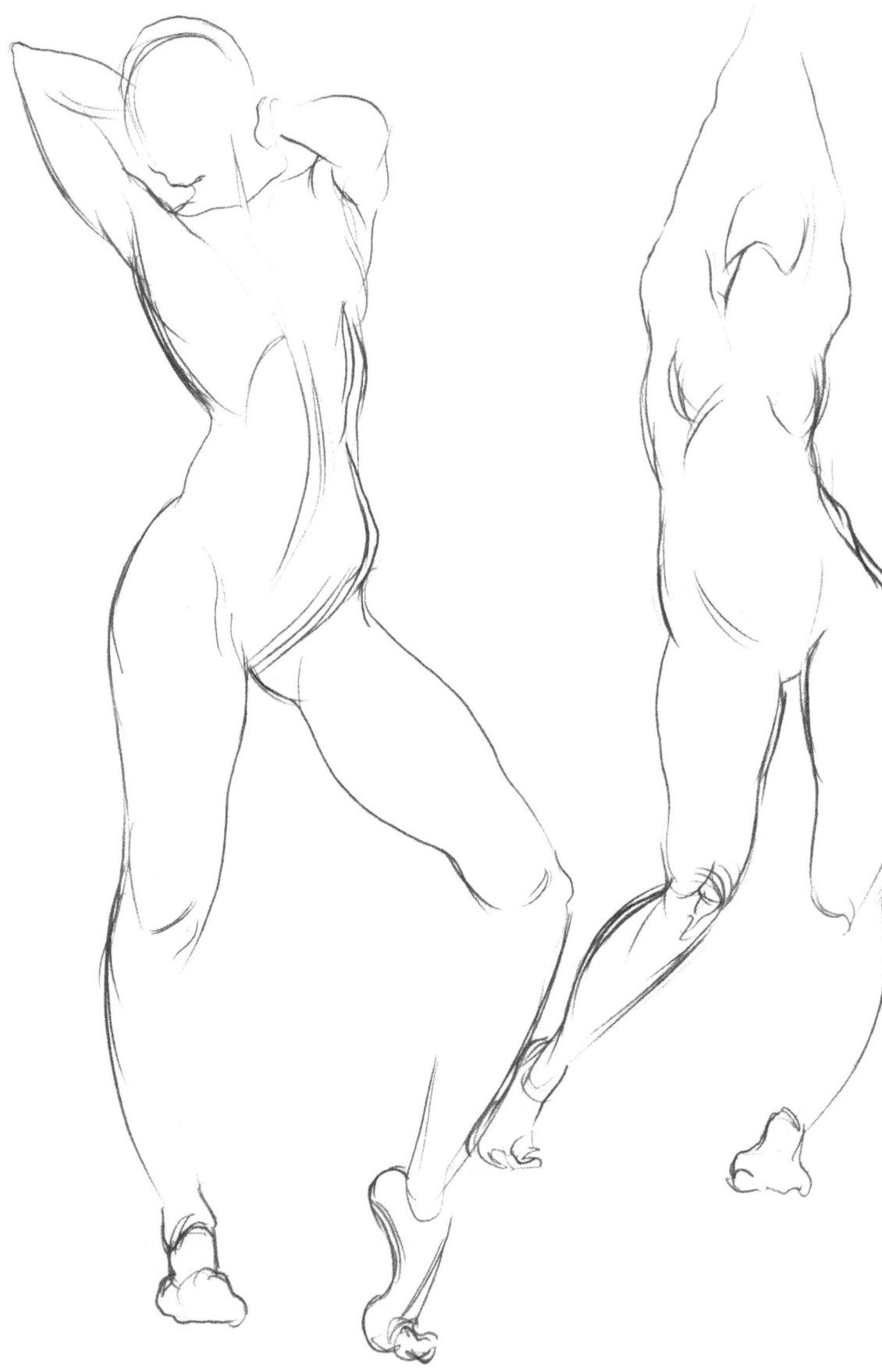

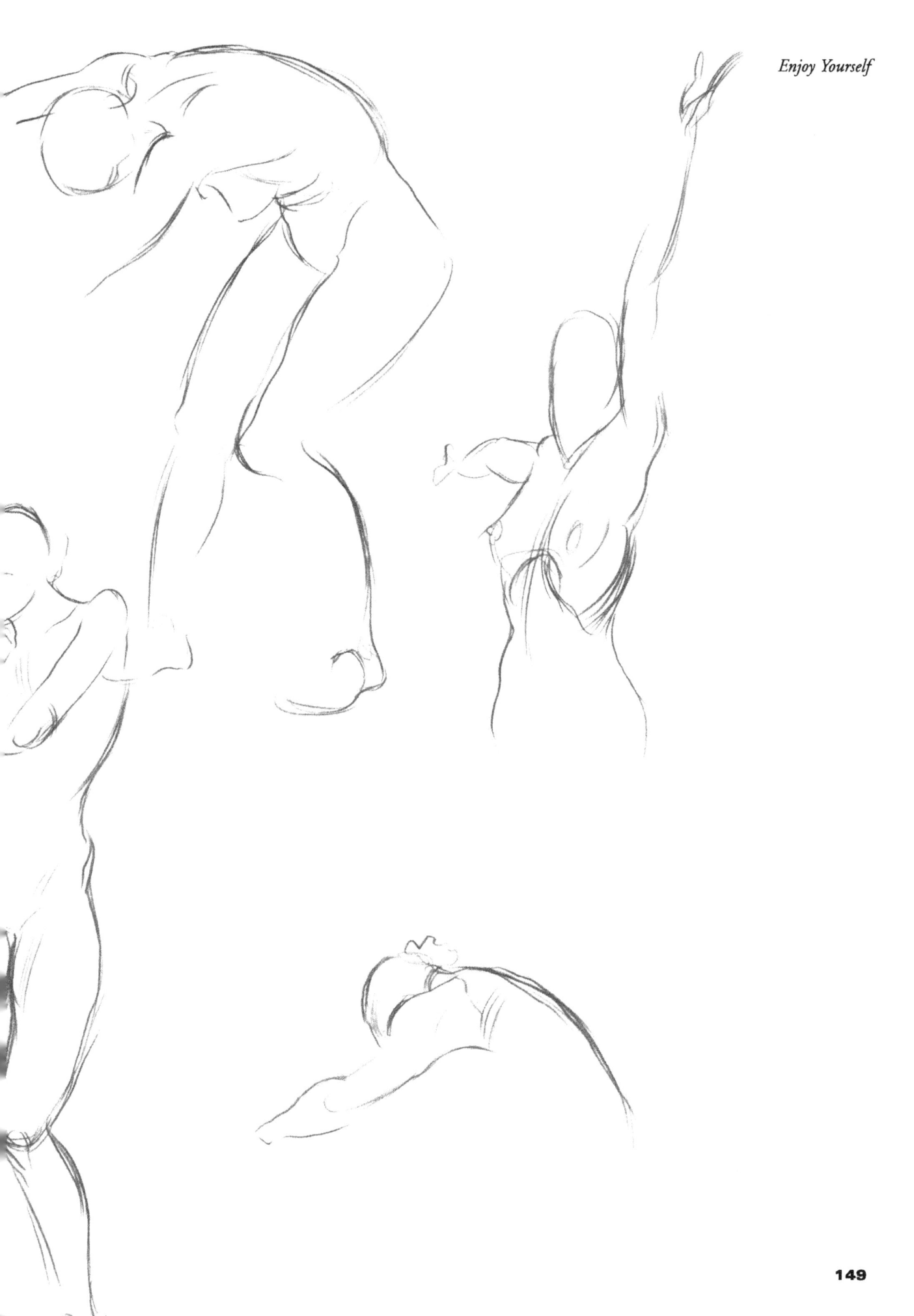

Enjoy Yourself

it, as though the hand itself retains the memory of complex forms and can simplify coherently. What has actually happened in this situation is that once you have trained yourself to think as you draw, you can't completely turn it off, and even when you draw faster than your mind can seemingly comprehend, you are now able to make extremely rapid subliminal decisions.

Also, when you turn to drawing the model for longer periods of time (by having the model assume the same pose after each rest period), you will find that your experience in deciding where to start the drawing and how to think about the pose in hierarchial terms will guide you in developing more tonal richness. The problem that many artists face when they spend a long time with one drawing is that they forget what their first impressions were or where the main emphasis of the drawing should be— they start to render each part as they come to it, and eventually the drawing goes dead. Using the same principles of drawing as in the shorter poses described in this book, you can avoid the problem of rendering by always seeing each new piece of information you add as playing a part in the drama of the whole pose. Whether you spend twenty minutes or four hours on a pose, it should feel, as you draw, that you can't wait to say more about the push or pull, or heaviness or delicacy or outstretched quality, that you noticed in your model's body in the first few seconds.

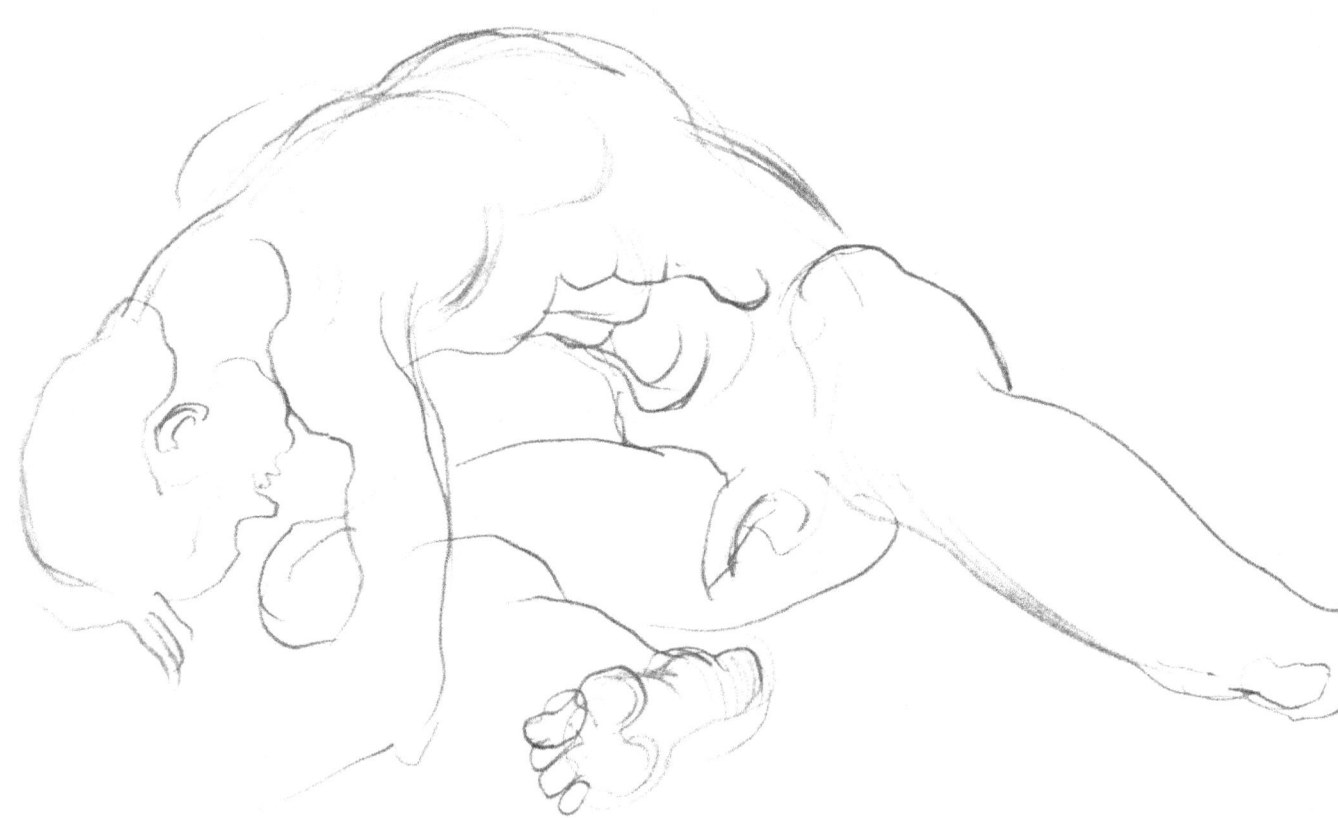

Enjoy Yourself

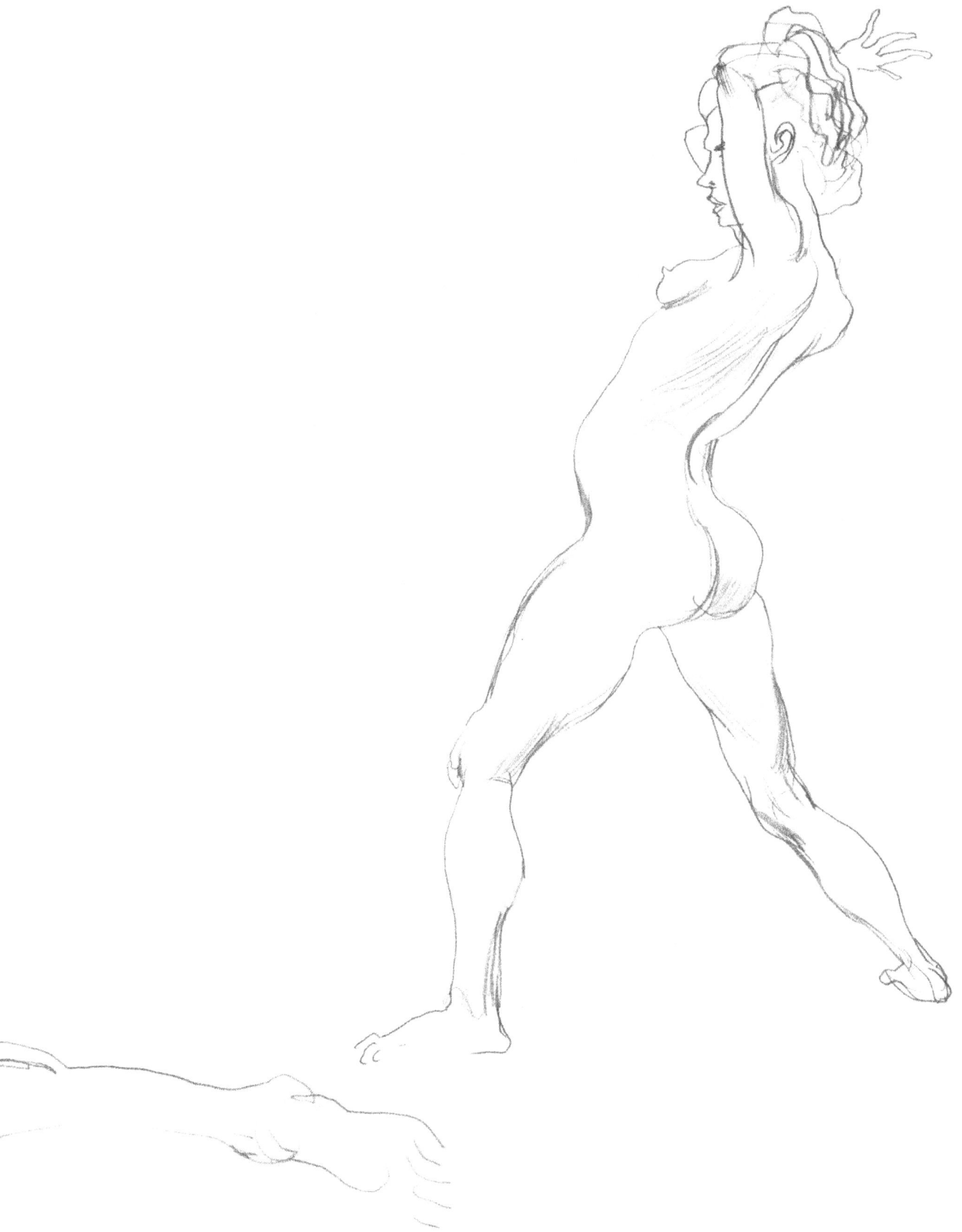

HIGH-FOCUS DRAWING

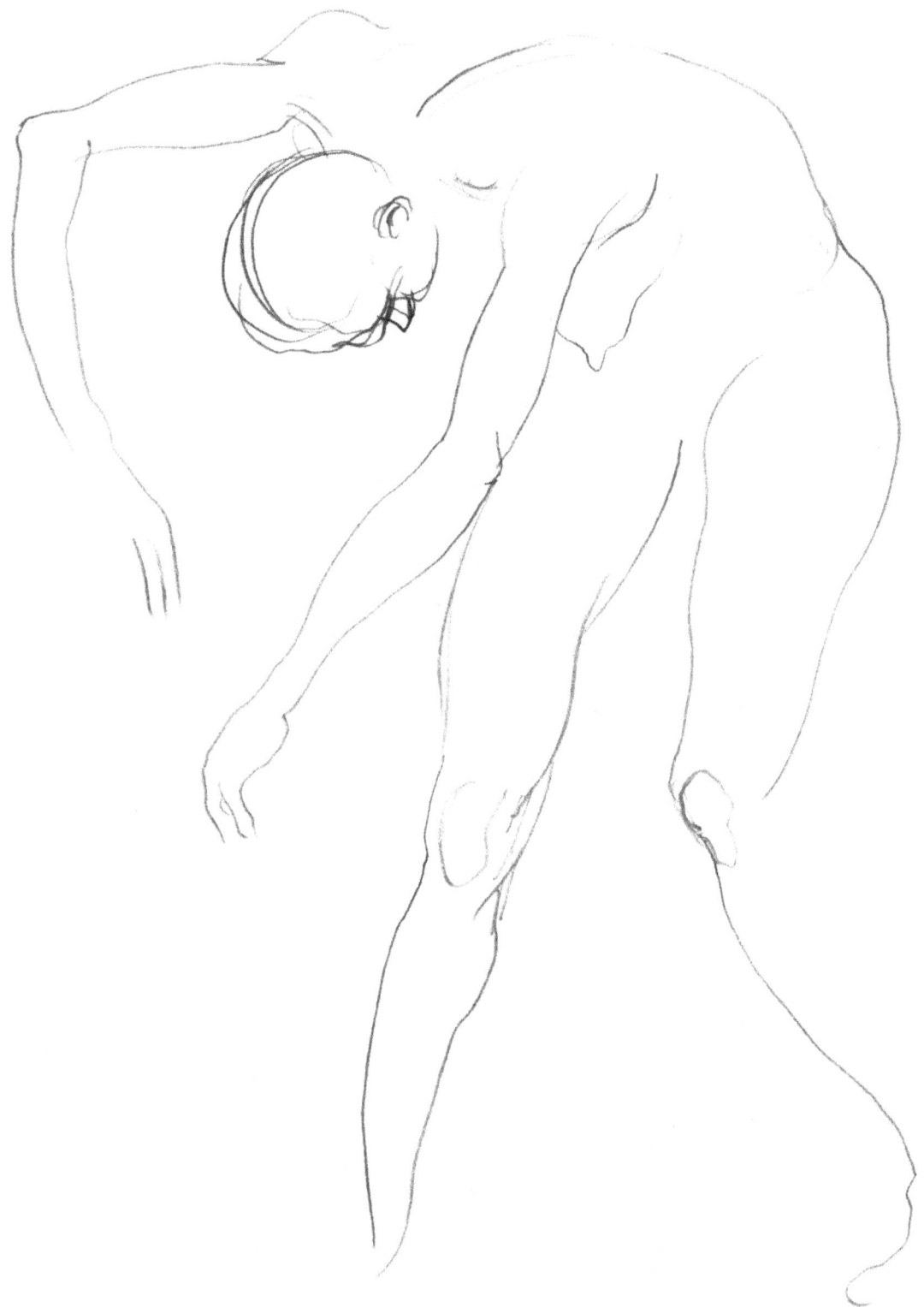

Enjoy Yourself

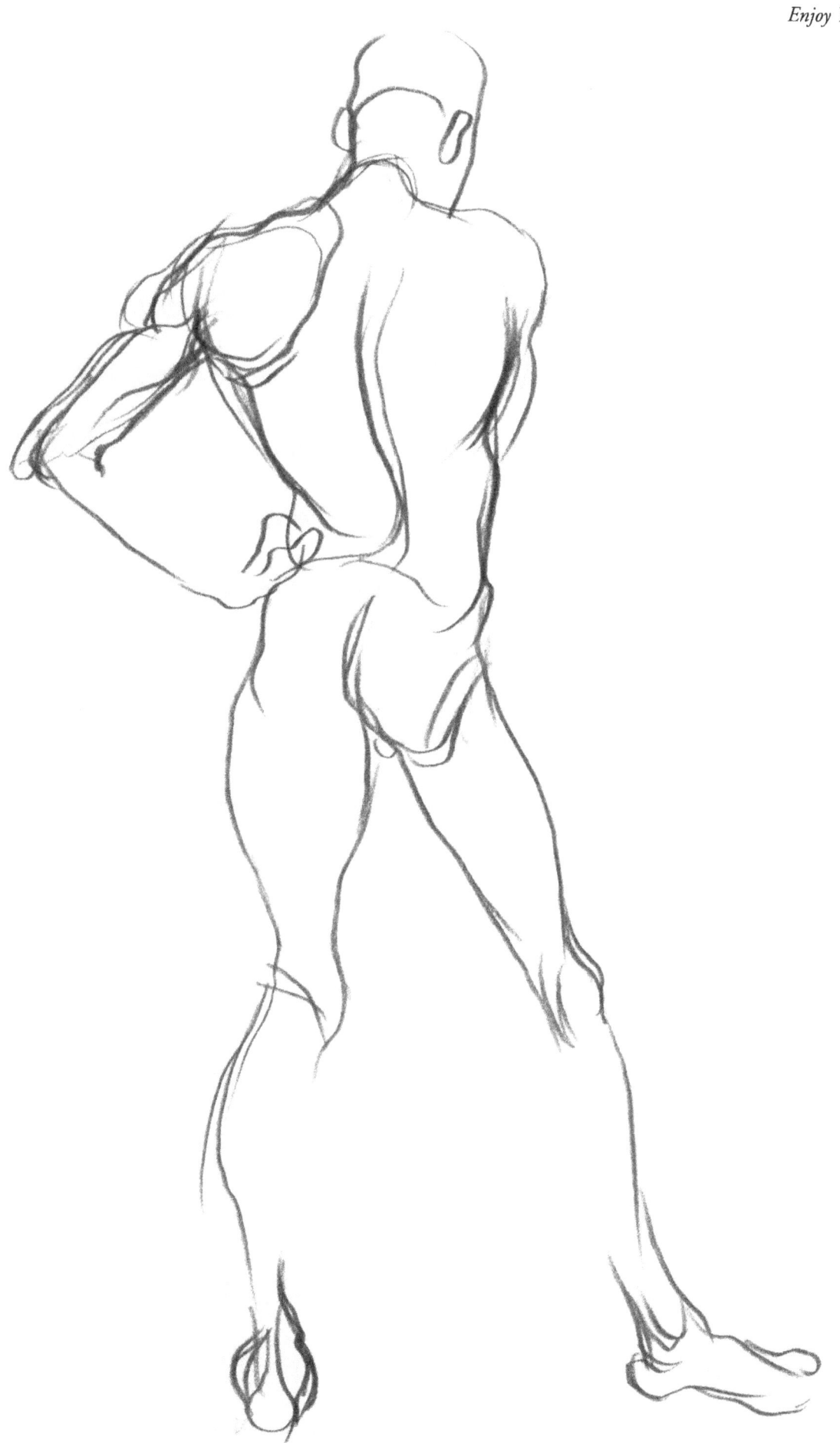

HIGH-FOCUS DRAWING

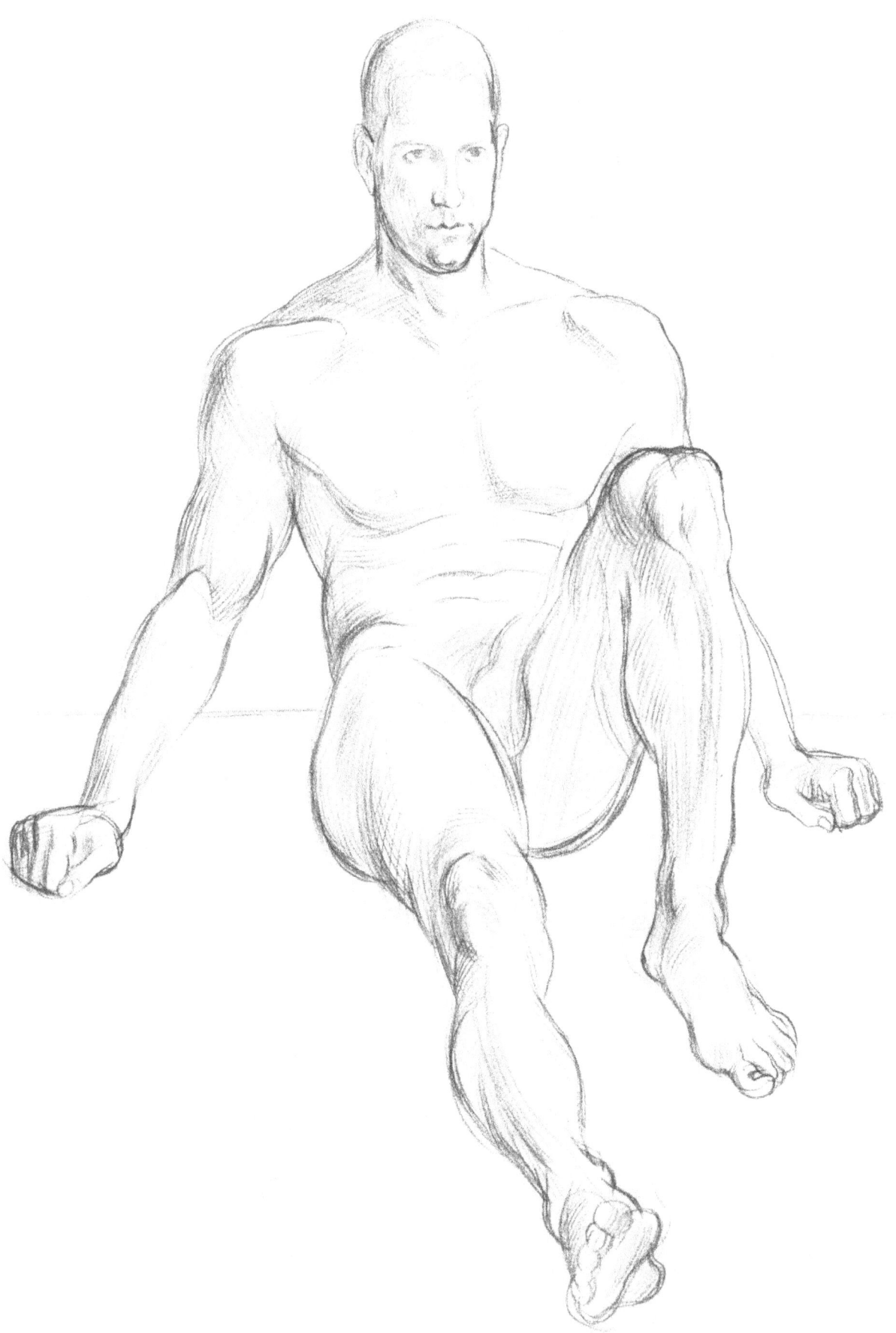

Enjoy Yourself

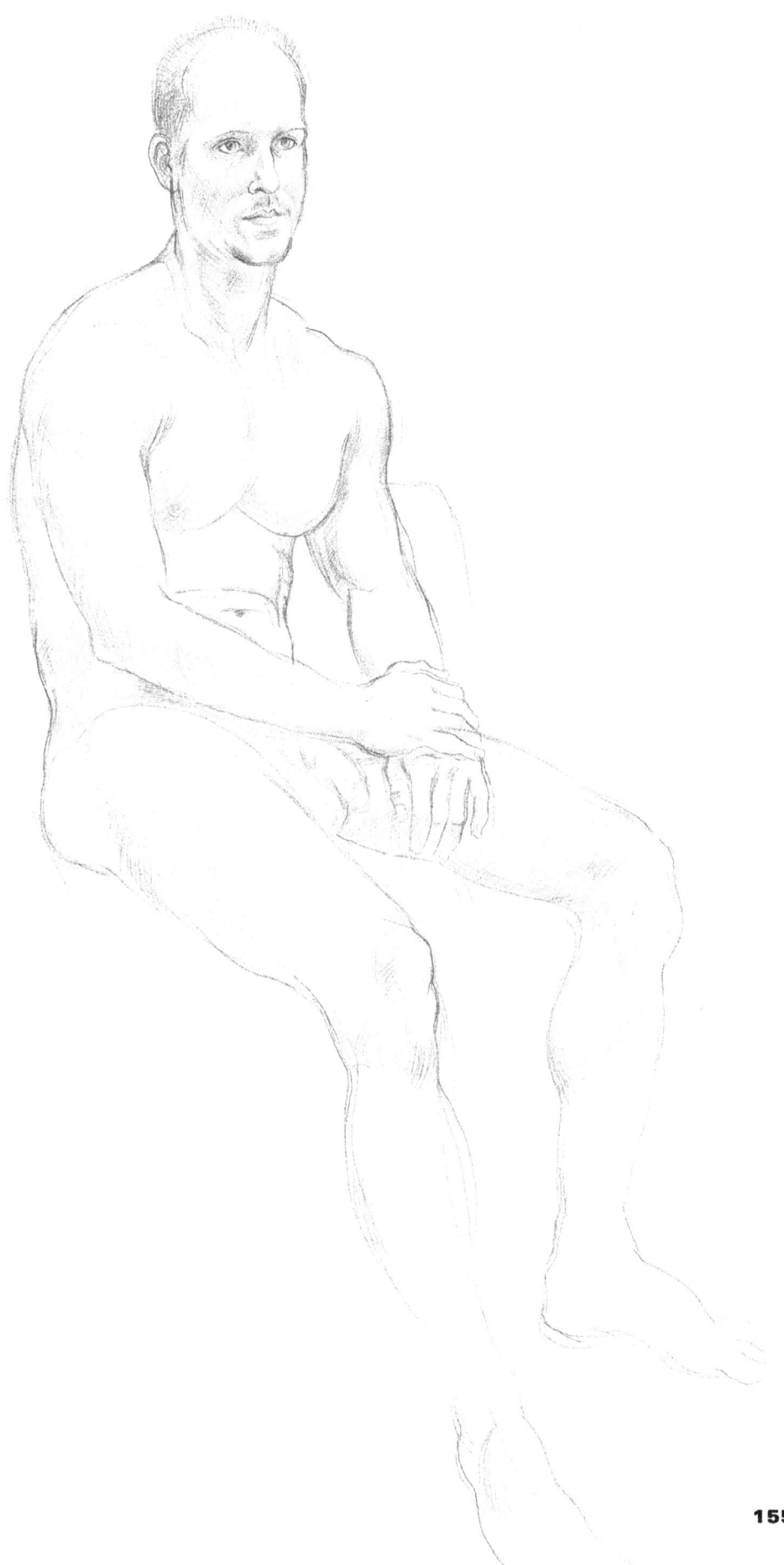

HIGH-FOCUS DRAWING

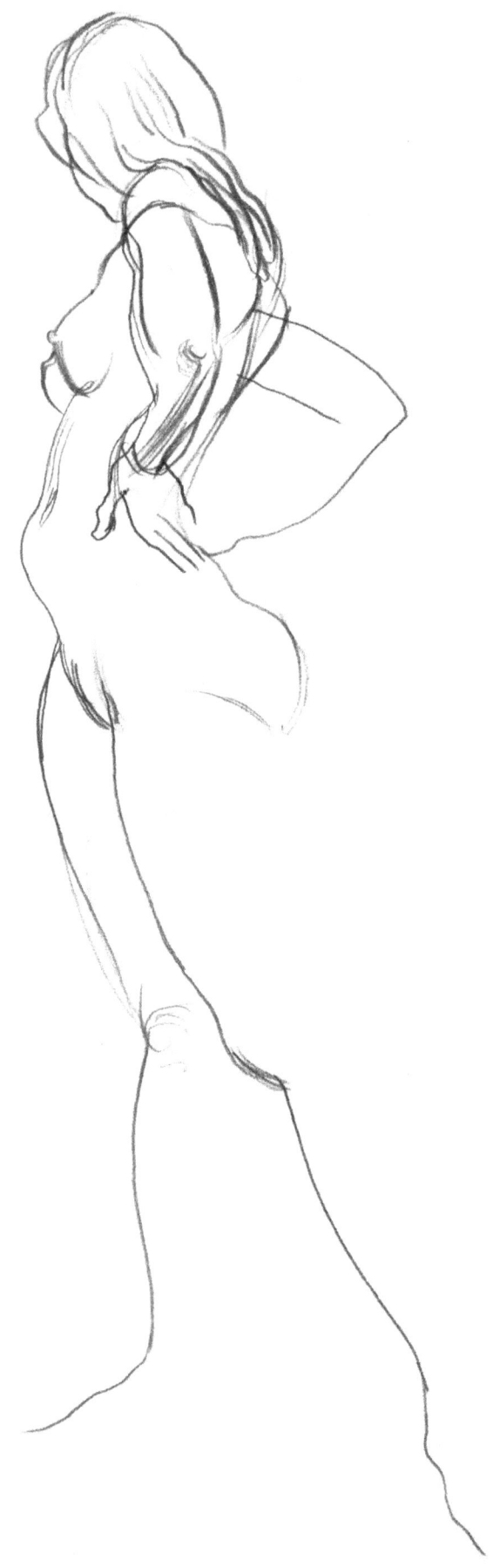

Enjoy Yourself

HIGH-FOCUS DRAWING

This book is very much the beginning of something and not the end. If you have understood my meaning and been able to reach your own pleasure in responding to the miracle of the human body, then you realize that you have learned how to sustain an observational dialogue with yourself that will change as each subject changes and as you change—and the consequences of this dialog can only be played out in time.

I have ended the book with drawings that I hope express some joy. They are not "master" drawings but they are part of the experience of my own art and my life with my students. Given the choice of closing this chapter with the drawings of Rembrandt, Degas, and Van Dyck, or with the modest successes we have made, I wanted to be able to say (with a little more conviction), "These were really fun and yes, they are possible!"

www.ingramcontent.com/pod-product-compliance
Lightning Source LLC
Chambersburg PA
CBHW041920180526
45172CB00013B/1337